Architects of Peace

Also by Michael Collopy

Works of Love Are Works of Peace:
Mother Teresa of Calcutta
and the Missionaries of Charity

ARCHITECTS OF PEACE

VISIONS OF HOPE IN WORDS AND IMAGES

PHOTOGRAPHY BY MICHAEL COLLOPY

EDITED BY MICHAEL COLLOPY AND JASON GARDNER

FOREWORD BY WALTER CRONKITE

New World Library
Novato, California

New World Library
14 Pamaron Way
Novato, California 94949
www.nwlib.com
1-800-972-6657

Cover and interior design: Toki Design, San Francisco
Editor: Jason Gardner
Editorial and research assistance: Katharine Farnam Conolly

Library of Congress Cataloging-in-Publication Data
 Architects of peace : visions of hope in words and images / photography by Michael
 Collopy ; edited by Michael Collopy and Jason Gardner ; foreword by Walter Cronkite.
 p. cm.
 ISBN 1-57731-081-0 (cloth : alk. paper)
 1. Pacifists—Biography. I. Collopy, Michael. II. Gardner, Jason, 1969–

 JZ5540.A73 2000
 327.1'72'0922—dc21

 00-038671

First printing, October 2000
ISBN 1-57731-081-0
Special Edition ISBN 1-57731-145-0
Printed in Hong Kong
Distributed to the trade by Publishers Group West
10 9 8 7 6 5 4 3 2 1

FOR ALMIS, SEAN, AND PAUL

9 INTRODUCTION

10 FOREWORD BY WALTER CRONKITE

14 DR. MAYA ANGELOU

16 NELSON MANDELA

18 CORETTA SCOTT KING

20 MAYA LIN

22 DAVID BROWER

24 GENERAL LEE BUTLER

27 MIKHAIL GORBACHEV

30 MOTHER TERESA

32 MARIAN WRIGHT EDELMAN

34 SARAH AND JAMES BRADY

36 JOSÉ RAMOS-HORTA

38 ARUN GANDHI

40 CÉSAR CHAVEZ

42 THICH NHAT HANH

44 JEAN-MICHEL COUSTEAU

46 PHIL LANE JR.

48 CRAIG KIELBURGER

50 ALICE WALKER

53 JEHAN SADAT

56 SHIMON PERES

58 ELIE WIESEL

60 STEVEN SPIELBERG

62 REVEREND JESSE JACKSON

66 JOAN BAEZ

68 IDA JACKSON

70 JANE GOODALL

72 OSCAR ARIAS SANCHEZ

74 MUHAMMAD YUNUS

78 DR. LORRAINE HALE

81 DR. C. EVERETT KOOP

84 DR. DAVID HO

86 LINUS PAULING

88 DR. HENRY A. KISSINGER

90 JIMMY CARTER

92 NADJA HALILBEGOVICH

94 BIANCA JAGGER

96 DR. MAHBUB UL-HAQ

98 GENERAL COLIN POWELL

100 RIGOBERTA MENCHÚ TUM

102 INGRID WASHINAWATOK EL-ISSA

104 THEO COLBURN

106 GEOFFREY CANADA

108 HAFSAT ABIOLA

110 REVEREND BENJAMIN WEIR

112 WEI JINGSHENG

114 ARCHBISHOP DESMOND TUTU

118 MAIREAD CORRIGAN MAGUIRE

120 LEAH RABIN

122 YAËL DAYAN

124 REVEREND BILLY GRAHAM

126 HIS HOLINESS POPE JOHN PAUL II

130 LECH WALESA

132 RICHARD LEAKEY

134 R. E. TURNER

136 CARLOS SANTANA

138 HARRY BELAFONTE

140 ANDREW YOUNG

142 SISTER HELEN PREJEAN

144 HARRY WU

146 F. W. DE KLERK

148 BENAZIR BHUTTO

150 MARGARET THATCHER

152 BELLA ABZUG

154 RON KOVIC

156 DITH PRAN

158 JODY WILLIAMS

161 HER MAJESTY QUEEN NOOR AL-HUSSEIN

164 MAHNAZ AFKHAMI

166 DR. HELEN CALDICOTT

168 CHIEF LEONARD GEORGE

170 PAUL HAWKEN

172 ROBERT REDFORD

174 HIS HOLINESS THE DALAI LAMA

176 ROBERT F. KENNEDY JR.

179 BIOGRAPHIES

189 ACKNOWLEDGMENTS

191 PERMISSIONS ACKNOWLEDGMENTS

When Mercury astronauts photographed the earth from space in the early 1960s, humankind saw the planet as a whole for the first time. In a way that only photographs can, it reminded us that our world has natural, inescapable limits. Since then, the image of earth has become part of contemporary culture—a beacon to environmental advocates, a marketing logo for advertisers. Yet the image is incomplete. Those magnificent, quiet photographs of our planet hide the profound influence we have had on its fragile surface—the swarming cities, the decimation of species, the violent battles over invisible borders.

We live in times of turmoil and promise. Our sacred ties of community to each other and to our world have been weakened by technological change, economic upheaval, and nationalist conflict. Our pace of change is leaving a good portion of the world's growing population hopelessly behind.

In the face of these challenges, and with so much at stake, one place to look for solutions is to the great figures of our time. One of these figures, Marian Wright Edelman, president of the Children's Defense Fund, inspired me to create this book with her profound speech at the 1996 State of the World Forum in San Francisco. "We are . . . living at an incredible moral moment in history," she said. "Few human beings are blessed to anticipate or experience the beginning of a new century and millennium. How will we say thanks for the life, earth, nations, and children God has entrusted to our care? What legacies, principles, values, and deeds will we stand for and send to the future through our children to their children and to a spiritually confused, balkanized, and violent world desperately hungering for moral leadership and community?"

Edelman asked several further questions: How would we measure progress in the new millennium? Would our era be remembered for its growing inequality or for our efforts to provide enough for all? Will we be known for our electronic culture's banality or for values of "caring, community, and justice"? For Edelman, the answers lie in "the values we stand for and in the actions we take today."

My own search for these answers led to the creation of this book. My hope is that these pages will help us all to consider how we would answer these questions for ourselves and our children.

The peace process needs to be nurtured and revered. I hope this book will serve to preserve the images and visions of these extraordinary people, who have sacrificed so much of themselves for the sake of others and for the sake of peace itself. I found extraordinary common threads of self-sacrifice and forgiveness in many of these stories.

Ultimately, I attempted to include people who were working toward peace from a diversity of viewpoints and backgrounds—to show how differences in culture and opinion could be united through the central goal of peace. I began by seeking well-known figures such as Mother Teresa, César Chavez, and Mikhail Gorbachev, but the book blossomed into a group of people I never could have predicted.

Some have lost loved ones or even their own lives in their fight for freedom and democracy; others have transformed their positions of privilege and education into powerful forces for peace. However controversial, each of these individuals has worked for peace in some influential way. While they may sit at the very center of bitter political battles, and may evoke passionate reactions in people, they have always remained committed to protecting peace through their individual ideals.

I hoped to create an atmosphere of sitting face-to-face, across the table from these figures, hearing their personal stories and sharing in an emotional connection, even if only for one brief moment. I always felt humbled by the participants' willingness to allow me into their lives and by their generosity in often writing original statements for the book.

I feel this project is a journey in faith and inspiration, and inevitably a work in progress. It is my hope that we can move beyond judgment to foster understanding and tolerance. I have come to believe that we have incredible power within our grasp when we dare to look deep within ourselves for change. One by one, we can recognize our brothers and sisters—especially those in need—first through our eyes, then in our minds, and eventually in our hearts. Our hearts hold the love and compassion we need to attain our goal of peace, where we may all live in harmony and equality, realizing the true community of the earth.

—Michael Collopy

WALTER CRONKITE

SINCE HUMANS FIRST SCRATCHED THOUGHT ON STONE WE HAVE recorded a longing for peace. The ancient Egyptians and the Greek philosophers pondered the difficulties of achieving it, and of achieving the prerequisite charity for our fellow men.

From Plutarch's *Lives* comes the quote from Anacharsis ridiculing Solon "for imagining the dishonesty and covetousness of his country-men could be restrained by written laws." That was around 600 B.C.E., a couple of millennia ago. Not much seems to have changed.

From the lessons of the Bible and other great religious works to modern government, humans always have recognized the need for equality and charity to free the world of war, pestilence, and want. Why is that so hard to achieve? What must we do to pierce this armor of self-ishness behind which individuals and governments shirk their responsi-bilities to their fellow man? Seeking an answer to this age-old question, I gather, is in essence the purpose of this book.

The effort obviously is a worthy one, and I suspect that the chances of success are greater than ever before. Perhaps the time has come at last when real progress can be made toward the amelioration, or even the elimination, of the problems that already afflict too much of humanity and threaten the rest of us, who in our ignorance believe that somehow we can remain immune. My optimism is based on the almost unbeliev-able advancement in communication that has enabled the people of the world to share their experiences and their hopes, their expectations, and, beyond, the possible solutions to our problems.

Television and the transmission of its programs by satellite has, indeed, created the global village. Its news and documentaries, with their constant close-ups of nations, civilizations, and cultures previously unknown to one another, has created a new bond of humanity—a real-ization among all of us that the differences presented by race or geogra-phy are not as great as our similarities. The airplane shrank our physical world; now the Internet is shrinking our intellectual world. Villagers in the most remote areas can now have, literally at their fingertips, access to the world's knowledge, wherein may be found the guidance to bring them into the modern world—to teach them, by practical example, hygiene and birth control and crop rotation and animal husbandry and a hundred other ways to improve their lives. Our great development in

communication is just one of the wonders of our past century—wonders that we must harness if we are to enjoy their great promise.

In this new century, one can only stand in awe of the potential for human advancement. In just the latter half of the last remarkable century, we were swept into at least six simultaneous eras, any one of which, by itself, could be considered an age of man. We were present at the birth of the nuclear age, the space age, the petrochemical age, the telecommunica-tions age, the computer age, the DNA age. Together, at their confluence, flows a great river of chance, unlike anything history has encountered before.

We call it the technological revolution—a revolution surely with more impact than the previous century's industrial revolution that forever altered the world.

Already vast economical and political changes have taken place, pro-pelled by growth and accompanied by rising expectations. But too fre-quently these changes have been blocked in less-developed nations by finite resources and inadequate educational systems. Meeting these problems and satisfying the needs of the disadvantaged is the challenge of our time.

And that is just my point: The new technologies give proof of humankind's intellectual capacity. Can we really believe that we are incapable of applying that same intellectual power to solving the great problems the world faces?

If we of the so-called developed nations—the possessors of these scientific and technological tools—can't solve the problems, someone else—perhaps someone less benign—will solve them for us. Can we believe that the beleaguered peoples of the world will long be tolerant of those who possess the tools but can't make them work for the good of humankind everywhere?

There is going to be a social and political and economic evolution that will explode with such suddenness as to have the character of revolu-tion. The revolutionary forces are already at work today, and they have humanity's dreams on their side.

We don't want to be on the other side. It is up to us—the educated, the informed, the wealthy possessors of the tools—to forgo self-aggrandizement and assume leadership of that revolution and channel it in a direction that will ensure freedom's future. ■

And God says, I have a dream. I have a dream that all of my children will discover that they belong in one family—my family, the human family—a family in which there are no outsiders. All, all belong, all are held in the embrace of this one whose love will never let us go, this one who says that each one of us is of incredible worth, that each one of us is precious to God because each one of us has their name written on the palms of God's hands. And God says, there are no outsiders— black, white, red, yellow, short, tall, young, old, rich, poor, gay, lesbian, straight—everyone. All belong. And God says, I have only you to help me realize my dream. Help me.

—Archbishop Desmond Tutu

DR. MAYA ANGELOU

THERE IS A NATURAL, SLOW TEMPERAMENT IN THE BODY OF those who are not themselves being harassed, imprisoned, segregated, or abused. And there is a rapid temperament which inhabits those who are aware of social and political discrepancies, whether those discrepancies affect their own condition or not.

The fact that people become heroes and sheroes can be credited to their ability to identify and empathize with "the other." These men and women could continue to live quite comfortably with their slow temperament, but they chose not to. They make the decision to be conscious of the other—the homeless and the hopeless, the downtrodden and oppressed. Heroism has nothing to do with skin color or social status. It is a state of mind and a willingness to act for what is right and just.

If we don't say enough about these heroes—those who went before us and acted in a heartful way—our young people will be discouraged from trying to do what is right. It is important to claim as part of our heritage the good action and the victories they engendered. ■

NELSON MANDELA

I WAS NOT BORN WITH A HUNGER TO BE FREE. I WAS BORN FREE—free in every way that I could know. Free to run in the fields near my mother's hut, free to swim in the clear stream that ran through my village, free to roast mealies under the stars and ride the broad backs of slow-moving bulls. As long as I obeyed my father and abided by the customs of my tribe, I was not troubled by the laws of man or God.

It was only when I began to learn that my boyhood freedom was an illusion, when I discovered as a young man that my freedom had already been taken from me, that I began to hunger for it. At first, as a student, I wanted freedom only for myself, the transitory freedoms of being able to stay out at night, read what I pleased, and go where I chose. Later, as a young man in Johannesburg, I yearned for the basic and honorable freedoms of achieving my potential, or earning my keep, of marrying and having a family—the freedom not to be obstructed in a lawful life.

But then I slowly saw that not only was I not free, but my brothers and sisters were not free. I saw that it was not just my freedom that was curtailed, but the freedom of everyone who looked like I did. That is when I joined the African National Congress, and that is when the hunger for my own freedom became the greater hunger for the freedom of my people. It was this desire for the freedom of my people to live their lives with dignity and self-respect that animated my life, that transformed a frightened young man into a bold one, that drove a law-abiding attorney to become a criminal, that turned a family-loving husband into a man without a home, that forced a life-loving man to live like a monk. I am no more virtuous or self-sacrificing than the next man, but I found that I could not even enjoy the poor and limited freedoms I was allowed when I knew my people were not free. Freedom is indivisible; the chains on any one of my people were the chains on all of them, the chains on all of my people were the chains on me.

It was during those long and lonely years that my hunger for the freedom of my own people became a hunger for the freedom of all people, white and black. I knew as well as I knew anything that the oppressor must be liberated just as surely as the oppressed. A man who takes away another man's freedom is a prisoner of hatred, he is locked behind the bars of prejudice and narrow-mindedness. I am not truly free if I am taking away someone else's freedom, just as surely as I am not free when my freedom is taken from me. The oppressed and the oppressor alike are robbed of their humanity.

When I walked out of prison, that was my mission, to liberate the oppressed and the oppressor both. Some say that has now been achieved. But I know that that is not the case. The truth is that we are not yet free; we have merely achieved the freedom to be free, the right not to be oppressed. We have not taken the final step of our journey, but the first step on a longer and even more difficult road. For to be free is not merely to cast off one's chains, but to live in a way that respects and enhances the freedom of others. The true test of our devotion to freedom is just beginning.

I have walked that long road to freedom. I have tried not to falter; I have made missteps along the way. But I have discovered the secret that after climbing a great hill, one only finds that there are many more hills to climb. I have taken a moment here to rest, to steal a view of the glorious vista that surrounds me, to look back on the distance I have come. But I can rest only for a moment, for with freedom comes responsibilities, and I dare not linger, for my long walk is not yet ended. ▪

CORETTA SCOTT KING

As we begin the twenty-first century, I think it is important that people of every race, religion, and nation join together to develop a shared vision of a world united in justice, peace, and harmony.

We should dare to dream of a world where no child lives in fear of war or suffers the ravages of militarism. Instead of spending more than two billion dollars a day on the arms race, as the governments of the world do now, we must invest in human and economic development, so that no one has to live in poverty. We must project a bold vision of a world where valuable resources are no longer squandered on the instruments of death and destruction, but are creatively harnessed for economic development and opportunity.

Let's dare to dream of a Beloved Community where starvation, famine, hunger, and malnutrition will not be tolerated because the civilized community of nations won't allow it. Instead of five hundred million people going to bed hungry every night, as is now the case, in the Beloved Community every human being would be well nourished.

We should dare to dream of a world being reborn in freedom, justice, and peace, a world that nurtures all of its precious children and protects them with compassion and caring. In such a Beloved Community, every child will be enrolled in a good school that has all of the resources needed to teach them to love learning. Young people will be able to get as much education as their minds can absorb and a full range of cultural opportunities to enrich their spirits.

In the Beloved Community, conflicts between nations will be resolved peacefully. Dictators will be replaced, not by civil war and terrorism, but by organized nonviolent movements that will insure that freedom, human rights, and dignity will be honored under all flags.

Instead of religious and racial violence and wars between nations, there will be interreligious, interracial, and international solidarity based on tolerance and respect for all cultures. With such a commitment, we will not only reduce cultural conflict, but also create a global community where a new vision of unity in faith can prevail.

We must find a way to tap the tremendous healing power of faith to promote a higher level of cross-cultural understanding and cooperation, which can help rid the world of war and violence. Even as we worship in many languages and call our common creator by a host of different names, let the people of every religion now make room in their hearts for interfaith brotherhood and sisterhood for the sake of humanity.

All of the world's great problems—the struggles for self-determination and human rights, stopping war, halting the arms race, checking the exploitation of multinational corporations, and confronting the global environmental crisis—must be addressed by nonviolent movements. Thus, twenty-five Nobel Peace Prize laureates have joined together in affirming that the first decade of the new century will be a decade for peace and nonviolence, and the first year of the twenty-first century will be devoted to nonviolence training and education.

As my husband, Martin Luther King Jr., said in a challenge he issued in 1967, "I suggest that the philosophy and strategy of nonviolence become immediately a subject for study and for serious implementation in every field of human conflict, and by no means excluding the relations between nations." And as Mohandas K. Gandhi, who inspired Martin, echoed, "we should train for nonviolence with the fullest faith in its limitless possibilities."

Both Gandhi and my husband understood that the great advantage of nonviolence is that its success does not depend on the integrity of political leaders. It depends on the courage and commitment of people of goodwill.

To meet the challenge of the Nobel laureates, we must join together in creating a nonviolent movement to achieve peace with justice that spans the globe. With courage and determination, we must sound the knell for the end of fear, apathy, and indifference to human suffering and proclaim a new century of hope, a century of protest and nonviolent resistance to injustice and repression throughout the nation and around the world.

At the dawn of the twenty-first century, we have an historic opportunity for a great global healing and renewal. If we will accept the challenge of nonviolent activism with faith, courage, and determination, we can bring this great vision of a world united in peace and harmony from a distant ideal into a glowing reality. ■

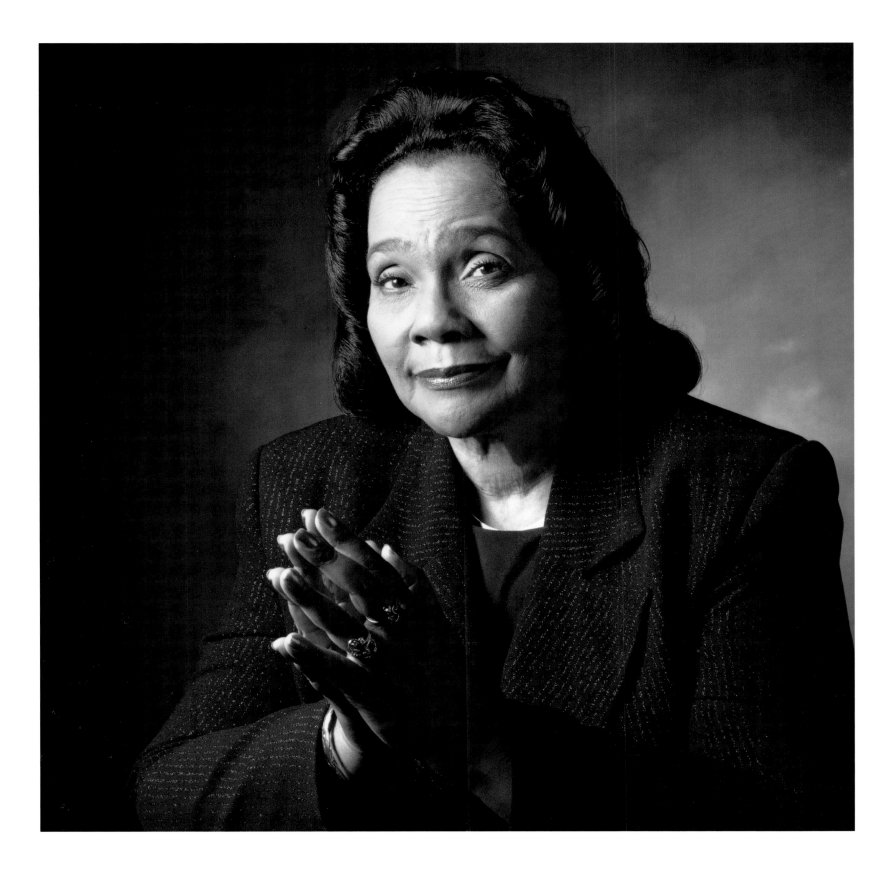

MAYA LIN

I CANNOT REMEMBER A TIME WHEN I WAS NOT CONCERNED WITH environmental issues or when I did not feel humbled by the beauty of the natural world. A strong respect and love for the land exists throughout my work.

I take inspiration from topography and natural phenomena: water patterns, solar eclipses, mappings of the ocean floor, ice formations, undulations of the landscape. My work asks the viewer to pay closer attention to the land.

As we begin the new millennium, we have to think of peace not just as among our own species but as encompassing all species that live on this planet. We must look at how our activities affect the natural world in which we live.

We are now seeing incredible losses of other species, occurring in large part from habitat destruction as we expand and grow into more and more territory. Experts have called it the sixth largest extinction the world has seen and the only one caused by one species, humankind.

I believe that peace will only come when we learn to live on this planet in a way that allows all other creatures to exist alongside us. ∎

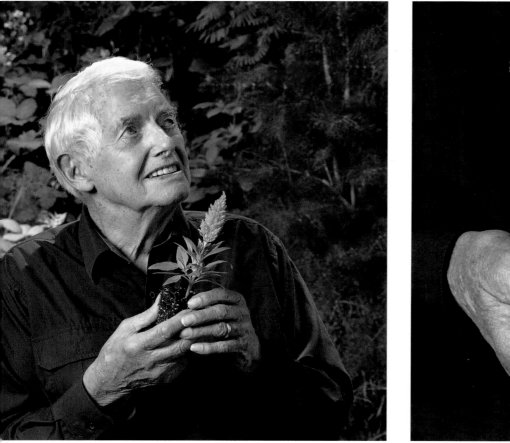

DAVID BROWER

WHAT I'M WORKING THE HARDEST ON NOW, IF I CAN SAY HARDEST at my age, is trying to establish a global CPR service: C for conservation, P for preservation, and R for restoration. You can sum it up in a ten-second sound bite: Conserve the golden eggs carefully. Preserve the goose or there will be no more golden eggs. And if you've already damaged the goose, get going on restoration.

It comes down to some fundamental requirements. Don't get rid of anything you can't replace, for example, such as species. Of course, we're getting rid of one species about every twenty minutes, because we don't understand the true value of nature. The forest service, for example, thinks the value of wilderness is the number of human footprints we put in it. That's like evaluating the Mona Lisa by weighing its paint.

I like to say that before we start criticizing capitalism, we ought to try it. We don't factor the value of nature and its services into the market equation. A wonderful, eye-opening book edited by Gretchen C. Daily called *Nature's Services* puts it in perspective. Every year we use roughly $33 trillion worth of nature's services throughout the world's civilizations, and we make little or no effort to pay any of that back. We just use it. Look at the service a bee provides us, for example. A bee doesn't charge hourly fees or anything else. But if we lose the bees, we're not going to eat. And the pollinators are disappearing. I just found that out in my own backyard. Last year we had lots and lots of flowers; this year, somehow, we have almost none. And with no crop, we're in trouble.

Let's not run our credit out on the earth. If we use $33 trillion worth of credit every year and don't pay anything back, someone's going to say, "I'm sorry, your credit line is exhausted." And when we lose the wilderness—if we lose it—the world becomes a cage.

Even if we know little about the wilderness outside, even if we've never left the city, we can still revel at what's going on in ourselves and where we came from. The patient egg and the lucky sperm—from these two entities comes everything necessary for you and for me, everything needed to be a person. You needed to be nourished by your mother, kept warm and safe until you emerged, and nurtured. But everything you needed to know comes from two cells, two seeds: How many eyelashes do you need? How do you build a retina? How do you build windshield wipers to keep the eyes from getting too dry? How do you build an immunity system? (At eighty-seven, my immune system has been developing for

so long I hardly have colds anymore. The grim reaper's not going to get me with something little like a cold. He'll have to get me some other way.)

All this works by itself. It wasn't invented in the Industrial Revolution. It wasn't the result of the Renaissance. Man's appearance on this earth isn't responsible for these systems. Everything now alive relates directly to when life began, a direct outcome of failures and successes along the way. Every one of us alive now is the result of three and a half billion years of pure success in the transmission of life's magic. And this happened in wilderness, because that's all there was. It's the ultimate encyclopedia, and we must stop degrading it.

I would like to see human beings honoring each other and the intelligence with which we were born—recognizing our wonderful, delightful variation. No two people ever will be or ever were alike. That difference is one of the exciting things we can all celebrate.

When I was about eleven, I read the entire Bible. I've forgotten what I read, and I certainly didn't understand it, but now I keep being reminded of some of my favorite quotes. My current favorites are from Isaiah: "Thou hast multiplied the nation, and not increased the joy" (Isaiah 9:3) and "Woe unto them that join house to house, that lay field to field, till there be no place, that they may be placed alone in the midst of the earth" (Isaiah 5:8). These verses point to two things—that God doesn't like sprawl, and that God does like wilderness.

The problem with the Ten Commandments, though, is that they are all about how to take care of each other, which is very important, but they don't have one suggestion about how to take care of the earth—not a word.

Maybe we should take Father Thomas Berry's advice: "Put the Bible on the shelf for twenty years, and read the earth." There is a vast amount of information out there and it's pretty fascinating stuff. Once you get even a little skilled at looking at it and trying to understand it, you will never find life dull again. We need to work with the earth, and do some global CPR: conserve, preserve, and restore. ■

I photographed David in his yard above the fog in the Berkeley hills. David has lived in his house nestled in the redwoods since 1947. Behind him on the right is the lacelike anise, or "lady's chewing tobacco," one of David's favorite plants because it attracts the western swallowtail butterfly.—M.C.

GENERAL LEE BUTLER
The Responsibility to End the Nuclear Madness

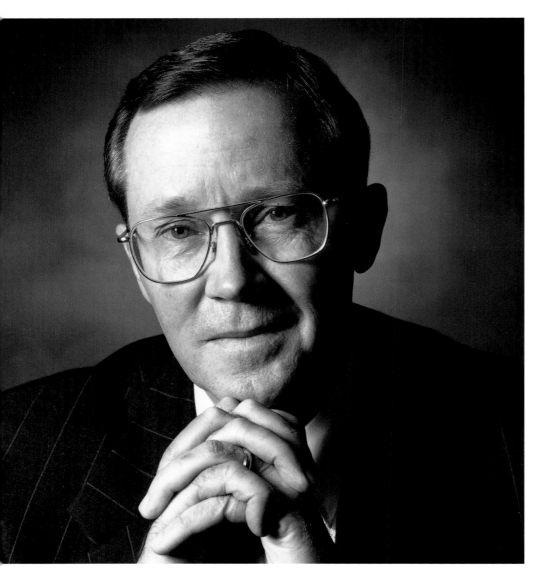

I GET A LOT OF QUESTIONS LIKE, "IF YOU HAD BEEN PRESIDENT Truman, would you have made the decision to drop an atom bomb on Hiroshima?" "Was this a revelation, was it an epiphany, what was the catalyst for your change of view?" The questions go to the issue of when I had the responsibilities as the commander of the nuclear forces, as a nuclear advisor to the president and, perhaps most particularly, as the person who devised the nuclear war plan. Did that give me pause? Were there reservations?

The evolution of my views was *not* an epiphany, not some road-to-Damascus revelation. From the very outset, the nuclear arena was superimposed with a blanket of secrecy that was virtually impenetrable. Access to the knowledge and access to the levers of power that control this arena were reserved to a very small number of people throughout its history in this country and in the Soviet Union.

I was commissioned as a lieutenant in June 1961. I became the commander of the nuclear forces of the United States in January 1991, almost thirty years later. Until the day I assumed those responsibilities, I had never been given access to the nuclear war plan of the United States in its entirety, even though in Washington I had policy responsibilities that directed the plan. I knew nothing about the submarine operations of the strategic nuclear forces of the United States, and I had an incomplete understanding of the process that would lead to a command from the president of the United States to unleash nuclear war in retaliation for a presumed strike.

DEEPENING DOUBTS

Up to that point I had developed a series of reservations and doubts that progressively deepened. I had no basis for understanding whether these concerns proceeded from a lack of information and insight, or whether they were rooted in the reality of bureaucratic processes run amuck, by the intrusion of the self-serving profit interests of the military-industrial complex, by the collision of cultures and turf in the Pentagon for budget dollars, or simply by the towering forces of alienation and

isolation that grew out of the mutual demonization between the U.S. and the Soviet Union over a period of forty-five years. I just didn't know.

Beginning in early 1991, I went through a process that very quickly accelerated and confirmed my worst fears and my worst concerns. What we had done in this country, what I believe happened in the Soviet Union, and what I think will inevitably happen in any country that makes the fateful decision to become a nuclear power—to acquire the capability to build and employ nuclear weapons—is this: *the creation of gargantuan agencies with mammoth appetites and a sense of infallibility, which consume infinite resources in messianic pursuit of a demonized enemy.* When that happens, it quickly moves beyond the capacity for any single individual or small group of people, like the president, the National Security Council, the chairman of the Joint Chiefs, or the Joint Staff, to control them or to understand. Let me give you some illustrations of what I mean.

A Chilling Ballet

In those responsibilities of commander of the forces responsible for the day-to-day operational safety, security, and preparation to employ those weapons, I was increasingly appalled by the complexity of this ballet of hundreds of thousands of people managing, manipulating, controlling, and maintaining tens of thousands of warheads and extremely complex systems that flew through the air, were buried in the bowels of the land, or patrolled beneath the seas of the world.

The capacity for human error, human failure, mechanical failure, or misunderstanding was virtually infinite. I have seen nuclear airplanes crash under the circumstances that were designed to replicate, but were inevitably far less stressful than, the actual condition of nuclear war. I have seen human error lead to the explosion of missiles in their silos. I have read the circumstances of submarines going to the bottom of the ocean laden with nuclear missiles and warheads because of failures, mechanical flaws, and human error. I read the entire history, and when I came away from it—because I was never given access to it before—I was chilled. I was chilled to the depth of my strategic soul.

Consider my responsibilities as a nuclear advisor. Every month of my life as a commander of the nuclear forces I went through an exercise called the Missile Threat Conference. It would come at any moment of the day or night. For three years I was required to be within three rings of my telephone so that I could answer a call from the White House to advise the president on how to respond to nuclear attack. The question that would be put to me in these conferences, and as it would be in the event, was "General Butler, I have been advised by the commander in chief of the North American Air Defense Command that the nation is under nuclear attack. It has been characterized thusly. What is your recommendation with regard to the nature of our reply?"

That was my responsibility, and occasionally that call came in the middle of the night as my wife, Dorene, and I lay in our bedroom. I had to be prepared to advise the president to sign the death warrant of 250 million people living in the Soviet Union. I felt that responsibility to the depth of my soul, and I never learned to reconcile my belief systems with it. Never.

My third responsibility was to devise the nuclear war plan of the United States. When I became the director of Strategic Target Planning, another hat I wore as the commander of the Nuclear Forces, I went down to my targeting room, several floors underground. I told my planners that we were going to get to know each other very well because I wanted to understand the plan in its entirety. I think this story is the most graphic illustration of the evolution of my views and my concerns and, ultimately, my convictions. When I began to delve into that war plan, I was absolutely horrified to learn that it encompassed 12,500 targets. I made the personal commitment—because I viewed it as absolutely integral to my responsibilities and the consequences of that targeting—to examine every single one of them in great detail.

Ending the Madness

It took me three years, but by three months I was absolutely convinced that it was the most grotesque and irresponsible war plan

that had ever been devised by man, with the possible exception of its counterpart in the Soviet Union, which in truth probably mirrored it exactly. Because what that plan implied was, among other things, in the event of nuclear war between two nations, in the space of about sixteen hours some twenty thousand thermonuclear warheads would be exploded on the face of our planet, signing the death warrant not just for 250 million Soviets, but likely for mankind in its entirety.

The second thing that I began to grasp was that neither in the Soviet Union nor the United States did any of us ever understand those consequences, because the calculation as to the military effectiveness of that attack was based on only one criterion, and that was blast damage. It did not take into account fire; it did not take into account radiation. Can you imagine that? We never understood, probably didn't care about, and certainly would not have been able to calculate with any precision, the holistic effects of twenty thousand nuclear weapons being exploded virtually simultaneously on the face of the earth.

That was the straw that tilted my conviction with regard to the prospects of nuclear war, and ultimately to an unavoidable responsibility to end this. To end it! And by the grace of God I came to that awareness and I inherited my responsibilities at the very moment the Cold War was ending and, therefore, I had the opportunity to end the madness.

So in those three years I did what I could to cancel all of the strategic nuclear modernization programs in my jurisdiction, which totaled $40 billion. I canceled every single one of them. I recommended to the president that we take bombers off nuclear alert for the first time in thirty years, and we did. I recommended that we accelerate the retirement of all systems designed to be terminated in present and future arms control agreements, and we did. We accelerated the retirement of the Minuteman II force. We shrank the nuclear warplanes of the United States by 75 percent. By the time I left my responsibilities, those 12,500 targets had been reduced to 3,000. If I'd had my way and I'd been there a while longer, I would have worked to reduce them to zero. Ultimately I recommended the disestablishment of my command. I took down its flag with my own hands.

Creeping Re-rationalization of Nuclear Weapons

When I retired in 1994, I was persuaded that we were on a path that was miraculous, that was irreversible, and that gave us the opportunity to actually pursue a set of initiatives, acquire a new mind-set, and re-embrace a set of principles, premised on the sanctity of life and the miracle of existence, that would take us on the path to zero. I was dismayed, mortified, and ultimately radicalized by the fact that within a period of a year that momentum again was slowed. A process that I have called the creeping re-rationalization of nuclear weapons was introduced by the very people who stood to gain the most by the end of the nuclear era.

The French reinitiated nuclear testing at the worst possible moment, as the Comprehensive Test Ban Treaty hung in the balance. We have reinitiated the process of demonization of "rogue nations"; what a horrible, pernicious misuse of language! What an anti-intellectual, dehumanizing process of reducing complex societies and human beings and histories and cultures to "rogue nations." Once you do that, you can justify the most extreme measure to include the reintroduction of nuclear weapons as legitimate and appropriate weapons of national security.

If we truly cling to the values that underlie our political system, if we truly believe in the dignity of the individual, and if we cherish freedom and the capacity to realize our potential as human beings on this planet, then we are absolutely obligated to pursue relentlessly our capacity to live together in harmony and according to the dictates of respect for that dignity, for that sanctity of life. It matters not that we continuously fall short of the mark. What matters is that we continue to strive. What is at stake here is our capacity to move ever higher to the bar of civilized behavior. As long as we sanctify nuclear weapons as the ultimate arbiter of conflict, we will have forever capped our capacity to live on this planet according to a set of ideals that value human life and eschew a solution that continues to hold acceptable the shearing away of entire societies. That simply is wrong. It is morally wrong, and it ultimately will be the death of humanity. ■

MIKHAIL GORBACHEV

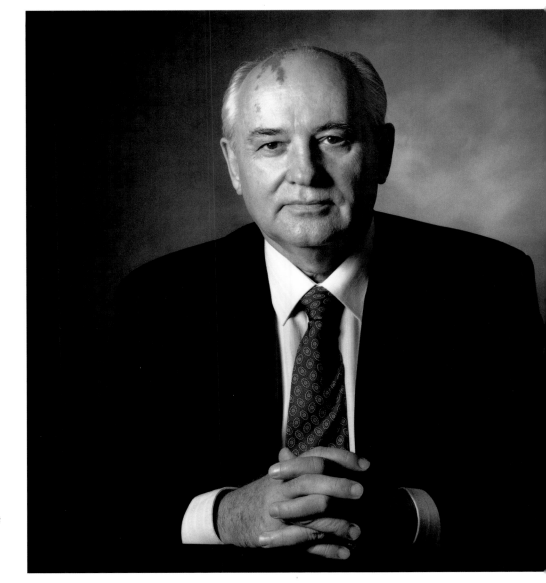

MY PERSONAL SITUATION AND EXPERIENCES AS THE PRESIDENT of the former Soviet Union have provided me with insight into an unimaginable terror that has been shared by only a few individuals on this planet. In my hands there rested the sheer raw power to unleash nuclear weapons on the world and destroy human life. For seven years this power was never more than a few feet away.

At all times of the day and night, wherever I went, whatever I did, awake or asleep, some military aide was nearby, holding at the ready that infamous black box containing the nuclear codes that became the dark and evil emblem of our tortured nuclear age.

I was haunted by the constant awareness that I might be required to calculate and decide in an instant of time whether some kind of nuclear action might be required in response to a real or imagined or mistaken attack perceived to be under way against my country. I know this nightmare was shared equally by Ronald Reagan and George Bush when they were president.

Each of us in our time in high office had our ample share of severe critics. But only we actually knew, far better than our worst critics ever dreamed, how truly fallible and all-too-human each of us really was. In a strange way, it was this fact and our recognition of it that perhaps brought us together more than anything else.

The ultimate absurdity of relying on nuclear weapons was dramatically revealed to me, and I am sure to President Bush as well, when we met in Washington in the summer of 1990.

During that visit, we shared a helicopter ride together to Camp David. Near President Bush sat a military aide with the nuclear codes enabling him to destroy the Soviet Union. Near me sat my military aide with the codes required to destroy the United States. Yet President Bush and I sat together on that small helicopter talking about peace. Neither of us planned to ever use the awesome power we each possessed. Yet we possessed it. And we both knew how ordinary and fallible we both were.

Even if it now seems that the danger of nuclear annihilation presented by the Cold War is over and mercifully behind us, it is my firm

27

belief that the infinite and uncontrollable fury of nuclear weapons should never be held in the hands of any mere mortal ever again, for any reason.

There is great peril in allowing ourselves to be lulled by a soothing but incorrect sense that because the Cold War has ended, the nuclear danger has eased and no longer requires urgent attention. If anything, this false sense of security makes the mortal danger that yet lurks in the shadow of our unfolding new affairs more perilous than ever.

The danger that has become apparent is what I would call the new arms race. I am referring to the continuing global proliferation of the most dangerous kinds of military technologies and the real threat of the spread of nuclear and other weapons of mass destruction. Furthermore, the advanced countries are turning out increasingly sophisticated weapons, and many conventional arms are assuming the quality of "absolute weapons."

In the final analysis, the nuclear threat is a direct product of the cult of force that has dominated the world for centuries. It is, if you will, its supreme incarnation. For it is more than just someone's threat to use force against another. It stands for the readiness to physically destroy the adversary. It is a kind of mental illness, the loss of reason that *Homo sapiens* must possess. The world of interdependence and cooperation must absolutely rule out the use of force, particularly of nuclear weapons, as the solution to any problems.

The world must take a series of interrelated and properly timed steps to alleviate further the nuclear danger. These should include further deep cuts in the Russian and American nuclear arsenals, with the other nuclear powers joining the process; the cessation of the production of weapons-grade plutonium; the complete and final cessation of nuclear weapons testing without exception; strengthening the International Atomic Energy Agency, extending its jurisdiction to the supplies of all "near nuclear" materials; and the substantial extension and modification of the Nuclear Non-Proliferation Treaty.

I am committed to a nuclear-free world. Whereas I understand those who are mindful of possible aggressive ambitions of some rogue dictator or authoritarian regime, *I believe that a new structure of international relations, which I here propose, combined with the absolute superiority of democratic nations in sophisticated conventional arms, provides guarantees that are quite sufficient for genuine national security in the new world order.*

The twentieth century must be seen as a *century of warning*, a call of caution to humankind for the necessity of developing a new consciousness and new ways of living and acting. Has it fulfilled this role? No, at least not completely.

It has been the fond hope of many that the end of the Cold War would liberate the international community to work together to avert threats and work in a spirit of cooperation in addressing the dangerous problems that affect the world as a whole. But, despite the numerous summit meetings, conferences, congresses, negotiations, and agreements, there does not appear to have been any tangible progress.

In all likelihood, no one—neither the political leaders nor any other thinking individual—really believed that right after the end of the Cold War we would immediately start living under a new world order. *Between the old order and the new one lies a period of transition that we must go through*—moving toward a new structure of international relations marked by cooperating, interacting, and taking advantage of new opportunities.

What we are actually seeing today, however, looks rather like a world disorder.

It is my belief that today's policymakers lack a necessary sense of perspective and the ability to evaluate the consequences of their actions. What is absolutely necessary is a critical reassessment of the views and approaches that currently lie at the basis of political thinking and a new combination of players to envision and carry us through to the next phase of human development.

The world is truly at a crossroads. We face many complex problems whose solutions will take more than just physical resources and financial expenditures. To meet these challenges the rules of international behavior will have to be changed. The roots of the current crisis of civilization lie within humanity itself. Our intellectual and moral development is lagging behind the rapidly changing conditions of our existence, and we are finding it difficult to adjust psychologically to the

pace of change. *Only by renouncing selfishness and attempts to outsmart one another to gain an advantage at the expense of others can we hope to ensure the survival of humankind* and the further development of our civilization.

Each generation inherits from its predecessors the material and spiritual wealth of civilization. And each generation is responsible for preserving this inheritance and developing it for the succeeding generations.

Human beings do not choose the times in which they live. It has fallen to our lot to live in extremely dramatic times.

Ours is a time of acute problems and unprecedented opportunities. We shall be able to accomplish our historic task of developing our inheritance only if, irrespective of our political opinions, religious beliefs, or philosophies, we try to understand and help one another and act in concert for a better future. ▪

President Gorbachev is one of those rare individuals who changes a room when he enters it. I first met him when I was scheduled to do a portrait of him at the opening of the Gorbachev Foundation in San Francisco. I had set up my equipment upstairs at their new headquarters, a small house near the foot of the Golden Gate Bridge. Gorbachev was scheduled to enter the house briefly and then give the keynote speech outside. By the time he arrived with his wife, Raisa, the tiny first floor was completely filled. I sensed that the overflowing crowd made him uncomfortable and that my hopes of photographing him were fading fast.

As I climbed the stairs to regroup with my publicist, I felt someone tug on my shoulder. It was Gorbachev, asking me to show him around the second floor. Of course, I immediately brought him to the room with my equipment. He walked into the room, smiled, and walked out. I learned later that being photographed for him was like going to the dentist.

Through their interpreter, I pleaded my case with Raisa, who convinced him to sit for me. Once he was in the chair, she teased him over my shoulder, prodding him to say "cheese," one of the few words I think she knew in English. Thanks to Raisa I was able to photograph President Gorbachev several times over the next few years. Her passing was a tremendous blow to everyone who had the great pleasure of being in her company.—M.C.

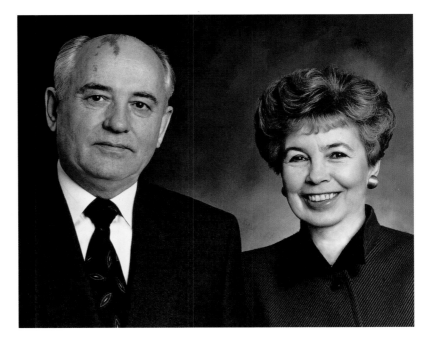

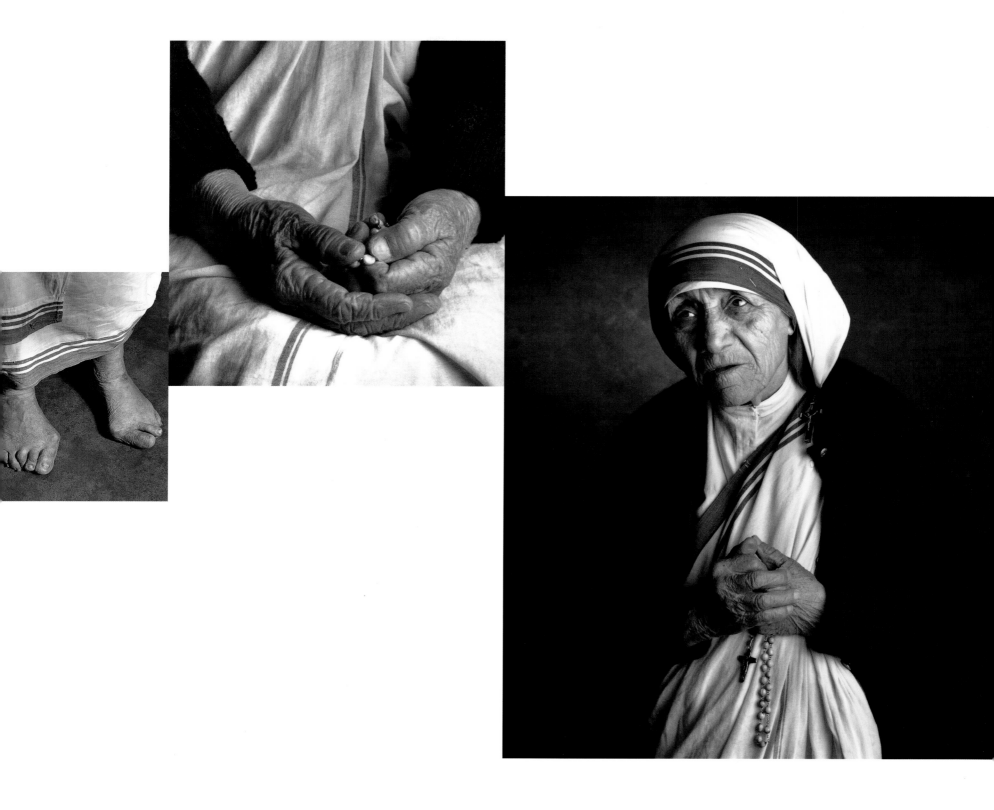

MOTHER TERESA

THE FRUIT OF SILENCE IS PRAYER; THE FRUIT OF PRAYER IS FAITH; the fruit of faith is love; the fruit of love is service; the fruit of service is peace.

Let us not use bombs and guns to overcome the world. Let us use love and compassion. Peace begins with a smile. Smile five times a day at someone you don't really want to smile at; do it for peace. Let us radiate the peace of God and so light His light and extinguish in the world and in the hearts of all men all hatred and love for power.

Today, if we have no peace, it is because we have forgotten that we belong to each other—that man, that woman, that child is my brother or my sister. If everyone could see the image of God in his neighbor, do you think we would still need tanks and generals?

Peace and war begin at home. If we truly want peace in the world, let us begin by loving one another in our own families. If we want to spread joy, we need for every family to have joy.

Today, nations put too much effort and money into defending their borders. They know very little about the poverty and the suffering that exist in the countries where those bordering on destitution live. If they would only defend these defenseless people with food, shelter, and clothing, I think the world would be a happier place.

The poor must know that we love them, that they are wanted. They themselves have nothing to give but love. We are concerned with how to get this message of love and compassion across. We are trying to bring peace to the world through our work. But the work is the gift of God. ■

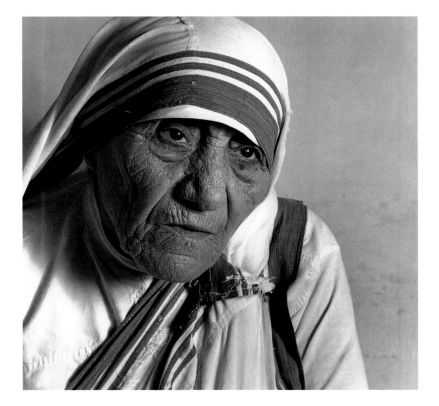

I was blessed to have known Mother Teresa for fifteen years. I especially treasure the times I was asked to drive her around while she was in San Francisco, because it enabled me to ask her questions. In the course of knowing Mother I always saw her receive each person the same way. She saw the face of God in everyone, always approaching each person with love, compassion, and the gift of her complete self. Time was never an issue. I once asked her, "How is it that you never seem to judge anyone who comes to you?" She said, "I never judge anyone because it doesn't allow me the time to love them."—M.C.

Marian Wright Edelman

Standing Up for the World's Children: Leave No Children Behind

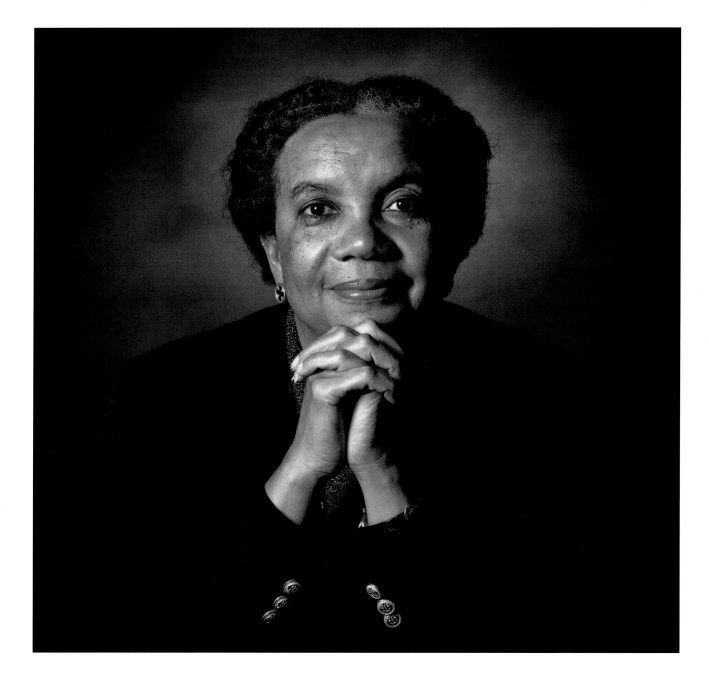

WE ARE LIVING IN A TIME OF UNBEARABLE DISSONANCE BETWEEN promise and performance: between good politics and good policy; between professed and practiced family values; between racial creed and racial deed; between calls for community and rampant individualism and greed; and between our capacity to prevent and alleviate human deprivation and disease, and our political and spiritual will to do so.

We are also living at an incredible moral moment in history. Few human beings are blessed to anticipate or experience the beginning of a new century and millennium. How will we say thanks for the life, earth, nations, and children God has entrusted to our care? What legacies, principles, values, and deeds will we stand for and send to the future through our children to their children and to a spiritually confused, balkanized, and violent world desperately hungering for moral leadership and community?

How will progress be measured over the next thousand years if we survive them? By the kill power and number of weapons of destruction we can produce and traffic at home and abroad? Or by our willingness to shrink, indeed destroy, the prison of violence constructed in the name of peace and security? Will we be remembered in the last part of the twentieth century by how many material things we can manufacture, advertise, sell, and consume, or by our rediscovery of more lasting, nonmaterial measures of success—a new Dow Jones for the purpose and quality of life in our families, neighborhoods, cities, national and world communities? By how rapidly technology and corporate-mergermania can render human beings and human work obsolete? Or by our search for a better balance between corporate profits and corporate caring for children, families, and communities? Will we be remembered by how much a few at the top can get at the expense of many at the bottom and in the middle, or by the struggle for a concept of enough for all? Will we be remembered by the glitz, style, and banality of too much of our culture in McLuhan's electronic global village or by the substance of our efforts to rekindle an ethic of caring, community, and justice in a world driven too much by money, technology, and weaponry?

The answers lie in the values we stand for and in the actions we take today. What an opportunity for good or evil we personally and collectively hold in our hands as parents; citizens; religious, community, and political leaders; and—for those Americans among us—as titular world leader in this post–Cold War and post-industrial era at the beginning of the third millennium.

A thousand years ago the United States was not even a dream. Copernicus and Galileo had not told us the earth was round or revolved around the sun. Gutenberg's Bible had not been printed. Wycliffe had not translated it into English, and Martin Luther had not tacked his theses on the church door. The Magna Carta did not exist; Chaucer's and Shakespeare's tales had not been spun; and Bach's, Beethoven's, and Mozart's miraculous music had not been created to inspire, soothe, and heal our spirits. European serfs struggled in bondage while many African and Asian empires flourished in independence. Native Americans peopled America, free of slavery's blight, and Hitler's holocaust had yet to show the depths human evil can reach when good women and men remain silent or indifferent.

A thousand years from now, will civilization remain and humankind survive? Will America's dream be alive, be remembered, and be worth remembering? Will the United States be a blip or a beacon in history? Can our founding principle "that all men are created equal" and "are endowed by their Creator with certain inalienable rights" withstand the test of time, the tempests of politics, and become deed and not just creed for *every* child? Is America's dream big enough for every fifth child who is poor, and every eighth child who is mentally or physically challenged? Is our world's dream big enough for all of the children God has sent as messengers of hope?

Can our children become the healing agents of our national and world transformation and future spiritual and economic salvation? Edmond McDonald wrote:

> When God wants an important thing done in this world or a wrong righted, He goes about it in a very singular way. He doesn't release thunderbolts or stir up earthquakes. God simply has a tiny baby born, perhaps of a very humble home, perhaps of a very humble mother. And God puts the idea or purpose into the mother's heart. And she puts it in the baby's mind, and then—God waits. The great events of this world are not battles and elections and earthquakes and thunderbolts. The great events are babies, for each child comes with the message that God is not yet discouraged with humanity but is still expecting good-will to become incarnate in each human life.

And so God produced a Gorbachev and a Mandela and a Harriet Tubman and an Eleanor Roosevelt and an Arias and each of us to guide the earth toward peace rather than conflict.

I believe that protecting today's children—tomorrow's Mandelas and Mother Teresas—is the moral and commonsense litmus test of our humanity in a world where millions of child lives are ravaged by the wars, neglect, abuse, and racial, ethnic, religious, and class divisions of adults. ◾

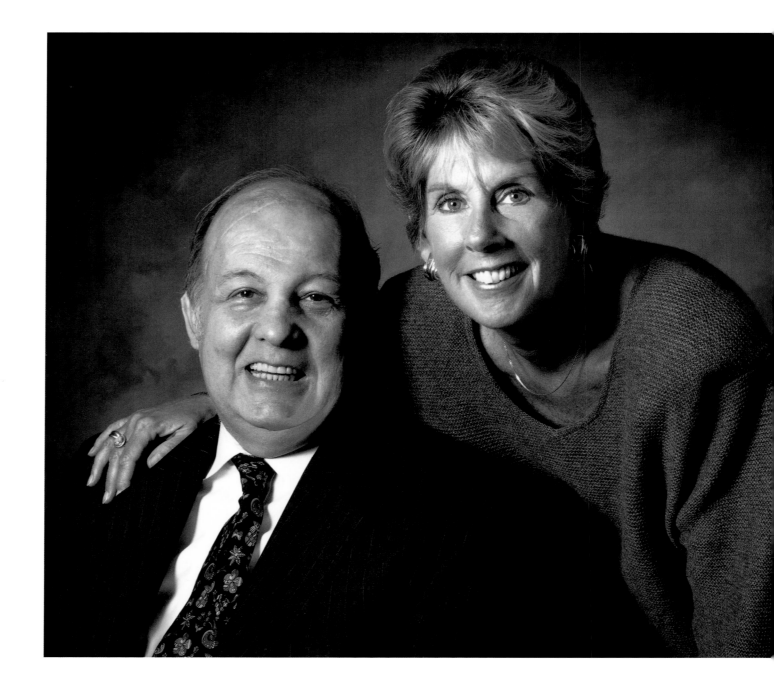

SARAH AND JAMES BRADY

ABOUT TWENTY YEARS HAVE PASSED SINCE JOHN HINCKLEY JR. fired the shots that severely wounded my husband, Jim, and drastically changed our family's life forever. Unfortunately, our experience is far from unique. Since that time, the same tragedy has struck hundreds of thousands of American families. Consider this: In just one year guns are used to kill more than thirty thousand Americans, and thousands more are injured. The fear of gun violence alone affects the quality of life of every American, even those who have never experienced it firsthand. What we forget is that living in fear does not have to be an inevitable part of life in America.

But it wasn't Jim's near-fatal shooting that moved me to get involved on the issue of gun violence. It was my role as a mother that spurred me into action. In 1985, my son Scott, then five years old, picked up a loaded pistol left in a family friend's car and, thinking it was a toy, pointed it at me. The gun was a .22, the same kind of gun John Hinckley used to shoot Jim. Fortunately, this time, no one was hurt. But I thought to myself, what kind of world do we live in where five-year-olds and mentally unstable people can easily get their hands on guns? I became determined to do whatever I could to prevent other families from experiencing the same tragedy we had. So I picked up the phone and called Handgun Control. And I've been at it ever since. The good news is that we have already begun to reverse the tide of gun violence sweeping across the country. Tough gun control laws, like the Brady Law, named for my husband, and the federal assault weapons ban have proven to be successful at keeping the wrong guns out of the wrong people's hands and have helped save lives. But more still needs to be done.

We are a nation awash with guns. It is estimated that there are more than 200 million guns in America. That's almost one gun for every man, woman, and child. The widespread availability of guns, especially handguns and assault weapons, to criminals and children in this country spurs lethal violence on a frighteningly regular basis. Today in America, more than eleven children are killed by guns every day. Altogether, we lose close to 100 people to gun violence daily. Guns are still the second leading cause of injury-related death in the United States, after motor vehicle–related incidents.

If guns made us safer, as the powerful gun lobby likes to argue, then we'd already be the safest country in the world. But sadly, America is the most violent industrialized country on earth. Consider: In 1996, handguns murdered 213 people in Germany, 106 in Canada, 30 in Great Britain—and 9,390 in the United States. In a nation that rightfully calls itself the last remaining superpower, this is a travesty of our strength and our ideals. And, a nation that glorifies guns should not be surprised when children act out their darkest fantasies with those same weapons, as happened in all-American towns like Jonesboro, Arkansas; Paducah, Kentucky; Springfield, Oregon; and Littleton, Colorado.

I am optimistic that we can change—that there will be a time in Jim's and my lifetime when we will no longer be afraid of guns invading our schools, workplaces, places of worship, parks, shopping malls, and homes. Our fight is not over.

Getting involved in the gun control movement did not feel like a choice. I felt that my personal experience compelled me to do so. The honor of working for a cause in which Jim and I truly believe has been a reward in itself. ■

JOSÉ RAMOS-HORTA

Revenge is easy, but forgiveness requires courage.

THIS CENTURY THAT IS ENDING HAS BEEN AN EXTRAORDINARILY eventful one, both rich in human endeavor in the attainment of our collective well-being and in self-destruction. It has registered mind-boggling conquests in every field of human activity. But the other side of the coin has been equally staggering—150 million people have died in violent conflicts.

In the course of this half century enormous progress has been made in the promotion and protection of human rights. Treaties, conventions, declarations, and resolutions have been adopted. However, much remains to be done. There cannot be true enjoyment of human rights as long as a culture of peace and tolerance does not prevail over ethnic and religious intolerance, as long as unemployment and poverty continue to affect millions of human beings the world over.

While there have been significant advances in civil and political rights, the right to food, shelter, education, health care, and basic clean water is not accessible to most people in the developing world. Even if a drop of clean water were to be the cure for AIDS, millions in Africa and Asia would not have access to this cure—they do not have access to clean water.

The greatest challenge we face [in this] new millennium comes from a world ever smaller for our expanding population, where competition for livable land, water, and food will be increasingly desperate. We expand as fast as we use up nature's nonrenewable resources and as fast as we destroy the forests, rivers, lakes, and oceans that we depend upon for our survival.

Many governments spend more money on weapons than on education and health care. Hundreds of millions of people in the developing world have no access to clean water and while the AIDS epidemic, malaria, cholera, malnutrition ravage an increasingly large number of communities in the world, the rich of the North continue to manufacture weapons and then try to sell them to the poor of the South.

Alarmed by the growing arms race and the unrestricted flow of weapons from the developed countries to the poorest nations of the South, a group of Nobel Peace Prize recipients established the Commission of Nobel Peace Laureates for Arms Control. Our aim is modest. We are calling for a ban on weapons deliveries to countries listed as human rights violators, to governments that are engaged in wars of aggression, military occupation, and annexation and spend more money on weapons than on education and health care.

Poverty knows no boundaries, has no culture or nationality. It coexists with opulence in Indonesia, China, the Philippines, India, Pakistan, Brazil, South Bronx, Chicago, downtown Los Angeles, in the *banlieue* of Paris, London, Moscow. It is spreading. It is the gravest threat to peace in the world.

The armies of hundreds of millions of poor people, the unemployed, landless, and homeless, who live below the poverty line, who cannot afford more than a meal a day, who cannot send their children to school, are closing in on the cities of the rich and privileged.

As we are ushering in the new millennium, the West should make a determined commitment to stand for justice, human dignity, and freedom everywhere in the world. ▪

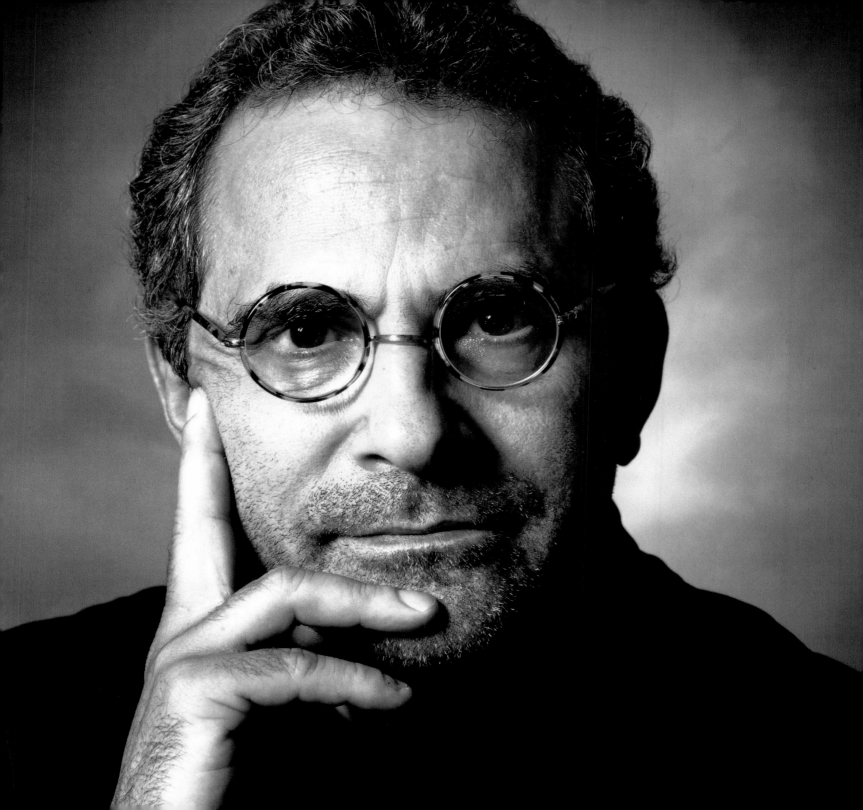

ARUN GANDHI

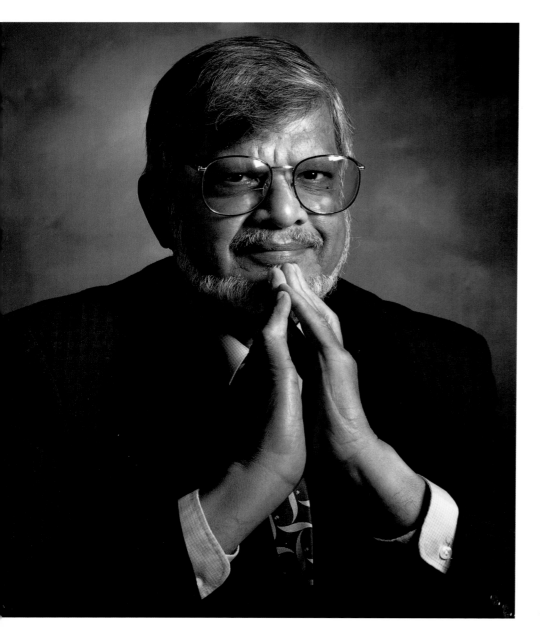

THE GREATEST CHALLENGE IN PROMOTING NONVIOLENCE IS THE English language and its limitations. The next is our perception, rooted for centuries, that violence is the only way we can resolve our problems.

When my grandfather Mohandas Karamchand Gandhi developed his philosophy of nonviolence in South Africa and wanted an appropriate word to describe it, he could not find one. He rejected "passive resistance" and "civil disobedience," saying there was nothing passive or disobedient about the movement. He even offered a reward to anyone who could come up with a positive English word to describe what he had in mind. Alas, no one could.

Gandhi decided a Sanskrit word might be more appropriate, as he was planning to move back to India and lead the Indian struggle for freedom. He found *satyagraha,* a combination of two Sanskrit words, described his philosophy the best: *satya*, meaning "truth," and *agraha*, meaning "the pursuit of." Thus, *satyagraha* means the pursuit of truth, the opposite of the Western concept of *possessing* the truth.

Nonviolence, therefore, can be described as an honest and diligent pursuit of truth. It could also mean the search for the meaning of life or the purpose of life, questions that have tormented humankind for centuries. The fact that we have not been able to find satisfactory answers to these questions does not mean there is no answer. It only means we have not searched with any degree of honesty. The search has to be both external and internal. We seek to ignore this crucial search because the sacrifices it demands are revolutionary. It means moving away from greed, selfishness, possessiveness, and dominance to love, compassion, understanding, and respect. It means that to be true to our faith and religion it is not enough to pray ten times a day. Rather we must make the Scriptures the basis of our existence.

Because of our materialistic, greedy lifestyle, we have become very possessive. We seek to possess not only material goods but even our spiritual beliefs—even peace, if we find it. How many times have we heard people say, "I am at peace with myself," or gurus say to their devotees, "find your peace and hold on to it." Can anyone find peace or spiritual awakening and hold on to it for themselves?

Grandfather liked to tell us the story of an ancient Indian king who was obsessed with finding the meaning of peace. What is peace? How

can we get it? And what should we do with it when we find it? These were some of the questions that bothered him. Intellectuals throughout his kingdom were offered a handsome reward to answer the king's questions. Many tried but none succeeded. At last, someone suggested the king consult a sage who lived just outside the borders of his kingdom.

"He is an old man and very wise," the king was told. "If anyone can answer your questions he can."

The king went to the sage and posed the eternal question. Without a word the sage went into his kitchen and brought a grain of wheat to the king.

"In this you will find the answer to your question," the sage said as he placed the grain of wheat in the king's outstretched palm.

Puzzled but unwilling to admit his ignorance, the king clutched the grain of wheat and returned to his palace. He locked the precious grain in a tiny gold box and placed the box in his safe. Each morning, upon waking, the king would open the box and look at the grain seeking an answer, but he could find nothing.

Weeks later another sage, passing through, stopped to meet the king, who eagerly invited him to resolve his dilemma.

The king explained how he had asked the eternal question but was given a grain of wheat. "I have been looking for an answer every morning but I find nothing."

"It is quite simple, your honor," said the sage. "Just as this grain represents nourishment for the body, peace represents nourishment for the soul. Now, if you keep this grain locked up in a gold box it will eventually perish without providing nourishment or multiplying. However, if it is allowed to interact with the elements—light, water, air, soil—it will flourish and multiply, and soon you would have a whole field of wheat to nourish not only you but so many others. This is the meaning of peace. It must nourish your soul and the souls of others, and it must multiply by interacting with the elements."

This is the essence of Gandhi's philosophy of nonviolence, or the pursuit of truth. In the lifelong pursuit of truth we must always be guided by love, compassion, understanding, and respect. We must allow everything we have to interact positively with the elements and help create a society of peace and harmony. The more possessions we have, the more we have to secure them from those who covet them. This generates feelings of jealousy and leads the needy to resort to taking by force what they cannot get through love and the compassion of the rich.

The best way to understand Gandhi's philosophy of nonviolence is to first understand the extent of the violence we practice, consciously or unconsciously, every day of our lives. Grandfather made me aware of the violence in society, including the violence within myself, by asking me to work on a family tree of violence, using the same principles as a genealogical tree.

"Violence has two children," he said, "the physical and passive forms. Now, every day before you go to bed I would like you to write under each heading everything you experienced during the day and its relationship with violence."

I had to honestly write down my own acts of violence during the day. This meant that every night I had to analyze my actions. If I found them to be violent, then the act had to be identified as such. It was an excellent way of introspection and acknowledgment of one's own violence.

We generally deny our own violence because we are ignorant about it or because we are conditioned to look at violence only in its physical manifestation—wars, fighting, killing, beating, rapes—where we use physical force. We don't, however, consider oppression in all its forms—name-calling, teasing, insulting, disrespectful behavior—as passive forms of violence.

The relationship between passive violence and physical violence is the same as the relationship between gasoline and fire. Acts of passive violence generate anger in the victim, and since the victim has not learned how to use anger positively, the victim abuses anger and generates physical violence. Thus, it is passive violence that fuels the fire of physical violence, which means if we wish to put out the fire of physical violence we have to cut off the fuel supply.

The choice before humanity, to quote Gandhi's words, is quite simple: We have to *be* the change we wish to see. Unless we change individually, no one is going to change collectively. For generations we have been waiting for the other person to change first. A change of heart cannot be legislated; it must come out of conviction. ■

CÉSAR CHAVEZ

OUR CONVICTION IS THAT HUMAN LIFE IS A VERY SPECIAL POSSESSION given by God to man and that no one has the right to take it for any reason or for any cause, however just it may be. We are also convinced that nonviolence is more powerful than violence. Nonviolence supports you if you have a just and moral cause. Nonviolence provides the opportunity to stay on the offensive, and that is of crucial importance to win any contest. If we resort to violence, then one of two things will happen: either the violence will be escalated and there will be many injuries and perhaps deaths on both sides, or there will be total demoralization of the workers. Nonviolence has exactly the opposite effect. If for every violent act committed against us we respond with nonviolence, we attract people's support. We can gather the support of millions who have a conscience and would rather see a nonviolent resolution to problems. We are convinced that when people are faced with a direct appeal from the poor struggling nonviolently against great odds, they will react positively. The American people and people everywhere still yearn for justice. It is to that yearning that we appeal.

But if we are committed to nonviolence only as a strategy or tactic, then if it fails our only alternative is to turn to violence. So we must balance the strategy with a clear understanding of what we are doing. However important the struggle is and however much misery, poverty, and exploitation exist, we know that it cannot be more important than one human life. We work on the theory that men and women who are truly concerned about people are not violent by nature. These people become violent when the deep concern they have for people is frustrated and when they are faced with seemingly insurmountable odds. We advocate militant nonviolence as our means of achieving justice for our people, but we are not blind to the feelings of frustration, impatience, and anger that seethe inside every farmworker. The burden of generations of poverty and powerlessness lies heavy in the fields of America. If we fail, there are those who will see violence as the shortcut to change.

It is precisely to overcome these frustrations that we have involved masses of people in their own struggle throughout the movement. Freedom is best experienced through participation and self-determination, and free men and women instinctively prefer democratic change to any other means. Thus, demonstrations and marches, strikes and boycotts

are not only weapons against the growers, but our way of avoiding the senseless violence that brings no honor to any class or community. When victory comes through violence, it is a victory with strings attached. If we beat the growers at the expense of violence, victory would come at the expense of injury and perhaps death. Such a thing would have a tremendous impact on us. We would lose regard for human beings. Then the struggle would become a mechanical thing. When you lose your sense of life and justice, you lose your strength.

The greater the oppression, the more leverage nonviolence holds. Violence does not work in the long run and if it is temporarily successful, it replaces one violent form of power with another just as violent. People suffer from violence. Examine history. Who gets killed in the case of violent revolution? The poor, the workers. The people of the land are the ones who give their bodies and don't really gain that much for it. We believe it is too big a price to pay for not getting anything. Those who espouse violence exploit people. To call men to arms with many promises, to ask them to give up their lives for a cause and then not produce for them afterward, is the most vicious type of oppression.

Most likely we are not going to do anything else the rest of our lives except build our union. For us there is nowhere else to go. Although we would like to see victory come soon, we are willing to wait. In this sense time is our ally. We learned many years ago that the rich may have money, but the poor have time. ∎

The top right image was taken at a wonderful birthday celebration for César at the Union Social Hall in San Francisco's Mission District. Mariachi music, the delicious scents of a traditional Mexican feast, and joyous chants—"Viva César Chavez!"—filled the air. On the wall, brightly painted banners framed the image of Our Lady of Guadalupe, the movement's symbol of strength. Despite the cheerful clamor around him, César embodied a quiet humility. I could see the pain and compassion in his eyes as he told me about a worker who had recently died of malathion poisoning, and how the farm owners had claimed it to be suicide. His vision remained firmly focused on the plight of those without a voice; his spirituality was deeply rooted in the lives of the poor. César was happy that night, but he was also reflective, as if drawing strength from the celebration around him for the battles ahead.—M.C.

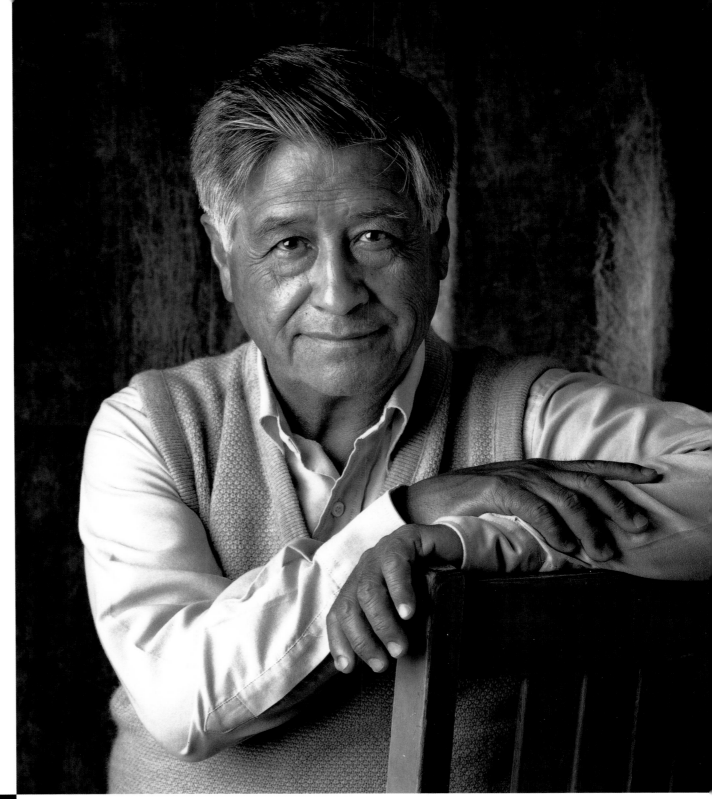

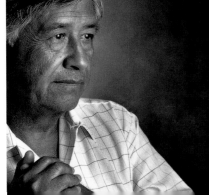

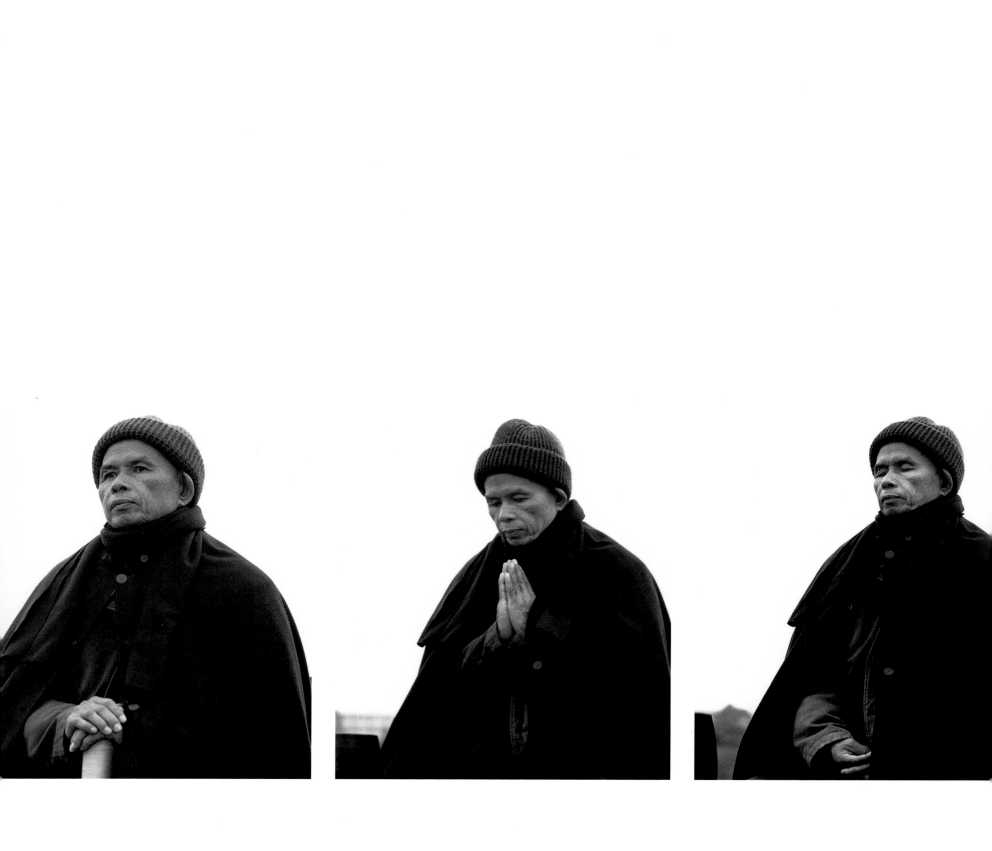

THICH NHAT HANH

SINCE I WAS A YOUNG MAN, I'VE TRIED TO UNDERSTAND THE nature of compassion. But what little compassion I've learned has come not from intellectual investigation but from my actual experience of suffering. I am not proud of my suffering any more than a person who mistakes a rope for a snake is proud of his fright. My suffering has been a mere rope, a mere drop of emptiness so insignificant that it should dissolve like mist at dawn. But it has not dissolved, and I am almost unable to bear it. Doesn't the Buddha see my suffering? How can he smile? Love seeks a manifestation—romantic love, motherly love, patriotic love, love for humanity, love for all beings. When you love someone, you feel anxious for him or her and want them to be safe and nearby. You cannot simply put your loved ones out of your thoughts. When the Buddha witnesses the endless suffering of living beings, he must feel deep concern. How can he just sit there and smile? But think about it. It is we who sculpt him sitting and smiling, and we do it for a reason. When you stay up all night worrying about your loved one, you are so attached to the phenomenal world that you may not be able to see the true face of reality. A physician who accurately understands her patient's condition does not sit and obsess over a thousand different explanations or anxieties as the patient's family might. The doctor knows that the patient will recover, and so she may smile even while the patient is still sick. Her smile is not unkind; it is simply the smile of one who grasps the situation and does not engage in unnecessary worry. How can I put into words the true nature of Great Compassion, *mahakaruna?*

When we begin to see that black mud and white snow are neither ugly nor beautiful, when we can see them without discrimination or duality, then we begin to grasp Great Compassion. In the eyes of Great Compassion, there is neither left nor right, friend nor enemy, close nor far. Don't think that Great Compassion is lifeless. The energy of Great Compassion is radiant and wondrous. In the eyes of Great Compassion, there is no separation between subject and object, no separate self. Nothing that can disturb Great Compassion.

If a cruel and violent person disembowels you, you can smile and look at him with love. It is his upbringing, his situation, and his ignorance that cause him to act so mindlessly. Look at him—the one who is bent on your destruction and heaps injustice upon you—with eyes of love and compassion. Let compassion pour from your eyes and don't let a ripple of blame or anger rise up in your heart. He commits senseless crimes against you and makes you suffer because he cannot see the way to peace, joy, or understanding.

If some day you receive news that I have died because of someone's cruel actions, know that I died with my heart at peace. Know that in my last moments I did not succumb to anger. We must never hate another being. If you can give rise to this awareness, you will be able to smile. Remembering me, you will continue on your path. You will have a refuge that no one can take from you. No one will be able to disturb your faith, because that faith does not rely on anything in the phenomenal world. Faith and love are one and can only emerge when you penetrate deeply the empty nature of the phenomenal world, when you can see that you are in everything and everything is in you.

Long ago I read a story about a monk who felt no anger toward the cruel king who had chopped off the monk's ear and pierced his skin with a knife. When I read that, I thought the monk must be some kind of god. That was because I did not yet know the nature of Great Compassion. The monk had no anger to hold back. All he had was a heart of love. There is nothing to prevent us from being like that monk. Love teaches that we can all live like the Buddha. ■

I was invited to meditate with Thây (which means teacher in Vietnamese) at 5:30 A.M. one September morning in Santa Barbara, California. We walked, pausing to hear bells in the distance, aware of each breath, each step, each sound of the waves crashing against the nearby coastline. Our eyes would meet occasionally, and I was struck with his piercing, gentle, childlike gaze—full of curiosity and wonder at the expanse of sky, sea, and sand around us.—M.C.

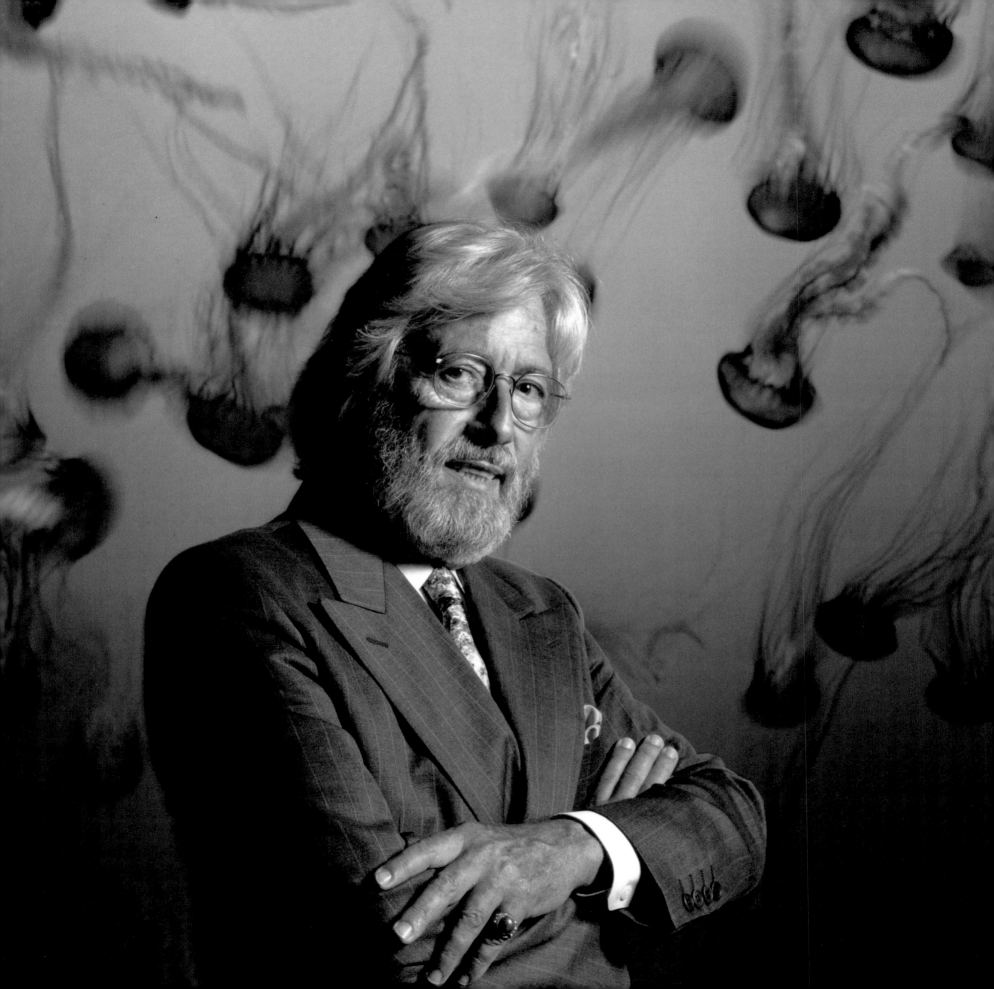

JEAN-MICHEL COUSTEAU

As an architecture student, I learned that good design is usually derived from shapes found in nature. Pure geometry is interesting enough, but it is cold. There is a logic and proportion in living organisms that has the capacity to fill us with joy. My favorite shape was the coil of the chambered nautilus. Not only is it the essence of streamlined functionality—even from the point of view of physics—but it also exists in harmony with light, depth, temperature, and other environmental factors that are essential for its survival.

Human societies too are only as good as their design. They must also be geared to survival. But in order to survive, they must exist in tune with their natural environment.

From the Sumerians to the Mayans to the people of Easter Island, the lesson of history is that a society out of balance with its environment cannot stand. Environmental pressures—whether through over-exploitation of resources, overpopulation, or a combination of the two—inevitably lead to social tension, injustice, insecurity, and war.

So much for the past. How are we doing in the present? Not very well.

Instead of enjoying an equitable balance of resources, the human family has become polarized into the haves and have-nots. Ethnicity, religion, gender, and political belief are used as justifications for some to benefit at the expense of others. At the top of the heap, there is the rule of law, while at the bottom, the imperatives of survival play themselves out with brutal simplicity. In 1998, forty-eight of forty-nine wars reported were taking place in the developing world, as the growing population of poor battled over increasingly meager spoils.

What does the future hold? Will we continue to fight over resources or ascend to a more enlightened distribution of nature's bounty? If we continue to treat nature as a treasure chest to be plundered, we will always be at odds with one another.

Already the seeds of future conflict have been sown. In the future, we will not fight over oil or gold or land, but over water. Water, the lifeblood of the planet, is scarce to begin with, and we make it more scarce yet by polluting what little we have. As a result, one-third of the human family is without access to clean drinking water. Such inequality cannot stand. It will be addressed either peacefully or militarily, but it will be addressed.

Is it too late to prevent us from self-destructing? No, for we have the capacity to design our own future, to take a lesson from living things around us and bring our values and actions in line with ecological necessity. But we must first realize that ecological and social and economic issues are all deeply intertwined. There can be no solution to one without a solution to the others.

Like cold geometric shapes, political and economic systems are abstractions that look good on paper, but they cannot nourish our need for living beauty or provide a model for the survival of our species.

Only nature can do that. ■

PHIL LANE JR.

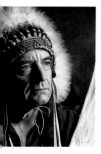

A WISE ELDER ONCE TOLD ME, "GRANDSON, THE LONGEST ROAD you will ever have to walk is the sacred journey from your head to your heart." Another elder said, "We will never solve the many critical and life-threatening issues before us solely through the intellect; for every problem the intellect solves it creates ten more." Unto itself the intellect is a sacred gift of the Creator, but, equally, without an open, visionary, and creative heart, there is no wisdom. Both the mind and heart are sacred. Both are inseparably connected.

To help us develop the wisdom of the heart, the wisdom of peace, we must turn to Mother Earth. "You know Grandson, the Great Spirit, Wakan Tanka, has given all people wisdom," my grandfather told me. "To every living thing he has given something special. Some people receive their knowledge and understanding through books. In your life, Grandson, you too must read and study books, but remember to take with you on your journey only those things that bring more unity within yourself and others, that bring goodness and understanding and help us to serve one another in better ways."

"Wakan Tanka," he continued, "also gave our Native people, and all other people who live close to Mother Earth, wisdom and knowledge through dreams, visions, fasting, prayer, and the ability to see the lessons the Creator has put in every part of creation. Look at those trees standing over there; the alder does not tell the pine tree to move over; the pine does not tell the fir tree to move over; each tree stands in unity, their mouth pressed toward the same Mother Earth, refreshed by the same breeze, warmed by the same sun, with their arms raised in prayer and thanksgiving, protecting one another. If we are to have peace in the world, we too must learn to live like those trees."

"Look, Grandson," he said, "at the beautiful teachings the Creator has put in the little stream. Feel the water and see how gently and lovingly it touches your hands. It travels through deserts and mountains and many places, but it never turns its back on anyone or anything. Even though it gives life to all living things, it is very humble, for it always seeks the very lowest spot. But it has great faith, power, and patience, for even if a mountain stands in its path, it keeps moving and moving until finally that mountain is washed into the sea. These are the spiritual gifts the Creator has given each one of us. If we are to be happy within ourselves and with one another, we too must develop these sacred gifts."

In all of our actions, we must seek to be living examples of the changes we wish to see in the world. By walking the path, we make the path visible. We must find the courage and dedication to use the wisdom of our elders on the path of a peaceful and equitable future. Using that wisdom, we will find we have the power to carefully and lovingly remove the barriers limiting our development as human beings and communities. The greater the difficulty in our path, the greater the opportunity for our growth and ultimate victory; we can always become more than we have ever been.

We know from our ancient teachings that the sacred eagle of humanity has two perfectly balanced and harmonious wings—one representing woman, and one representing man. In our relationships as women and men, brothers and sisters, mothers and fathers, we must join together to eliminate all forms of disrespect, mistreatment, or lack of sharing in the responsibility of raising the world's children. It is my deepest prayer that with every new sunrise, we can recognize more and more that the most sacred and holy of all the wonderful gifts the Creator has given us is the birth of a child. Everything we can do to provide our children and communities the best possible future is a sacred gift and responsibility.

For is not the moment long, long overdue, my beloved relatives, through the unfailing power and love of our good creator, for us to free ourselves completely from the hurt of both the past and present, so we may truly soar like majestic eagles to the promised greatness of our sacred destiny and future? ■

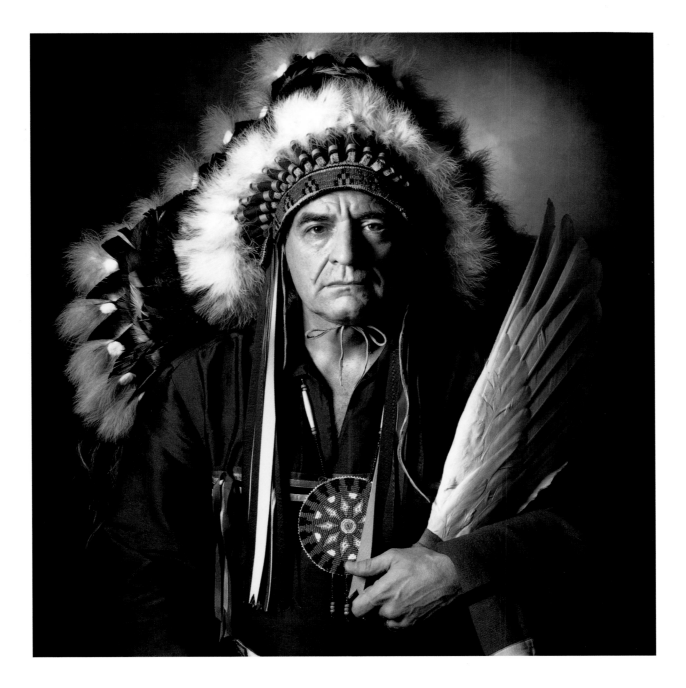

CRAIG KIELBURGER

WHEN I WAS VERY YOUNG I DREAMED OF BEING SUPERMAN, soaring high above the clouds and swooping down to snatch up all of the bad people seeking to destroy our planet. I would spend hours flying across the park, stopping momentarily to kick a soccer ball in my path or to pat my dog, Muffin, who ran faithfully at my heels.

One day, when I was twelve years old and getting ready for school, I reached for the newspaper comics. On the front page was a picture of another twelve-year-old boy from Pakistan, with a bright red vest and his fist held high. According to the article, he had been sold into bondage as a weaver and forced to work twelve hours a day tying tiny knots to make carpets. He had lost his freedom to laugh and to play. He had lost his freedom to go to school. Then, when he was twelve years old, the same age as me, he was murdered.

I had never heard of child labor and wasn't certain where Pakistan was—but that day changed my life forever. I gathered a group of friends to form an organization called Free the Children.

Over the past four years, in my travels for Free the Children, I have had the opportunity to meet many children around the world—children like Jeffrey, who spends his days in a Manila garbage dump, alongside rats and maggots, where he sifts through decaying food and trash, trying to salvage a few valuable items to help his family survive. He dreams of leaving the garbage dump one day.

I have met children like eight-year-old Muniannal, in India, with a pretty ribbon in her hair, but no shoes or gloves, who squats on the floor every day separating used syringes gathered from hospitals and the streets for their plastics. When she pricks herself, she dips her hand into a bucket of dirty water. She dreams of being a teacher.

I have met children in the sugarcane fields of Brazil who wield huge machetes close to their small limbs. The cane they cut sweetens the cereal on our kitchen tables each morning. They dream of easing the hunger pains in their stomachs.

Poverty is the biggest killer of children. More than 1.3 billion people—one-quarter of the world's population—live in absolute poverty, struggling to survive on less than one dollar a day. Seventy percent of them are women and children. I dream of a day when people learn how to share, so that children do not have to die.

Every year, the world spends $800 billion on the military, $400 billion on cigarettes, $160 billion on beer, and $40 billion playing golf. It would only cost an extra $7 billion a year to put every child in school by the year 2010, giving them hope for a better life. This is less money than Americans spend on cosmetics in one year; it is less than Europeans spend on ice cream.

People say, "We can't end world poverty; it just can't be done." The 1997 United Nations Development Report carries a clear message that poverty can be ended, if we make it our goal. The document states that the world has the materials and natural resources, the know-how, and the people to make a poverty-free world a reality in less than one generation.

Gandhi once said that if there is to be peace in the world it must begin with children. I have learned my best lessons from other children—children like the girls I encountered in India who carried their friend from place to place because she had no legs—and children like José.

I met José in the streets of San Salvador, Brazil, where he lived with a group of street children between the ages of eight and fourteen. José and his friends showed me the old abandoned bus shelter where they slept under cardboard boxes. They had to be careful, he said, because the police might beat or shoot them if they found their secret hideout. I spent the day playing soccer on the streets with José and his friends—soccer with an old plastic bottle they had found in the garbage. They were too poor to own a real soccer ball.

We had great fun, until one of the children fell on the bottle and broke it into several pieces, thus ending the game. It was getting late and time for me to leave. José knew I was returning to Canada and wanted to give me a gift to remember him by. But he had nothing—no home, no food, no toys, no possessions. So he took the shirt off his back and handed it to me. José didn't stop to think that he had no other shirt to wear or that he would be cold that night. He gave me the most precious thing he owned: the jersey of his favorite soccer team. Of course, I told José that I could never accept his shirt, but he insisted. So I removed the plain white T-shirt I was wearing and gave it to him. Although José's shirt was dirty and had a few small holes, it was a colorful soccer shirt and certainly much nicer than mine. José grinned from ear to ear when I put it on.

I will never forget José, because he taught me more about sharing that day than anyone I have ever known. He may have been a poor street child, but I saw more goodness in him than all of the world leaders I have ever met. If more people had the heart of a street child, like José, and were willing to share, there would be no more poverty and a lot less suffering in this world.

Sometimes young people find life today too depressing. It all seems so hopeless. They would rather escape, go dancing or listen to their favorite music, play video games or hang out with their friends. They dream of true love, a home of their own, or having a good time at the next party. At sixteen, I also like to dance, have fun, and dream for the future. But I have discovered that it takes more than material things to find real happiness and meaning in life.

One day I was the guest on a popular television talk show in Canada. I shared the interview with another young person involved in cancer research. Several times during the program this young man, who was twenty years old, told the host that he was "gifted," as indicated by a test he had taken in third grade. Turning my way, the host inquired whether I, too, was gifted. Never having been tested for the gifted program, I answered that I was not.

When I returned home my mother asked me, "Are you certain you aren't gifted?" I realized that I had given the wrong answer. I *was* gifted, and the more I reflected, the more I concluded that I had never met a person who was not special or talented in some way.

Some people are gifted with their hands and can produce marvelous creations in their capacity as carpenters, artists, or builders. Others have a kind heart, are compassionate, understanding, or are special peacemakers; others, again, are humorous and bring joy into our lives. We have all met individuals who are gifted in science or sports, have great organizational skills or a healing touch. And, of course, some people are very talented at making money. Indeed, even the most physically or mentally challenged person teaches all of us about the value and worth of human life.

I think that God, in fact, played a trick on us. He gave each and every person special talents or gifts, but he made no one gifted in all areas. Collectively, we have all it takes to create a just and peaceful world, but we must work together and share our talents. We all need one another to find happiness within ourselves and within the world.

I realize, now, that each of us has the power to be Superman and to help rid the world of its worst evils—poverty, loneliness, and exploitation. I dream of the day when Jeffrey leaves the garbage dump, when Muniannal no longer has to separate used syringes and can go to school, and when all children, regardless of place of birth or economic circumstance, are free to be children. I dream of the day when we all have José's courage to share. ■

ALICE WALKER

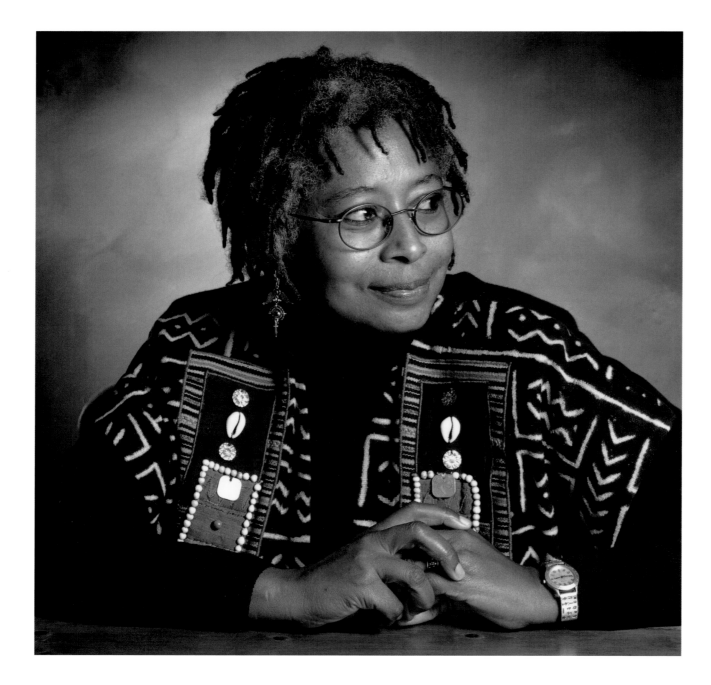

My activism—cultural, political, spiritual—is rooted in my love of nature and my delight in human beings. It is when people are at peace, content, *full*, that they are most likely to meet my expectations, selfish, no doubt, that they be a generous, joyous, even entertaining experience for me. I believe people exist to be enjoyed, much as a restful or engaging view might be. As the ocean or drifting clouds might be. Or as if they were the human equivalent of melons, mangoes, or any other kind of attractive, seductive fruit. When I am in the presence of other human beings I want to revel in their creative and intellectual fullness, their uninhibited social warmth. I want their precious human radiance to wrap me in light. I do not want fear of war or starvation or bodily mutilation to steal both my pleasure in them and their own birthright. Everything I would like other people to be for me, I want to be for them.

I have been an activist all my adult life, though I have sometimes felt embarrassed to call myself one. In the sixties, many of us were plagued by the notion that, given the magnitude of the task before us— the dismantling of American apartheid—our individual tasks were puny. There was also the apparent reality that the most committed, most directly confrontational people suffered more. The most "revolutionary" often ended up severely beaten, in prison, or dead. Shot down in front of their children, blown up in cars or in church, run over by racist drunks, raped, and thrown in the river.

In Mississippi, where I lived from 1967 to 1974, people who challenged the system anticipated menace, battery, even murder, every day. In this context, I sometimes felt ashamed that my contributions at the time were not more radical. I taught in two local black colleges, I wrote about the Movement, and I created tiny history booklets which were used to teach the teachers of children enrolled in Head Start. And, of course, I was interracially married, which was illegal. It was perhaps in Mississippi during those years that I understood how the daily news of disaster can become, for the spirit, a numbing assault, and that one's own activism, however modest, fighting against this tide of death, provides at least the possibility of generating a different kind of "news." A "news" that empowers rather than defeats.

There is always a moment in any kind of struggle when one feels in full bloom. Vivid. Alive. One might be blown to bits in such a moment and still be at peace. Martin Luther King Jr. at the mountaintop. Gandhi dying with the name of God on his lips. Sojourner Truth baring her breasts at a women's rights convention in 1851. Harriet Tubman exposing her revolver to some of the slaves she had freed, who, fearing an unknown freedom, looked longingly backward to their captivity, thereby endangering the freedom of all. To be such a person or to witness anyone at this moment of transcendent presence is to know

that what is human is linked, by a daring comparison, to what is divine. During my years of being close to people engaged in changing the world, I have seen fear turn into courage. Sorrow into joy. Funerals into celebrations. Because whatever the consequences, people, standing side by side, have expressed who they really are, and that ultimately they believe in the love of the world and each other enough *to be that*— which is the foundation of activism.

It has become a common feeling, I believe, as we have watched our heroes falling over the years, that our own small stone of activism, which might not seem to measure up to the rugged boulders of heroism we have so admired, is a paltry offering toward the building of an edifice of hope. Many who believe this choose to withhold their offerings out of shame.

This is the tragedy of the world.

For we can do nothing substantial toward changing our course on the planet, a destructive one, without rousing ourselves, individual by individual, and bringing our small, imperfect stones to the pile.

In this regard, I have a story to tell.

In the mid-sixties during a voter registration campaign in south Georgia, my canvassing partner, Beverly, a local black teenager, was arrested on a bogus moving-violation charge. This was meant to intimidate her, "show her her place," and terrify her family. Those of us who feared for her safety during the night held a vigil outside the jail. I remember the raw vulnerability I felt as the swaggering state troopers— each of them three times Beverly's size, and mine—stomped in and out of the building, scowling at us. The feeling of solidarity with Beverly and our friends was strong, but also the feeling of being alone, as it occurred to me that not even my parents knew where I was. We were black and very young; we knew no one in white America paid the slightest attention to the deaths of such as us. It was partly because of this that we sometimes resented the presence of the white people who came to stand, and take their chances, with us. I was one of those to whom such resentment came easily.

I especially resented blond Paul from Minnesota, whose Aryan appearance meant, when he was not with us, freedom and almost worship in the race-obsessed South. I had treated him with coolness since the day we met. We certainly did not invite him to our vigil. And yet, at just the moment I felt most downhearted, I heard someone coming along the street in our direction, whistling. A moment later, Paul appeared. Still whistling a Movement spiritual that sounded strange, even comical, on his lips, he calmly took his place beside us. Knowing his Nordic presence meant a measure of safety for us, and without being asked, he offered it. This remains a moment bright as any I recall from that time.

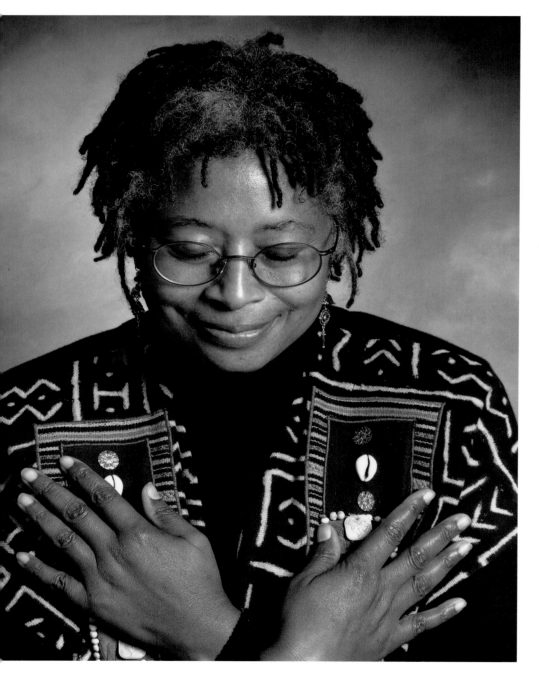

As a poet and writer, I used to think being an activist and writing about it "demoted" me to the level of "mere journalist." Now I know that, as with the best journalists, activism is often my muse. And that it is organic. Grounded in my mother's love of beauty, the well-tended garden and the carefully swept yard, her satisfaction in knowing everyone in her environment was sheltered and fed; and in my father's insistence, even as a poor black man, easily "disappeared" for any political activity, that black people deserved the vote, black children deserved decent schools.

All we own, at least for the short time we have it, is our life. With it we write what we come to know of the world. I believe the Earth is good. That people, untortured by circumstance or fate, are also good. I do not believe the people of the world are naturally my enemies, or that animals, including snakes, are, or that Nature is. Whenever I experience evil, and it is not, unfortunately, uncommon to experience it in these times, my deepest feeling is disappointment. I have learned to accept the fact that we risk disappointment, disillusionment, even despair, every time we act. Every time we decide to believe the world can be better. Every time we decide to trust others to be as noble as we think they are. And that there might be *years* during which our grief is equal to, or even greater than, our hope. The alternative, however, not to act, and therefore to miss experiencing other people at their best, reaching toward their fullness, has never appealed to me.

I have learned other things: One is the futility of expecting anyone, including oneself, to be perfect. People who go about seeking to change the world, to diminish suffering, to demonstrate any kind of enlightenment, are often as flawed as anybody else. Sometimes more so. But it is the awareness of having faults, I think, and the knowledge that this links us to everyone on Earth, that opens us to courage and compassion. It occurs to me often that many of those I deeply love *are* flawed. They might actually have said or done some of the mean things I've *felt,* heard, read about, or feared. But it is their struggle with the flaw, surprisingly endearing, and the *going on anyhow,* that is part of what I cherish in them.

Sometimes our stones are, to us, misshapen, odd. Their color seems off. Their singing, like Paul's whistling, comical and strange. Presenting them, we perceive our own imperfect nakedness. But also, paradoxically, the wholeness, the rightness, of it. In the collective vulnerability of presence, we learn not to be afraid. ■

JEHAN SADAT

EVERY DAY, SOMEWHERE IN THIS WORLD, THERE ARE MOTHERS and fathers and children who are being challenged by the environment in which they live, struggling to survive with limited or, in some cases, no access to education, health care, and employment. In the worst situations, there are families trying to exist without proper food, shelter, and clothing, things that most of us take for granted. And in every nation, there are families drowning in despair, because they have lost faith, thus allowing the ordinary problems of life to creep into their minds and souls, devouring them from within, stripping away their ability to love and care for each other. If only these despondent souls understood that we are all imperfect human beings on the same journey from this life to the next. If only they accepted that with God, they could deal with the trials and tribulations of this life with fortitude and courage. When my husband decided to follow the path of peace, we both knew the risk he would be taking. We both knew that whatever he did would change our life forever.

Without God, without the family, mankind is lost, left to wander and stumble blindly in a wilderness of desperation. Without God, we will never be able to realize the beauty of peace and the wholeness of life. When the family is sound and the relationship between its members is rooted firmly in mutual love, trust, respect, and dignity, then, and only then, can the entire community hope to be strong and weather the storms of life. Under any other conditions, society, no matter how developed or how prosperous, is doomed.

Having divided my time between Egypt and the United States for the past fifteen years, I have become quite comfortable with the American way of life. But I must tell you that at first I felt like I had landed

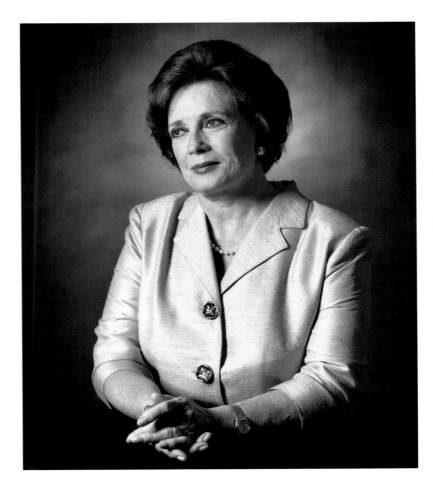

on another planet. It is to Egypt, however, that I must turn in order to illustrate my religious, cultural, and social attitudes toward the family. To us, the center of life is the family, an attitude validated by the depictions of daily activities that are found on our ancient temple walls and in our museums.

From our agrarian background, we developed strong bonds to the land and to the family, creating within us a deep sense of social responsibility that is prevalent in our modern way of life. The holy month of Ramadan best illustrates this. No one can grow up in such an atmosphere and become immune to the condition of life for others. As we say in Egypt, "Paradise without people is not worth the having."

When a Westerner describes the family, he is speaking of the father, mother, and children. But when an Egyptian speaks of family, he means the father, mother, children, aunts, uncles, nieces, nephews, and scores of cousins. And there are no strangers in Egypt. Everyone is generously welcomed, whether by a rich uncle in Cairo or a distant and poor cousin in Aswan. We think of ourselves as belonging to one big family.

Like families everywhere, the Egyptian family has had to adjust and adapt to the times; nevertheless, our bonds of family run deep and wide. We rely upon each other in happiness and in pain. I could have never survived the sorrow of losing my husband without the love and support of my family. By the same token, the weddings of my children and the birth of each of my eleven grandchildren gave cause for celebration. I would not be doing what I am doing now without the support of my family. As Egypt continues to develop, the rituals of family life will naturally change. They will not, however, be replaced or forgotten. We will never allow our ties to family and our connection to the land to be completely and permanently broken.

Although the world has undergone many changes, both good and bad, in the past century, change need not imply the loss of traditional values. Nor is progress another word for moral decay. It is not development and progress which jeopardize values and morality but rather the

absence of a strong and secure moral foundation developed first and foremost in the family. Surely, it is possible for one to enjoy the conveniences of modern life—airplanes and automobiles, computers and cell phones, microwaves and VCRs—without losing one's sense of values. When we love God, love our families, we can enjoy life without betraying the practices of decency, without abandoning the traditions of our cultures.

To me, tradition is the accumulation of past experiences, social standards, and technology and is, therefore, dynamic in nature. For a society to be fully developed, it must comprehend and accept the relevance of both social and religious traditions to the welfare of its people. My religion, Islam, is more than 1,444 years old; yet it remains a living system of beliefs, setting forth the principles and code of ethics that have sustained and will sustain generation after generation of believers. This is also true of the other great religions whose codes of conduct are practiced today. Compassion, integrity, justice, tolerance, and love do not belong to one people or religion, nor will they ever become irrelevant and obsolete.

The holy book of Islam, the Qur'an, clearly prescribes how we are to treat each other, especially parents. It tells us to be kind to them, obeying, respecting, and loving them, with an attitude of humility and tenderness. Treatment of parents is second only to the worship of God. And mothers hold a very special place. . . . Mothers are the ones who give us life, carrying us for nine months, enduring great pain to bring us into the world. They are our first teachers, giving us the lessons and values we will carry for the rest of our lives. A mother's greatest gift to her society is a righteous son or daughter. Our prophet said, "Heaven lies at the feet of mothers."

It is also written that if our parents attain old age in our homes, then we are to show them no sign of impatience or reproach, but rather speak to them with kind words. When caring for our parents, we are being given the opportunity to show our own children how they are to treat us. Through our example, they will learn how to act toward us

when we are in the same stage of life. In fact, they will also learn how to treat all of their elders.

Behavior in marriage is also addressed in Islam. The relationship between a husband and wife is one of God's signs; therefore, there should be an atmosphere of peace and quiet, kindness and mercy between husband and wife. The Qur'an states, "Your wives are your inner garments and you are their inner garments." This does not mean that a spouse is as common and ordinary as a favorite sweater, but rather each partner is to protect and cover the mistakes of the other. Husband and wife should never expose the deficiencies and shortcomings of the other but rather complement and beautify each other. The foundations of the marriage are nourished by loyalty and love, growing ever stronger with experiences and wisdom that only time can bring.

In Islam, men and women bear the same responsibility toward God, thus each must account for individual deeds. Within marriage and the family, each has a particular role and function to play. Man is the head of the family and has the duty to fend and care for his wife and children, while the woman is to be queen in her home. It is her duty to raise her children properly, assuring their education and instilling the correct values, nourishing them not only with the food of the flesh but also the food of the soul, which is love and faith in God. This does not mean that the husband plays no part in the development of his children or that he is superior to his wife. Never! Husband and wife must work together, in a loving way, in order to bring peace and happiness to the family. Sometimes, however, the marriage may fail, and they must divorce, but children should not suffer because their parents cannot live together in harmony.

My husband came from a village not far in kilometers from Cairo but worlds apart in style—what one would call primitive, with large, poor families and limited resources. To the casual observer, Sadat's life was full of hardships and empty of opportunities. But in reality, his was a life overflowing with love, faith, and family. My husband wrote,

"I could never turn against or show the least lack of loyalty to my family, since this is in sharp contradiction with the family values I was brought up on—the values that continue to sustain my lifeblood and determine my mental life more effectively than anything else. Indeed, the faith I have in these values deepens day after day, so much that I have come to believe that only adherence to such values can save society—that there can be hope only for a society which acts as one big family and not as many separate ones." The same was true for me in Cairo.

Salam, peace, is at the very core of Islam, which places great emphasis on democracy, compassion, justice, tolerance, and the sanctity of the family. It was Sadat's uncompromising faith in God and his love for the people, Arabs and Israelis, that led him on the path to peace in the Middle East. For peace, he paid with his life. And for peace, my children lost their father, and I lost my husband. Despite the years of grief we have endured and the emptiness left forever in our family, we have no regrets for what Anwar Sadat did for Egypt, Israel, and the whole world. We are proud to be his family, proud to know that he gained his place in history by being a man of peace.

My husband also wrote: "In Mit Abut Kum . . . I learned something else that has remained with me all my life; the fact that wherever I go, wherever I happen to be, I shall always know where I really am. I can never lose my way because I know that I have living roots there, deep down in the soil of the village, in that land out of which I grew."

I feel the same. No matter where I may go in this world, Egypt is my breath, and my family is the beating of my heart. My love for my family, my country, and my God gives wholeness and peace to my life. The love given me by my children, grandchildren, and Anwar Sadat gives me great satisfaction, pride, and happiness. I will leave you today with this final thought: Preservation of the family is the enactment of God's will and is, therefore, the promotion of peace that brings the wholeness and happiness of life.

May God fill your homes with love and our world with peace. ∎

SHIMON PERES

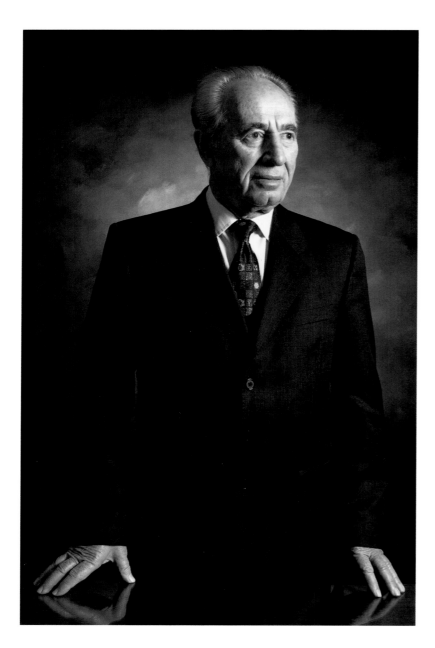

THE WORLD INTO WHICH I WAS BORN NO LONGER EXISTS, BUT I have been fortunate enough to be present at the birth of a new world—sometimes as an onlooker, sometimes as an active participant in the act of creation.

But even now I am not inclined to give up dreaming. Two dreams in particular take up much of my waking thoughts. One concerns the future of the Jewish people, the other the future of the Middle East.

In the new era the world has now entered upon, the wealth and power of nations depend more on the development of intellectual resources than on the possession of natural resources. Quality is the key criterion rather than quantity, universalism is superseding nationalism. All this poses new problems that nations and their leaders have not had to grapple with before. In the past, a nation's identity was molded from its people's special characteristics, the geography of its land, the unique properties of its language and culture. Today, science has no national identity, technology no homeland, information no passport. A country's intellectual standard is more significant than its size. The productivity of its arable land counts for more than its acreage.

Modern man speaks two languages: the language of verbal communication and the language of computers. National cultures and heritages must compete for man's attention with the mind-absorbing advances of universal science.

The Jewish people's challenge in today's world is to defend its unique heritage. This is no less demanding a task than was the previous national challenge—the physical defense of the homeland. Preserving the Hebrew language in the world of today and tomorrow is as much a strategic undertaking as guarding the borders has been until now. The test is how to ensure that our children remain Jewish—Jewish not merely by their ethnic origins but by their self-identity and sense of mission.

In history, Judaism has been far more successful than the Jews themselves. Jews were frequently persecuted, exiled, plundered, and murdered. The Jewish people remained small and weak, but the Jewish spirit went on from strength to strength. The Bible is to be found in hundreds of millions of homes throughout the monotheistic world. The moral majesty of the Book of Books has been undefeated by the

vicissitudes of history. On the contrary, time and again history has succumbed to the Bible's immortal ideas. The message that the one, invisible God created Man in his image, and that there are therefore no higher and lower orders of man, has fused with the realization that morality is the highest form of wisdom—and perhaps of beauty and courage, too. It is that which distinguishes man from beast. Slings and arrows and gas chambers can annihilate men, but they cannot destroy human values, dignity, and freedom.

Jewish history presents an encouraging lesson for humankind. For nearly four thousand years, a small nation carried a great message. For part of this period, the nation dwelt on its own land; later, it wandered in exile. This small nation swam against the tides and was repeatedly beaten, banished, and downtrodden. There is no example in all of history—neither among the great empires nor among their colonies and dependencies—of a nation, after so long a saga of tragedy and misfortune, rising up again, shaking itself free, gathering together its dispersed remnants, and setting out anew on its national adventure, defeating doubters within and enemies without, reviving its land and its language, rebuilding its identity, and reaching toward new heights of distinction and excellence. The message of the Jewish people to mankind is that faith can triumph over all adversity.

The Jews are traditionally the People of the Book, but in today's world the book must fight to hold its own against the screen. The depth of the book must compete against the speed of the screen. Man's natural image, as portrayed in print, must vie with his made-up face as it appears on camera. The screen, of course, has clear advantages in this struggle: it is accessible, ubiquitous, absorbed without effort. It amuses and entertains us. But the screen, ultimately, distorts our image.

The conflicts [of the future] will be over the content of civilizations, not over the territory they occupy. Over many centuries, Jewish culture has lived on alien soil. Now, it has taken root again in its own soil. For the first time in history, some five million people speak Hebrew as their native language. That is both a lot and a little: a lot because there have never been so many Hebrew speakers before; but a little because a culture based on five million people can hardly withstand the pervasive, corrosive effects of the global television culture.

In the five decades of Israel's existence, our efforts have been focused on reestablishing our territorial center. In the future, we shall have to devote our main effort to reestablishing our spiritual center. The Jewish people is neither a nation nor a religion in the accepted sense of those terms. Its essence is a message rather than a political structure, a faith rather than an ecclesiastical hierarchy. The Jewish people and the Jewish religion are one and the same. Judaism—or Jewishness—is a fusion of belief, history, land, and language. Being Jewish means belonging to a people that is both a chosen people and a universal people. My greatest dream is that our children, like our forefathers, do not make do with the transient and the sham but continue to plow the historic Jewish furrow in the field of the human spirit. My hope is that Israel will become the center and source of our heritage, not merely a homeland for our people; that the Jewish people will not need to depend on others but will give of itself to others.

As for our region, the Middle East, Israel's role is to contribute to the region's great and sustained revival. It will be a Middle East without wars, without fronts, without enemies, without ballistic missiles, and without nuclear warheads. A Middle East in which people, goods, and services can move freely from place to place without the need for customs clearance and police licenses. A Middle East in which every believer will be free to pray in his own language, Arabic or Hebrew or Latin or whatever language he chooses, and in which his prayers will reach their destination without censorship, without interference, and without offending anyone. A Middle East in which nations strive for economic equality, but encourage cultural pluralism. A Middle East in which every young man and woman can attain a university education. A Middle East in which living standards are in no way inferior to those in the most advanced countries of the world. A Middle East in which waters flow to slake thirst, to make crops grow and deserts bloom, in which no hostile borders bring death, hunger, or despair on the peoples of the region. A Middle East of competition, not of domination. A Middle East in which men and women are their neighbors' allies, not their hostages. A Middle East that is not a killing field but a field of creativity and growth. A Middle East that honors its past history deeply in that it strives to add new, noble chapters to that history. ■

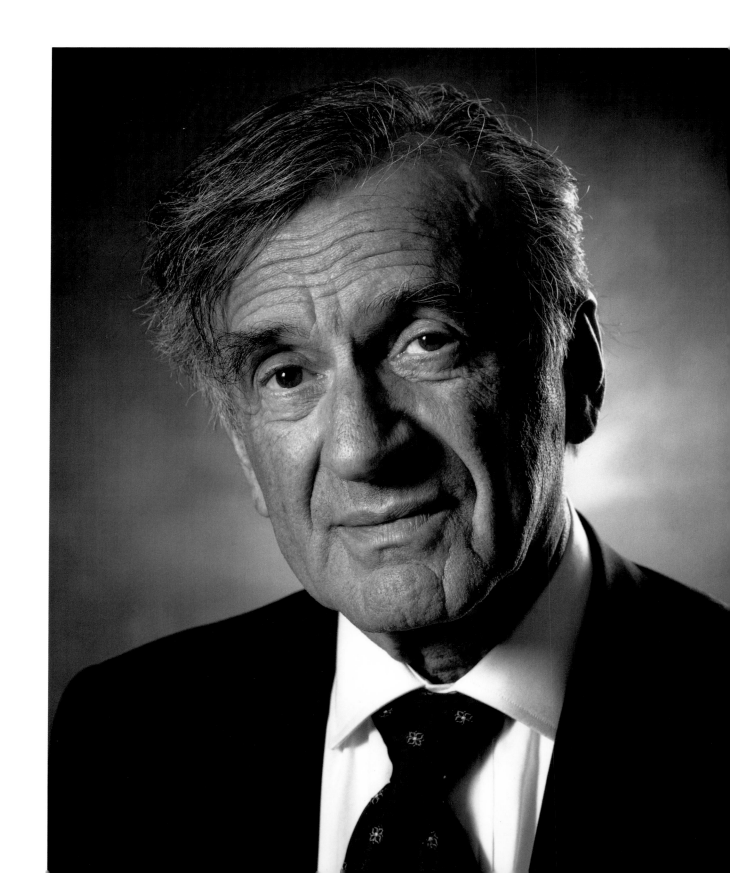

ELIE WIESEL

Beginning with the Nobel laureate conference in 1988, the Foundation for Humanity that Marion and I created at the end of 1986 has been organizing international conferences on a single theme: "The Anatomy of Hate."

"Hate," the key word, describes the passions, often contradictory and always vile, that have torn and ravaged the twentieth century. Only the twentieth century? In truth, the word contains and illustrates the full recorded memory of human cruelty and suffering. Cain hated his brother and killed him; thus the first death in history was a murder. Since then, hate and death have not ceased to rage.

Hate—racial, tribal, religious, ancestral, national, social, ethical, political, economic, ideological—in itself represents the inexorable defeat of mankind, its absolute defeat. If there is an area in which mankind cannot claim the slightest progress, this surely is it. It does not take much for human beings, collectively or individually, to suddenly one day pit themselves like wild beasts one against the other, their worst instincts laid bare, in a state of deleterious exaltation. One decision, one simple word, and a family or a community will drown in blood or perish in flames.

Why is there so much violence, so much hate? How is it conceived, transmitted, fertilized, nurtured? As we face the disquieting, implacable rise of intolerance and fanaticism on more than one continent, it is our duty to expose the danger. By naming it. By confronting it. ■

59

STEVEN SPIELBERG

I WAS SHOCKED MANY YEARS AGO TO READ A STATISTIC SHOWING an alarming number of Americans who had only the barest knowledge of the Holocaust, and a startling number who had no knowledge at all. This was bad enough for the adult population. For younger people, it had the potential to begin a plague of ignorance.

That fact, more than anything else, compelled me to make *Schindler's List* in 1993—even though I knew that what I could put on film, the most powerful medium, could only show a fraction of the suffering that occurred—suffering I cannot begin to imagine.

If there was one result of making *Schindler's List* that was particularly gratifying, it was that more than 1,250,000 high school students have seen the film, either on their own or at the free high school showings arranged through the cooperation of Universal Pictures, American theater owners, and the governors and departments of education of more than forty-five states. It is particularly noteworthy that most of these showings have been in places far from the urban, Jewish centers, places where students may have never even met a Jew, such as Wasilla, Alaska; Pocatello, Idaho; and Summersville, West Virginia.

My hope with my last film, *Saving Private Ryan,* was to honor those who ended the Holocaust. D day was the pivot point of the twentieth century. All that went before was preparation, all that followed was consequence. And then there were the men of D day—the junior officers, NCOs, and enlisted men—who hit the beaches at Omaha and Utah on June 6, 1944. They were born mostly between 1920 and 1925. To them had come the responsibility, the sacrifice, and the honor of saving Western civilization. This isn't Hollywood hyperbole; it is simple fact.

At 0500 hours, June 6, 1944, the outcome of World War II was very much in doubt. If Hitler's armies were able to stop the invasion and then drive the British, Canadian, and American forces back into the sea, he would have been free to move major forces from his western to his eastern front, enough maybe to win a victory—and almost certainly enough to impose a stalemate. The war would have gone on. The Holocaust would have gone on. It really is too terrible to imagine.

It all came down to a bunch of twenty-year-olds—men like Dick Winters, Len Lomell, Dutch Schultz, Bob Slaughter, Melvin Paisley, Barney Oldfield, James Colella, Peter Howenstein, and John Harrison. John Harrison lost his brother to the war. The Sullivan family lost all five brothers. The Borgstroms lost four. The Slighs, three. The Hobacks, their only two sons. The Niland family also lost two sons. If these men hadn't defied death to ensure our freedom, then *this* day would never have come.

It is to honor these men and their buddies—the men who put an end to the Holocaust and saved Western civilization—that I made *Saving Private Ryan.*

My hope in making *Schindler's List* and *Saving Private Ryan* is that eyes have been opened. My hope is that lives have been changed. ∎

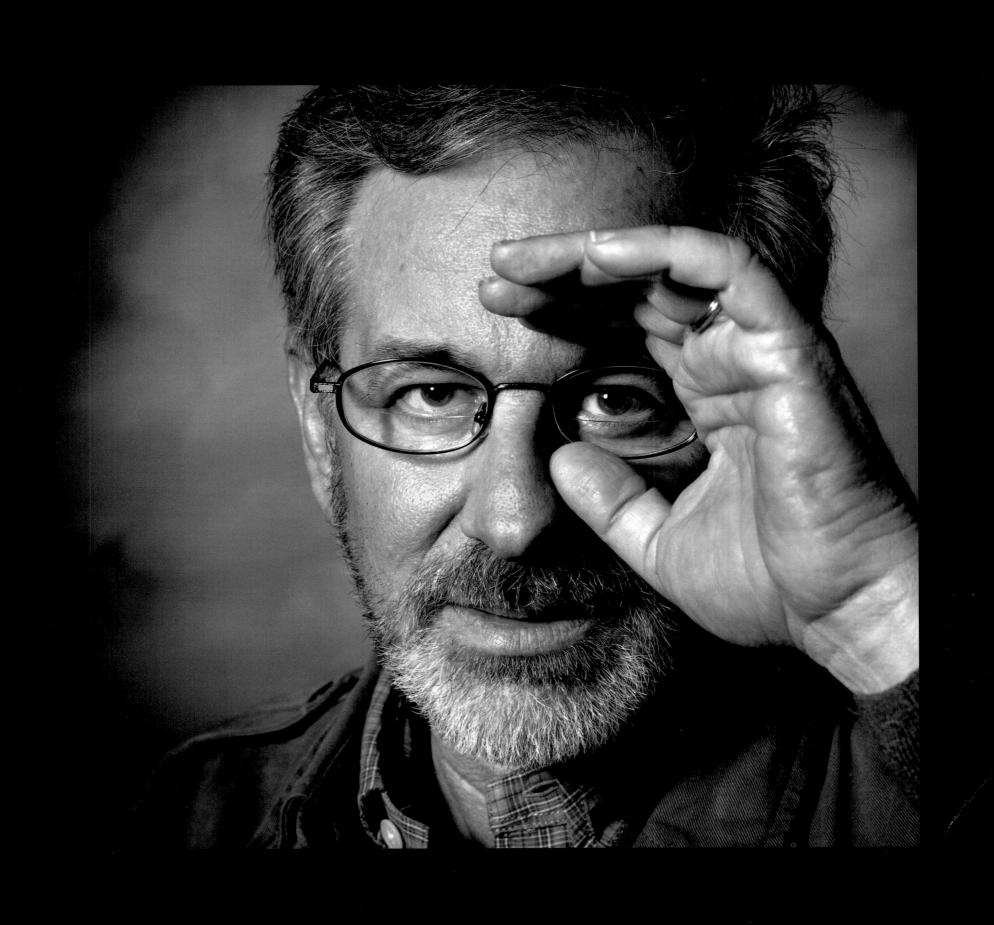

REVEREND JESSE JACKSON

THE PROMOTION AND PRESERVATION OF HUMAN RIGHTS CAN and should be the driving force for world affairs in this post–Cold War era. If it is, the world can be transformed. A new sense of hope can be transmitted throughout the nations. Such is the glory and power of human rights—measured by one yardstick for all human beings.

The elevation of human rights to this exalted position requires great strength and fortitude by those in power. It requires politicians to think and act in fundamentally different ways. This is the highest possible moral standard and moral plane on which to conduct the affairs of state. It is a place where few have chosen to go: Jesus, Dr. King, Nelson Mandela, and Gandhi are names that come to mind; these are difficult footsteps in which to follow. This is not a part-time job. This is not for the faint of heart.

I wish to propose some guiding principles for evaluating the integrity of this new and strengthened commitment to human rights. These principles should serve as the yardstick by which the earnestness of world leaders is measured. Is all this talk of human rights something more than hype or spin? We'll know if the behavior of the rich and powerful nations of the world are informed by these ideas:

1) The principle of human rights must be applied with consistency around the world. This principle transcends geography; it transcends ethnicity, culture, race, language, and religion. A commitment to human rights demands inclusion. No one should be left behind. There are not some among us who are more human than others; God does not prefer the life of an American or a European to the life of an African or a Malaysian.

The first real test of the developed world's newfound commitment to human rights will come in places like Sierra Leone, which stood by the United States and its allies in World War I and World War II. They were a democracy. Yet when they were overthrown, there was no rush to protect its more than one million exiled and 750,000 killed.

The problems that prompted action in Kosovo are, sadly, dwarfed by the size of problems facing this African nation. A $1.5 billion aid package for Kosovo was announced at the 1999 G8 summit; where is the aid package for Sierra Leone? My own country, which appropriated $13 billion to cover costs associated with the war in Yugoslavia, is sending the rather meager sum of $15 million to the West African organization that worked to end the war in Sierra Leone.

A tale of two continents? Perhaps. But not for long, because nations that are serious about their commitment to human rights simply cannot abide by disparities such as this. This gap in commitment must be breached.

I wish to challenge not only governments on this score, but also the international media to bridge its own very real gap in coverage. Pictures and sounds of people in distress can move the world to action, but if no one sees or hears or reads about a story like Sierra

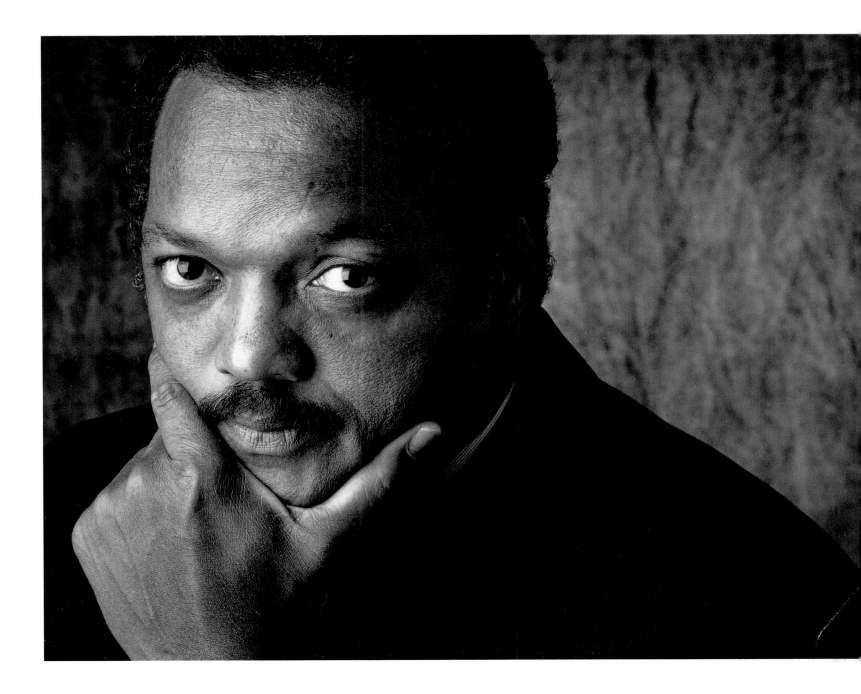

Leone, action is deferred. The responsibility is not one of governments alone.

We also can't just say it's racism. When people saw dogs biting blacks in Birmingham, Alabama, people the world over—both white and black—said, "We choose humans." When they saw the massacres in Soweto and Sharpsville, they chose the massacred over the killers. When the people saw, they responded.

2) A commitment to the principle of human rights requires clear and unambiguous respect for international law and support for the international organizations that administer it. When it comes to an organization like the United Nations, we cannot pick and choose when we wish to work within its framework without greatly weakening its effectiveness.

We circumvented the UN at the onset of the war against Yugoslavia, only to welcome the intervention of the UN-sponsored war crimes tribunal at the war's midpoint. We worked outside the umbrella of the UN in order to avoid a negative response from Russia and China, only to cede tremendous authority to Russia and China in the process that led to a cessation of bombing.

We learned the value of working within the UN framework during the Persian Gulf War, as the UN marshaled world opinion against the behavior of Iraq's leader, Saddam Hussein. Let us now relearn that very important lesson in light of our new sense of international priorities. Let us embrace and empower the UN.

3) The principle of human rights must be applied outside the military context. Indeed, since military action presumes the failure of all other diplomatic measures, the military option is limited when it comes to advancing a human rights agenda around the globe. But if we're serious about human rights, then the major military and economic powers must figure out ways to intervene that fall short of war. We have missiles, morals, and minds: our minds and morals are assets that should be put to work.

Eradication of disease, expansion of health care facilities, building new networks of food distribution—these must become the tools of nations truly committed not only to the preservation, but also the expansion, of human rights around the globe. Surely, this is what is meant by the verse in Isaiah about "beating swords into plowshares." Sharp young minds must be turned away from the instruments of war and turned toward the instruments of peace. They must be taught to build bridges, not blow them up; to grow food, to replenish the land.

And when it comes to trade, nations devoted to the principle of human rights cannot abide by a trading regime that represents a race to the bottom. Trade cannot be exploitative; in exploitation lie the seeds of future violence, revolution, and armed conflict. Rather, trade must be conceived and implemented as a strategy to raise the incomes and prospects of buyer and seller alike. Affirmative steps must be taken to ensure that environmental and labor concerns are addressed, that economic justice is done. This is the mandate of a renewed commitment to human rights.

4) A commitment to human rights requires a preference for negotiation to military action. Yes, there are monsters out there and there will be occasions when war is both inevitable and just. But there will be many more occasions when relations between and among nations are more complex, more nuanced—with good and bad motives attributed to all sides. On these more frequent occasions, we must not fear to

negotiate, to talk over our differences, to try to resolve them short of armed conflict. A willingness to negotiate requires real mental and spiritual strength, it requires real confidence, but it often holds out the best chance to achieve the desired change.

When I've returned from Syria or Cuba or Yugoslavia having successfully completed missions that seemed impossible in prospect, I am often asked, what did you do that was so different from what others have done? The answer is: I tried.

Love your enemy, the Bible tells us. Well, there are four good reasons why loving your enemy makes sense in foreign affairs: 1) your enemy is a human being and deserves some fundamental level of respect and dignity, 2) love, in spite of your anger, will cause you to reach out when you might otherwise have shut the door, 3) a sense of empathy, mindful of the hopes and fears of your enemy, greatly enhances the probability of conversion, and 4) you might just find some insight into how your own behavior contributed to the standoff.

Look at just how ineffectual we have been where all negotiation has been cut off: Hussein, Castro, Qaddafi, and Khomeini, while he was alive. The failure to negotiate has become a lifetime ticket to power for these individuals.

Peace is more difficult than war. War is one-sided; it can be waged unilaterally. Peace requires two sides; it requires that all players come to the table. Peace involves reconciliation; it requires building bridges of trust. This is the harder job. But the goal is worth it.

The great warriors for peace—Gandhi, Dr. King, and Jesus—died in the cause of reconciliation. The fruits of peace may be deferred, but they will be realized, and they will be all the sweeter.

5) A commitment to human rights requires that we always keep a mirror close at hand, so that we might judge ourselves by the same high standards we demand of others. As an American, I want to keep that mirror handy, so that I might reflect on facts such as these: the largest number of jailed young people in the world; the disproportionate share of blacks who are jailed; the widest gap in income and wealth in the world; our number of first-class jails and second-class schools. I want to look at that mirror and see what others might see.

Vanity asks the question, Is it popular? Politics asks the question, Will it work, is it feasible? Morality and conscience ask the question, Is it right? This is a haunting question of hope that will not go away— Is it right?—whether in South Africa, Moscow, Belgrade, Delhi, or Paris—Is it right?

If the question, "Is it right?" begins to be asked with greater frequency by governmental leaders around the world, we will have achieved something very significant. So let the word go forth: in Kashmir, in Taiwan, in Sierra Leone, in Tibet, in East Timor—wherever human rights are under attack, there is a lot of talk going on that represents a ray of hope.

Perhaps we have finally learned the lesson of 2 Samuel, where David laments the deaths of Saul and Jonathan with the cry, "How the mighty have fallen." Let us avoid the arrogance that comes with power. Instead, let us act, as Jesus acted when confronted by the lost sheep in the Book of Luke—focusing our attention on those who have gone astray.

Let us say to the leaders of our day: We are with you in the elevation of human rights. That which is morally right cannot be repressed. ■

JOAN BAEZ

I WAS FORTUNATE TO HAVE BEEN BORN WITH THIS VOICE, TO USE it in ways that lend credibility to traditional music and beyond, and also to further the cause of nonviolence.

Social change without music would be void of soul. Nonviolence without music, meditation, action, and a willingness to take risks probably doesn't exist. In my mind's eye I can see the black children leaving a church to knowingly be arrested, singing at the top of their lungs, "I ain't gonna let nobody turn me around. . . ." I'm proud to have sung with them, and with many others in times of social change, political revolt, great deprivation, and the attendant joys, fears, and sorrows. ■

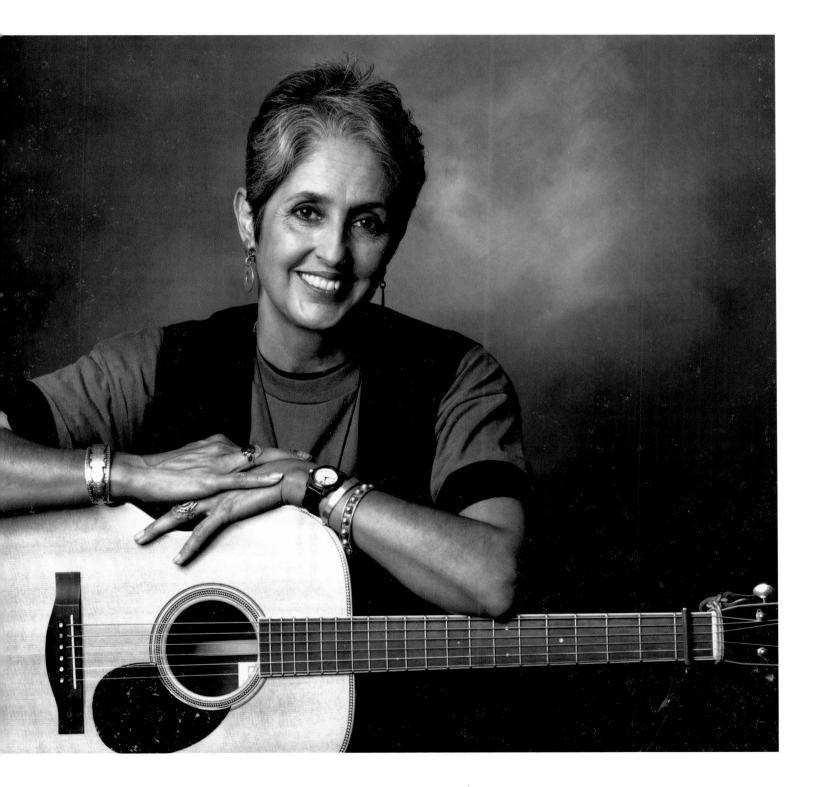

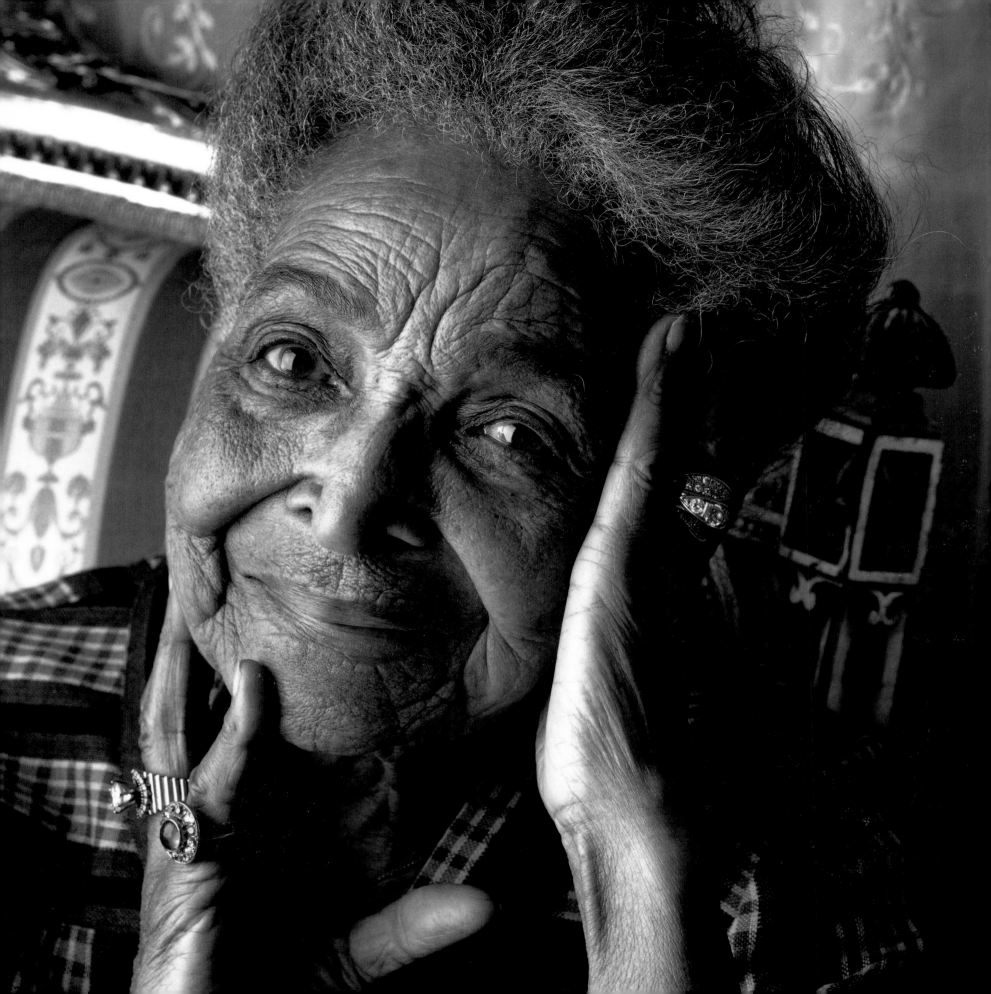

IDA JACKSON

THERE WAS NOT MUCH FOR A WOMAN TO DO EXCEPT TEACH, back then. I was the only black teacher [in Oakland, California] until about 1939.

[My father] was a math and geography genius and he worked with my brother and me so we would have an education. I had to go to private school because the only public school that admitted blacks was a city school outside of our limits. My brother got a job on a milk truck in a white area without my mom knowing. I was accepted into private school by a northern white woman and had graduated by age thirteen as one of the only blacks at the school.

My parents had taught us, "Never feel any man or woman is your superior just because he or she is white." When we came from school in the northern part of Vicksburg, Mississippi, the white kids would push us off the sidewalk and make us walk in the gutter. When my father learned about it, he told us, "Don't walk in the gutter. Stand and fight." We tied our books into straps and protected ourselves by putting hairpins in the books.

FOR SOME REASON, WHITE KIDS OFTEN GET MOTIVATED TO GET an education, whereas black kids have not been encouraged to plan on attending college. Even today, many teachers fail to encourage black children to get an education, and not enough parents become familiar enough with the subjects their children study. In my days of teaching, I found counselors who would encourage children to take general courses, rather than college preparatory courses, including chemistry, math, geometry, and the sciences.

Overall, I found most students during my era were capable of learning. Some did not show the same capacity as others, but everyone can learn to read and write.

A kid gets bored because he or she does not have any teaching on the values and fundamentals of an education. Many of the best-educated blacks come from homes of parents who had little or no education. Today, many black students still don't feel it's necessary to get an education, but a black child still needs to know more than a white to get the same type of job.

Everyone ought to make sure the black child is familiar with blacks who have become successful as role models. The parent is the first role model. As the parent lives, so will the child, and the use of drugs and alcohol in front of children is the worst thing that parents could do. Our kids need to be taught not to accept drug monies and to work for what they get. All blacks have a responsibility to learn as much as possible and to correct children who are going astray.

Youth will suffer without the wisdom of their elders. I do believe that blacks ought to band together to fight drugs that are being passed on to our children. And parents must live so children will respect and listen to them. ■

Growing up in the Bay Area, I had always admired the profound achievements of Ida Jackson, a true champion of education, health care, and civil rights. As the first accredited black high school teacher in California, Ida achieved great success, despite the constant obstacles of racial discrimination. Rarely taking credit for her own accomplishments, she frequently cited her older brother's enormous personal sacrifices in raising her.

A couple years after this photo was taken, Ida was mugged in her home. She was knocked unconscious and found by friends days later. The thieves took many valuables, including the rings she is wearing here. Asked whether she knew the intruders, she admitted that she had a good idea who it was, but that her jewelry were mere possessions and unimportant to her. She never pressed charges.—M.C.

JANE GOODALL

As we move into this millennium it is easy to be overwhelmed by feelings of hopelessness. We humans have destroyed the balance of nature: Forests are being destroyed, deserts are spreading, there is terrible pollution of air, earth, and water. Climate is changing, people are starving. There are too many humans in some parts of the world, over-consumption in others. There is human cruelty to "man" and "beast" alike; there is violence and war. Yet I do have hope. Let me share my four reasons.

Firstly, we have at last begun to admit to the problems that threaten the survival of life on earth. And we are problem-solving creatures. Our amazing brains have created modern technology, much of which has greatly benefited millions of people around the globe. Sadly, along with our tendency to overreproduce, it has also resulted in massive destruction and pollution of the natural world. But can we not use our awesome problem-solving ability to now find more environmentally friendly ways to conduct our business? Good news: It's already happening as hundreds of industries and businesses adopt new "green" ethics. And we must play our part—in our billions we must adopt less-harmful lifestyles. Refuse to buy products from corporations that do not conform to new environmental standards. We *can* change the world.

Secondly, nature is amazingly resilient. Given the chance, poisoned rivers can live again. Deforested land can be coaxed—or left—to blossom again. Animal species, on the verge of extinction, can sometimes be bred and saved from a few individuals.

My third reason for hope lies in the tremendous energy, enthusiasm, and commitment of young people around the world. Young people want to fight to right the wrongs, for it will be their world tomorrow—they will be the ones in leadership positions, and they themselves will be parents. This is why the Jane Goodall Institute started Roots & Shoots, an environmental education and humanitarian program for youth. Roots creep under the ground to make a firm foundation. Shoots seem small, but to reach light they can break brick walls.

Hope—millions of roots and millions of shoots can break through, break all the problems humans have created, make change. Roots & Shoots groups, from kindergarten to college, work to make the world a better place for animals, the environment, and the human community. The central message of Roots & Shoots is that every individual matters, every individual has a role to play, every individual makes a difference.

My fourth reason for hope lies in the indomitable nature of the human spirit. There are so many people who have dreamed seemingly unattainable dreams and, because they never gave up, achieved their goals against all the odds, or blazed a path along which others could follow.

So let us move into this millennium with hope—with faith in ourselves, in our intellect, in our indomitable spirit. Let us develop respect for all living things. Let us try to replace violence and intolerance with understanding and compassion. And love. ∎

When traveling, Jane shares "objects of hope" with the people she meets. Among these is a shard of limestone from Robin Island, where Nelson Mandela labored for seventeen of his twenty-two years in prison. This shard remains a potent symbol of what is possible, as Jane never thought apartheid would end without bloodshed.

Another item is a simple wooden comb made by a Tanzanian leper who lost all his fingers and toes before the disease was checked. He weaves the strands of wool with his stumps and teeth, decorating the combs so he can sell them and live with dignity instead of begging.

Perhaps the most popular object is Jane's mascot, Mr. H, the chimp shown here with the banana. Mr. H was made by Gary Haun, who lost his eyesight at twenty-five while in the U.S. Marines. Gary decided not to let his blindness spoil his life and so became a magician who performs for children. He is so good that the children don't realize he's blind. Jane has brought Mr. H to twenty-nine countries, and he has been touched by more than 150,000 people. —M.C.

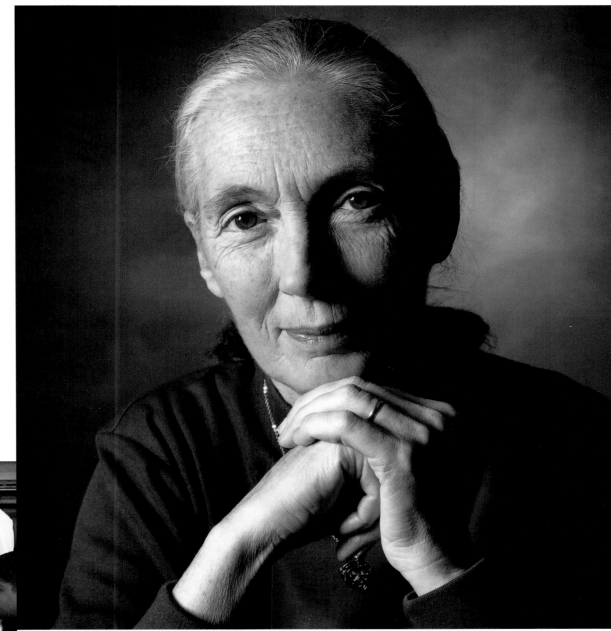

OSCAR ARIAS SANCHEZ

RESPONSIBILITY, AS A MORAL QUALITY, SERVES AS A NATURAL, voluntary check for freedom. In any society, freedom can never be exercised without limits. Thus, the more freedom we enjoy, the greater the responsibility we bear, toward others as well as ourselves. The more talents we possess, the bigger the responsibility we have to develop them to their fullest capacity.

The opposite is also true: as we develop our sense of responsibility, we increase our internal freedom by fortifying our moral character. When freedom presents us different possibilities for action, including the choice to do right or wrong, a responsible moral character will ensure that the former will prevail.

Sadly, this relationship between freedom and responsibility has not always been clearly understood. Some ideologies have placed greater importance on the concept of individual freedom, while others on the unquestioning commitment to the social group.

Without a proper balance, unrestricted freedom is as dangerous as imposed social responsibility. Great social injustices have resulted from extreme economic freedom and capitalist greed, while at the same time cruel oppression of people's basic liberties has been justified in the name of communist ideals and society's interests.

Either extreme is undesirable. At present, with the disappearance of the East-West conflict and the end of the Cold War, with the failure of Marxist experiments and the gradual humanization of capitalism, humanity seems closer to the desired balance between freedom and responsibility. We have struggled for freedom and rights. It is now time to foster responsibility and human obligations.

The initiative to draft a Universal Declaration of Human Obligations is not only a way of balancing freedom with responsibility, but also a means of reconciling ideologies and political views that were deemed antagonistic in the past. The basic premise, then, should be that humans deserve the greatest possible amount of freedom, but also should develop their sense of responsibility to its fullest in order to correctly administer their freedom.

Because rights and duties are inextricably linked, the idea of a human right only makes sense if we acknowledge the duty of others to respect it. Regardless of a particular society's values, human relations are universally based on the existence of both rights and duties.

The [United Nations'] Universal Declaration of Human Rights describes a detailed set of conditions which, if present, are believed to be conducive to a good life. Among these are freedom, equality, economic and social security, and peace, aspirations which portray the main challenges that lie ahead of humanity.

Nevertheless, of the Universal Declaration's thirty articles only one—Article 29—refers to human duties. The only other reference to obligations is a brief section of Article 1 which states that all human beings are endowed with reason and conscience, and should act towards another in a spirit of brotherhood. This spirit of brotherhood, or solidarity, is precisely what the world needs more of today. Solidarity with our fellow humans, solidarity between nations, and solidarity towards our planet Earth.

The importance of the concept of responsibility should not be overlooked. After all, it is a sense of responsibility that makes people accountable for their actions. Indeed, we are all responsible for the problems humanity faces today: destruction of the environment, extreme poverty, and the persistence of armed conflict around the globe. These threats are nothing else than the result of human action—action driven, in most cases, by greed, selfishness, or just plain ignorance. Whatever the reasons, humanity clearly can no longer afford to endure such tragedies. ■

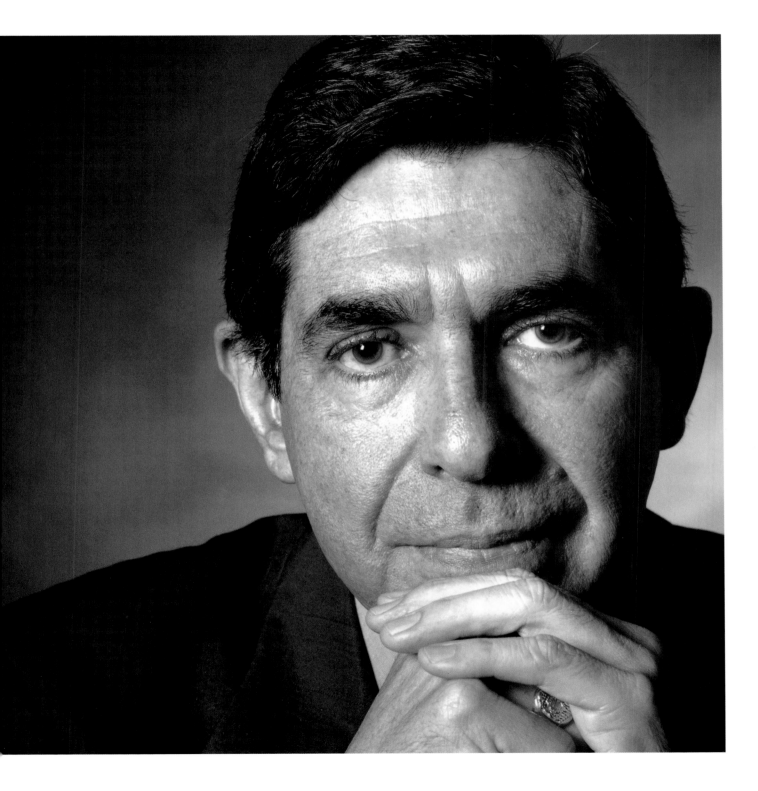

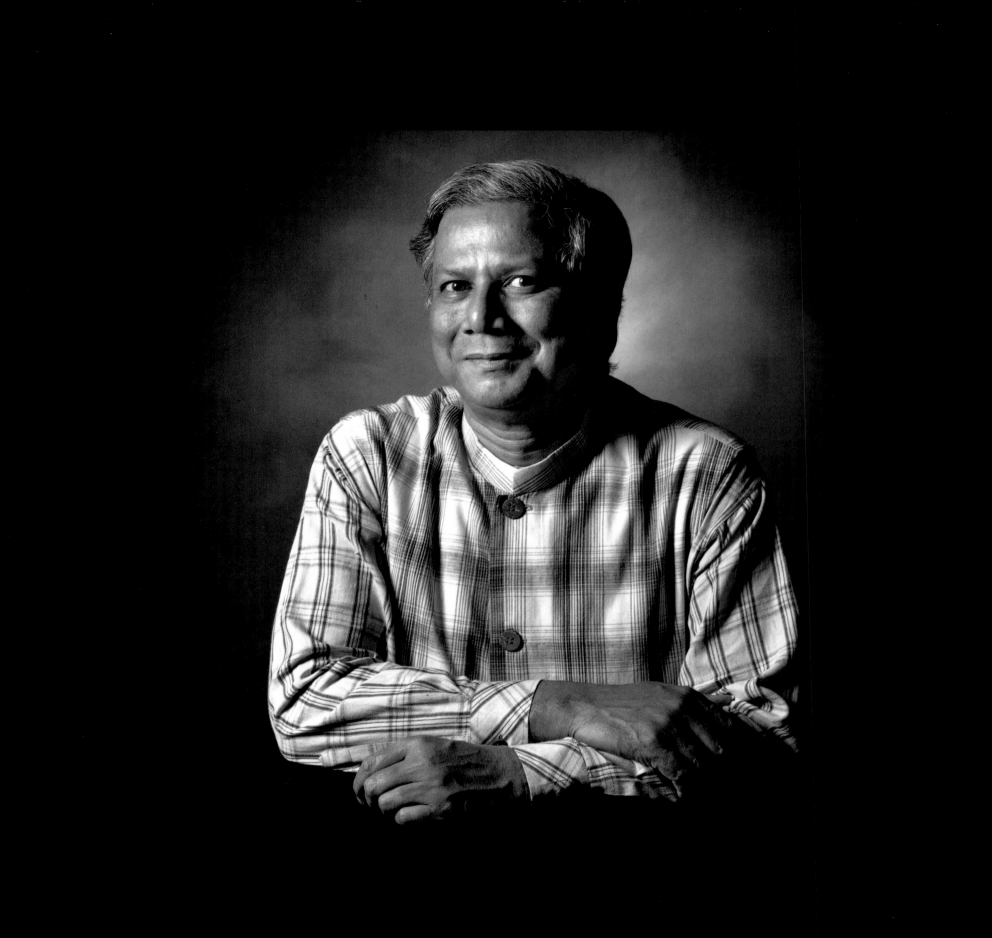

MUHAMMAD YUNUS

EMPOWERMENT OF THE POOR

MY EFFORTS TO EMPOWER THIRD WORLD POOR BEGAN, appropriately enough, with an independence movement—the independence of Bangladesh. In 1971, my homeland was confronted with a war, bloodshed, and a tremendous amount of misery. During that war, I was teaching in the United States. But after nine months of fighting, Bangladesh became independent and I went back, thinking I would join the people in the rebuilding process and help create the nation of our dreams. As the days went by, however, the situation in Bangladesh did not improve. It started sliding down fast, and we ended up with a famine at the end of 1974.

By this time, I was teaching at Chittagong University on the outskirts of Chittagong City, Bangladesh, and I felt terrible. There, I taught economics in the classroom with all the enthusiasm of a brand-new Ph.D. from the United States. I felt as if I knew everything, that I had all the solutions. But then I would walk out of the classroom and see skeletons all around me, people waiting to die. There are many, many ways to die, but none is so cruel as to die of hunger; death inches toward you, you see it, and you feel helpless because you can't find one handful of food to put inside your mouth. And the world moves on.

I couldn't cope with this daily tragedy. It made me realize that, whatever I had learned, whatever I was teaching, was all make-believe; it had no meaning for people's lives. So I started trying to find out why the people in the village next door to the university were dying of hunger. Was there anything I could do as a human being to delay the process, to stop it, even for one person?

I traveled around the village and talked with its people. Soon, all my academic arrogance disappeared. I realized that, as an academic, I wasn't really solving global problems; I wasn't even solving national problems. I decided to abandon my bird's-eye view of the world, which

allowed me to look at problems from above, from my ivory tower in the sky. I assumed, instead, the worm's-eye view and tried to probe whatever came right in front of me—smelling it, touching it, seeing if I could do something to improve it. Trying to involve myself in whatever capacity I could, I learned many things in my travels.

But it was one particular incident that pointed me in the right direction. I met a woman who was making bamboo stools. After a long discussion, I discovered that her profit for the stools averaged the equivalent of two American pennies a day. I could not believe anyone could work so hard, create such beautiful bamboo stools, and make so little. She explained that she didn't have the money to buy the bamboo that goes into the stools; she had to borrow from the trader, who required that she sell the product to him alone and at a price he decides. She was virtually bonded labor to that person. And how much did the bamboo cost? She said about twenty cents; if it was good bamboo, twenty-five cents. I said, "My god, people suffer for twenty cents and there's nothing anyone can do about it?"

Thinking it over, I wondered whether I should just give her the twenty cents. But then I came up with a better idea: I could make a list of people in the village who needed that kind of money to be self-employed. After several more days of traveling, a student of mine and I came up with a list of forty-two such people. When I added up the total dollars they needed, I experienced the biggest shock of my life: it added up to twenty-seven dollars! I felt ashamed to be a member of a society that could not provide twenty-seven dollars to forty-two hard-working, skilled human beings. To escape my shame, I took the twenty-seven dollars out of my pocket and gave it to my student and said, "Take this money. Give it to those forty-two people we met and tell them this is a loan, which they can pay back whenever they are ready.

In the meantime, they can sell their product wherever they get a good price."

The people of the village were quite excited to receive the money; such a thing had never happened to them before. Seeing such excitement made me wonder what more I could do to help them. Should I continue providing them money or should I arrange for them to secure their own funds? I thought of the bank located on campus. In a meeting with the manager, I suggested that his bank lend the money to the forty-two people I had met.

"You're crazy!" he said. "It's impossible! How can you lend money to the poor people? They're not credit worthy." . . .

The bankers had been trained to believe that poor people are not capable of running profitable businesses. Their minds were blind to the results they had been shown. Luckily, my mind had not been trained that way.

Finally I thought, why am I trying to convince them? I'm already convinced that poor people can be advanced business loans and will pay them back. So why don't I just set up a separate bank of my own? I wrote up a proposal and went to the government for permission. It took two years of convincing. . . . At last, in 1983, Grameen Bank—a formal, independent financial institution—was opened. I founded it as an alternative to the current banking system, which I found to be biased against both the poor and women. . . .

Recognizing this bias, I wanted to make sure that women made up half of all Grameen's borrowers. But it wasn't easy to persuade the women in Bangladesh to join the bank. A man isn't even allowed to address a woman in her village.

The usual response I heard was, "No, I don't need money. Give it to my husband." We kept telling them that we understood their husband could take it but that we wanted to give the money to the women if they needed it for a business idea. Yet, they would say, "No, I don't have an idea." And that was repeated in village after village, by woman after woman. It took a lot of convincing before any woman could believe that she, herself, could use a loan to earn income. All we needed was patience. We asked that women borrow from Grameen in groups of five and, once we were able to convince one woman, our work was half done. She then was an example that convinced her friends and then her friends' families and so on. . . .

Many women couldn't believe someone trusted them enough to loan them such an amount of money. As tears rolled down their cheeks, they promised to work very hard and make sure they paid back every penny of it. And they did. Grameen requires tiny weekly payments so that, over the course of one year, business loans can be paid back with interest. By the time the loans are paid off, the women are completely different people. They have explored themselves, found themselves. Others may have told them they were no good, but on the day a loan is paid off, the women feel as though they can take care of themselves and their families.

We noticed so many good things happening in the families where the woman was the borrower instead of the man. So we focused more and more on the women, not just 50 percent. Today, Grameen Bank works in thirty-six thousand villages in Bangladesh; has 2.1 million borrowers, 94 percent of them women; and employs twelve thousand people. The bank completed its first billion dollars in loans four years ago, and we celebrated it. A bank that starts its journey giving twenty-seven dollars in loans to forty-two people and comes all the way to a billion dollars in loans is cause for celebration. We felt good to have proven all those banking officials wrong. . . .

I went back to the officials who are now my banking colleagues and admonished them: "You said poor people are not loan worthy. But for twenty years, they've been showing every day who is worthy and who isn't. It's been the rich people in Bangladesh who haven't paid back their loans because it's been only the rich people who were granted them. With Grameen Bank, it's the poor people who are paying back." Our recovery rate has remained more than 98 percent since we began. So my question now is, are the bank's people worthy?

Researchers say that there must be some trick to it—I can't be reporting the right figures, I'm hiding things. But when they investigate

our records, they see the same numbers. They come in with hostility and leave as great admirers of our bank. Researchers now say that the income of all our borrowers is steadily increasing. The World Bank reports that one-third of our borrowers have clearly risen above the poverty line, another one-third are a matter of months or a couple of years away from this achievement, and the remaining one-third are at different levels below that. I say, if you can run a bank, lend money, get your money back, cover all your costs, make a profit, and get people out of poverty—what else do you want?

Are poor people loan worthy? Does the world still wait for evidence? Does it care? I keep saying that poverty is not created by poor people; poverty is created by the institutions we have built around us. We must go back to the drawing board to redesign those institutions so they do not discriminate against the poor as they do now. We have heard about apartheid and felt terrible about it, but we don't seem to feel anything about the apartheid practiced by financial institutions. Why should some potential entrepreneurs be rejected by a bank simply because they are thought to be unworthy of a loan? By the evidence, it is clear that the opposite is true.

It is the responsibility of all societies to ensure human dignity for every member of that society, but we haven't done very well in that endeavor. We talk about human rights, but we don't link human rights with poverty. Poverty is the denial of human rights. And it's not just the denial of one human right—put together all the many ways our society denies human rights and that spells poverty.

Grameen-type programs are now popping up in many countries. To my knowledge, fifty-six countries—including the United States—are involved in such endeavors. But the effort doesn't have the momentum it needs. There are 1.3 billion people on this planet who earn the equivalent of one American dollar or less a day, who suffer extreme poverty. If we create institutions capable of providing business loans to the poor for self-employment, they will see the same success we have seen in Bangladesh through Grameen Bank. I see no reason why anyone in the world should be poor. ∎

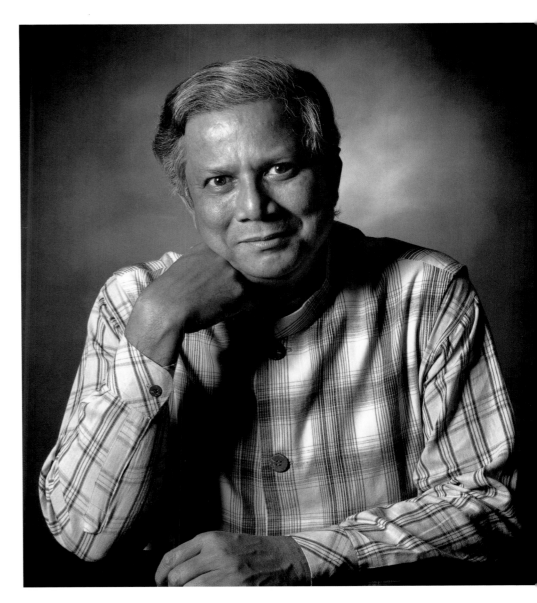

DR. LORRAINE HALE

IT HAD BEEN A LOVELY DAY, WARM BUT PLEASANT. I WAS JUST WISHING I felt the same about my career. My mind churned over the events of another frustrating day working in the New York City school system.

I'd stopped by to see my mother, Clara Hale, before heading home. She gave me some lemonade, a listening ear, and, in her usual manner, gentle but straightforward advice. Actually, it was the same advice I'd heard all my life. As I waited at the red light, I could hear her voice as clearly as though it were coming from my car radio:

"Lorraine, God put you on this earth for a reason. He's going to reveal that reason to you. Just wait. And keep your heart open so you'll see it when He puts it in front of you."

The light changed. As I was about to make a left turn, I noticed a woman sitting on a wooden crate just on the edge of the curb. She was nodding off with a bundle in her arms. I had seen this scene so often, I would look, but not really see. Then I noticed the bundle jerk and I thought I saw a tiny arm.

The car behind me blew its horn. I inched ahead as I thought about the frightening possibility that the nodding woman was responsible for the care of a baby.

One block passed . . . then two . . . three . . . four. Abruptly, I made a sharp right turn, forgetting to signal. Back down the street I went, back to 146th Street, where the mother and baby came back into view.

Little did I know that in those few moments, I had done far more than redirect my car—I had redirected my life and the lives of my family—not to mention the lives of more than three thousand babies.

I parked the car and watched the woman. She was in a deep nod. I feared the baby might slip out of her arms and onto the hard sidewalk.

"Excuse me, are you all right?" I asked her. I asked several times with no response. Finally she looked up, struggling to focus on my face. I knew the look. She was on heroin and really out of it.

"Here, go to this address," I said, pressing a piece of paper into her frail hand. "My mother will help you. She loves babies and it would give you a chance to get yourself together. Her name is Mrs. Hale. The children call her 'Mommy Hale.' Just say her daughter sent you."

Mother called me the next morning. "Lorraine, there is a junkie at my door and she said you sent her," she said with sharp deliberation.

For a moment, the event of the day before escaped me. I took a deep breath. "Mother, I don't know any junkies," I said without remembering.

"Then please explain to me where she got this note with my name and address written in *your* handwriting . . ."

Driving to her apartment, I was uncomfortable. Mother was terribly put out with me. I'd forgotten to tell her. Her reaction was unusual. It was second nature to both of us to minister to, rescue, and love babies. By the time I arrived, the mother had left the baby. But she returned just a few hours later, demanding that Mother give her child back to her. "Look here," Mother told her in no uncertain terms, "I've raised my own children, I don't need yours to raise. Now you straighten yourself up and raise her yourself. You're this baby's mother!"

Without replying, the woman walked out the door, gripping the baby close to her. The day passed, and although we both reflected on the ugly scene that morning, we had a good visit. Some hours later, we heard the doorbell ring. There the woman stood, visibly shaken and tearful, back with the baby. Her words were slurred, but she was trying hard to sound straight.

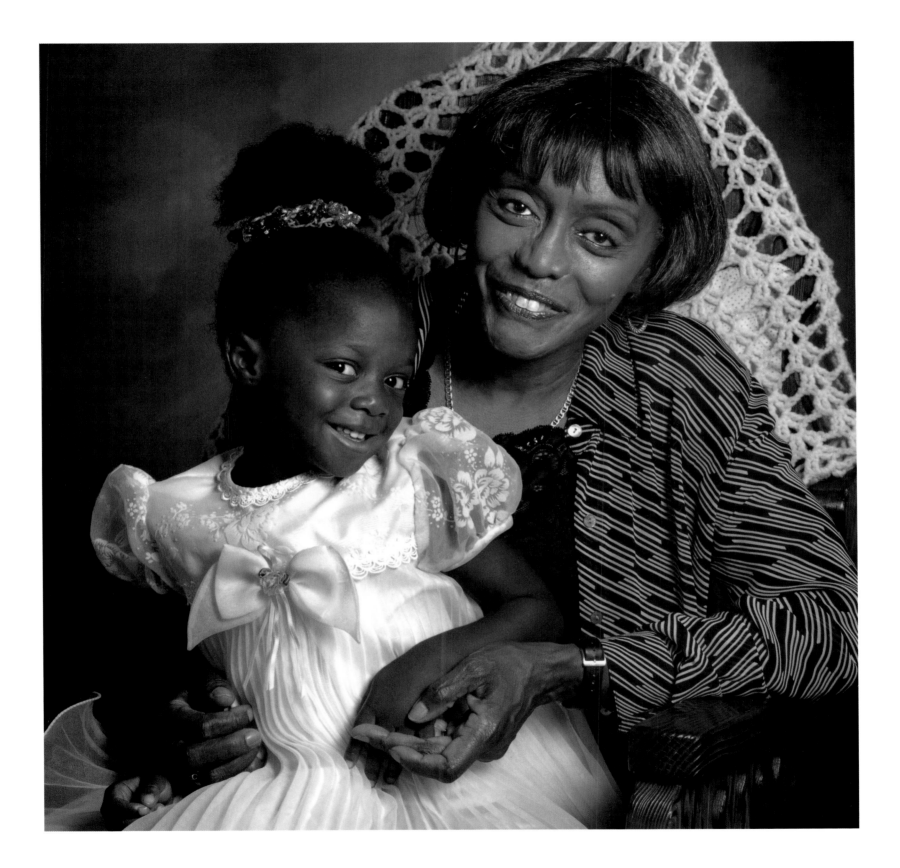

"My baby. She's, she's . . ." Toothless, her face grimaced. Tears filled her eyes. It was a mixed cry for help, perhaps. But I could hear the deep anguished cry of a mother totally overwhelmed. She left quickly down the stairs—too uptight to take the elevator—before we could get anything from her.

Mother closed the door and walked into the kitchen, holding the baby in one arm. She started stirring oatmeal as if nothing had happened.

"She's gone," Mother said softly.

"What's the baby's name?" I asked.

"I don't know," Mother replied.

"How old is she?"

"I don't know," was the same reply.

"How long are you keeping her?"

"I don't know," Mother said once again.

"Well, what *do* you know?" I asked, wondering if I'd have to go fishing all day to get some information out of her.

"I know you have to get a second job in order to help take care of this baby, Lorraine."

That beautiful little girl—we called her Amanda—became the first drug-addicted baby we ever cared for. Overnight, Mother, then sixty-five, abandoned any thought of retirement and became known as the "special lady" who would care for babies of drug addicts. Within three months her apartment was lined wall to wall with cribs for twenty-two infants. By then, I knew this would be my future as well. Thus began Hale House Center for the Promotion of Human Potential.

Just as Mother had predicted, God had revealed my reason for being. Clearly, He had placed us here to help these precious, innocent little ones know His kind of love: love that is more enduring than the long weeks of comforting them through the nightmare of drug withdrawal. We went on to care for abandoned babies, babies born addicted to drugs, alcohol, and tobacco, and sometimes infected with HIV, the virus that causes AIDS.

Thank God, we were there for that heroin-addicted woman sitting on that street corner. To think that if I'd missed that divine appointment, little Amanda might never have survived to be the lovely twenty-two-year-old she is today—and there might never have been a Hale House. And to think of all the smiles and sloppy kisses I would have missed on the faces of His children.

We've had to work hard to hold a steady course in uncharted waters. Our only compass in the beginning was the one in our hearts. It pointed straight to God's word in Psalms 82:3–4, which says, "Defend the cause of the weak and fatherless; maintain the rights of the poor and oppressed. Rescue the weak and needy."

To do that, it costs something—your time, your energy, your money, your love. It's those things that have made Hale House a reality, and alive with love. It was established and has been maintained by people willing to live the conviction that every child deserves love and dignity. Babies don't give themselves drugs or AIDS. And they are no less worthy of being loved and cared for than a healthy child. If anything, they need to be affirmed of their worth in a greater way because of their afflictions.

May God help us show them they are precious, help us show them they are valuable and their lives matter, help us love them whether their lives are brief or last a full lifetime. ■

We decided the most appropriate place for the photographs was Mother Hale's old room. They are sitting in the rocking chair where Mother Hale comforted hundreds of babies through the years. Walking through Hale House, I was struck by the loving care given each child. Mirrors lined the walls at the children's level so that they can fully understand how important they are.—M.C.

Dr. C. Everett Koop

From the time I was six years old I knew that I wanted to be a surgeon, and even as a young boy I trained my hands for future surgical maneuvers by cutting pictures out of magazines using both my right and left hands. But I also spent hours with my first chemistry set, at first just making colorful solutions, then conducting what may have been some rather sophisticated experiments for a twelve-year-old. As a teenager I combined my interest in chemistry with my budding interest in surgery by performing simple operations on some of the many stray cats that prowled my Brooklyn, New York, neighborhood. Using the ether that I supplied, my mother would anesthetize the cats while I removed an unnecessary organ, such as one ovary. We were a good team, and I never lost a feline patient!

After my mother's death in 1974 at age eighty-six, I found among her treasured papers an essay that I had written as a high school senior. Its concluding paragraph summed up my hopes for careers in both science and medicine:

> Now at sixteen I picture myself a surgeon—nothing would give me a bigger thrill and would please me more than to operate on a human being from an altruistic viewpoint of relieving his ills, or from the scientific viewpoint of giving to science some information unknown to it.

That was the joint dedication to science and medicine that shaped my forty-year career as one of the United States' first pediatric surgeons. In the late 1940s and 1950s I, and a handful of other surgeons, were pioneers in this new field of surgery, often being forced to invent new operations as we encountered congenital abnormalities in newborns that had never before been corrected surgically. Although we were serving primarily as doctors attempting to bring healing and comfort to our tiny patients and their worried families, we were, at the same time, scientists pushing the surgical frontier into the unknown, all the while documenting our hard-won surgical successes. By performing thousands of new and then routine operations, through surgical research, published articles, and innovations in science, pediatric surgery eventually became an established surgical specialty. In those operations that were particularly difficult to perform on newborns, in the brief forty-year span of my surgical career I witnessed a mortality rate of 95 percent become a survival rate of 95 percent, thanks to the progress made in pediatric surgery.

In addition I learned that for all of its reliance on science, medicine is also an art. I learned that pediatric surgery requires a gentle touch, not just on the fragile tissue of an infant's body, but also on the fragile emotions of patients and their families. I learned that to do full justice to my interests in science, surgery, and research, I had to apply myself not merely to curing, but also to caring.

My stress on the human dimension of science remained important as I left my surgical career to become the United States Surgeon General. As surgeon general I always seemed to be issuing a "Surgeon General's Warning" about one thing after another that threatened the health of the American people: cigarettes, smokeless tobacco, AIDS, Reye's syndrome, violence, and a host of others. In each case I had to be certain that the science behind the health warning was impeccable and able to withstand the critics who sought to dismiss the warnings. But I also needed to ensure that the science made sense on a personal level. I had to listen to the American people as well as to talk (sternly) to them. Also, I wanted to be certain that my message reached the most vulnerable, often those high-risk groups living in poverty on the fringes of this affluent and sometimes overconfident society.

Now, in my present career as national lecturer, author, and advocate for the health of the American people, I find myself once again motivated by the concerns of both science and medicine. As I did when

surgeon general, I strive to advise people about what they can do to promote health and avoid disease. In this ongoing endeavor I base my message on the best science, as, for instance, in my effort to communicate the dangers of hepatitis C. But I have also discovered that relying on the best science is not enough, because it can be pushed aside by politics and economics, or, to put it another way, by greed. . . .

One can observe similar trends in the world of health care delivery. At the end of the twentieth century the scientific research community has done wonders to fulfill medicine's historic goals of prolonging life and alleviating suffering. Almost every day we read about a new scientific breakthrough that provides a cure for this, relief for that, and new hope for millions of people suffering from a variety of diseases. But we know that scientific progress is not enough. We have seen that the dictates of economics, that "dismal science," limit the benefits of medical science. I practiced surgery in the so-called golden age of medicine, a time when it seemed that each day medical science could do more for patients, and more and more Americans gained access to the health insurance that would provide needed health care. But now, as daily an increasing number of Americans lose their health insurance (the United States has close to fifty million uninsured citizens), and as most of those who are insured are covered through economically driven managed care plans, those who need health care the most are often the ones who get it the least.

Physicians' unhappiness with a system that diluted their focus on patients with cost issues made them the initial advocates of managed care. The managers and physicians in these early health maintenance organizations (HMOs) were unexpectedly surprised to find that maintaining their patients' health provided the added benefit of containing health care costs. This had been accomplished by shifting the focus to preventive care, to a standardization of practice that resulted in better outcomes, and by elimination of unnecessary tests and procedures. Now, in all too many cases, that added benefit has become the primary purpose of managed health care companies, as Wall Street investors have determined that hospital companies and health care companies should be treated like any other business, as an opportunity for investors to make money. Profit, not health, is the prime objective of this kind of managed care.

I am concerned about the intrusion into medical education by these investor-controlled health care companies: Some have even bought medical schools, and at least one has subsequently filed for bankruptcy. I do not want the education of our next generation of physicians to be held hostage to bottom-line oriented managers who buy and sell hospitals, medical practices, and medical schools as though they were pork futures. Americans are only slowly realizing how many medical decisions have been taken out of the control of physicians and other health care personnel and placed on the desks of accountants and businessmen. Every American should be concerned about the unwillingness of managed care companies to do their fair share in supporting medical education and medical research, especially clinical research.

I do not intend my remarks to be a diatribe against managed care. This is still very much a fluid situation, and it may work out in such a way that HMO patients will be delighted to deal with relaxed doctors free to make clinical decisions in a financially neutral environment. However, it could also develop so that patients find themselves shuttled about from gatekeeper to nurse, denied costly specialists and unable to penetrate the bureaucratic maze of a health care company that cares more about profits than patients. . . .

I believe that it may take a decade or so to find a new equilibrium involving HMOs, medical innovations, patient concerns, and physician-directed decision making, an equilibrium that will deliver what is medically necessary, not what is merely profitable. I am hopeful, but not certain, that what is in the best interest of the patient will begin to prevail over what is in the best interest of the health care company investors. This attitude must support medical research as well as medical care. The issues of managed care, patient rights, physician professionalism, medical research, and health care in America need to be lifted from the bottom line to our highest aspirations. ■

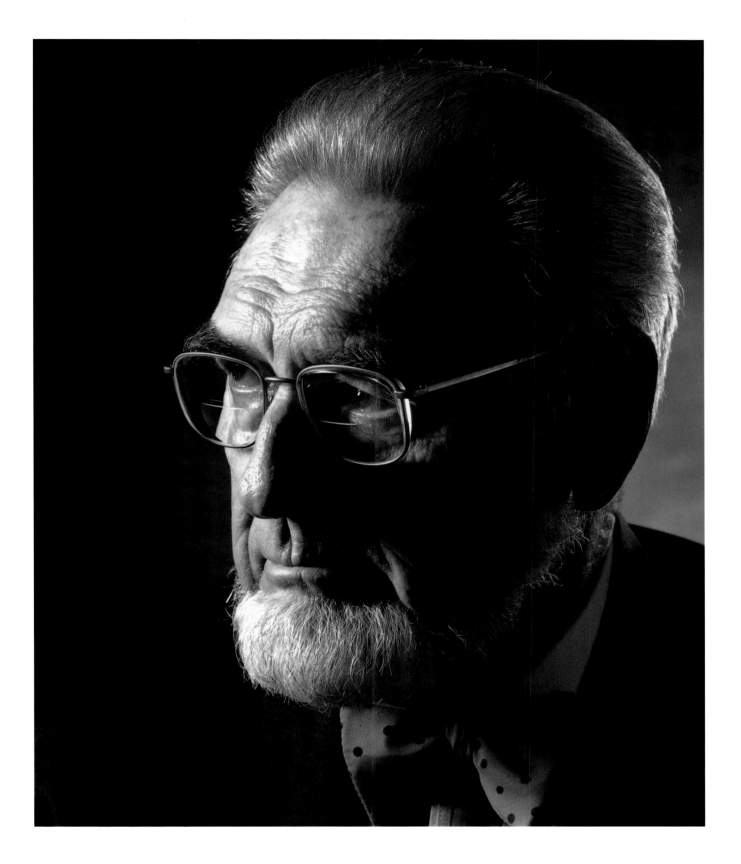

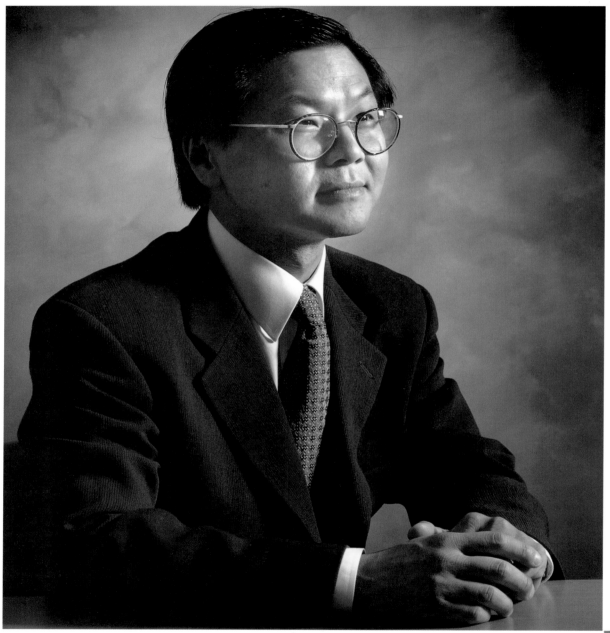

Dr. David Ho

I feel extremely privileged to work on AIDS. As a young physician in Los Angeles in 1981, I was fortunate enough to witness the beginning of the visible part of the AIDS epidemic. Over the course of a year, young men, one after another, appeared at the hospital with a multitude of opportunistic infections, leading to death within days to weeks. It was evident that their immune systems were damaged. But by what? Their medical histories strongly suggested the possibility of a sexually transmitted agent that caused immunodeficiency. And yet, any description of a similar syndrome was nowhere to be found in the medical literature. The disease was obviously new!

In this manner, AIDS appeared insidiously and mystified doctors and scientists alike. No one could have predicted that nineteen years later, we would face a global epidemic of HIV infection that is arguably the plague of the millennium. Today, HIV continues to spread at an alarming rate of sixteen thousand new cases per day, and several hundred million infections are expected by the end of the decade. For a biomedical scientist, what could represent a greater opportunity than to conduct research on a lethal microbe that threatens the health and stability of the entire world?

How we respond to the AIDS crisis is also a measure of our care for one another. Even if an AIDS vaccine is developed—our only real hope of averting an unparalleled medical disaster—it will require an extraordinary effort of political will among our leaders to get it to the people who need it most. It is my profound hope that we can rise to the challenge. ■

LINUS PAULING

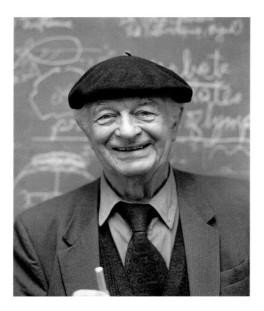

I BELIEVE THAT THERE WILL NEVER AGAIN BE A GREAT WORLD war, if only the people of the United States and the rest of the world can be informed in time about the present world situation. I believe that there will never be a war in which the terrible nuclear weapons— atom bombs, hydrogen bombs, superbombs—are used. I believe that the development of these terrible weapons forces us to move into a new period in the history of the world, a period of peace and reason, when world problems are not solved by war or by force, but are solved by the application of man's power of reason, in a way that does justice to all nations and that benefits all people.

I believe that this is what the future holds for the world, but I am sure that it is not going to be easy for the world to achieve this future. We have to work to prevent the catastrophe of a cataclysmic nuclear war, and to find the ways in which world problems can be solved by peaceful and rational means. . . .

The time has now come for man's intellect to win out over the brutality, the insanity of war. ■

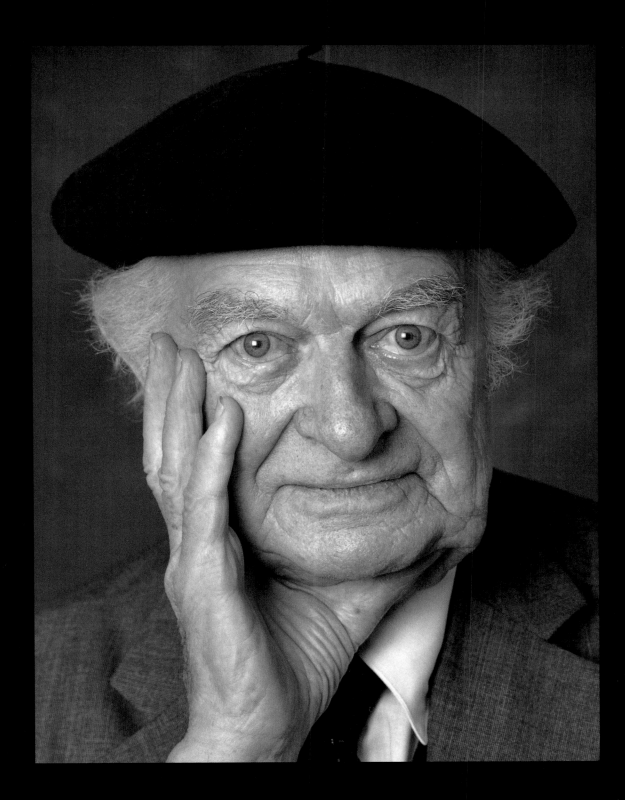

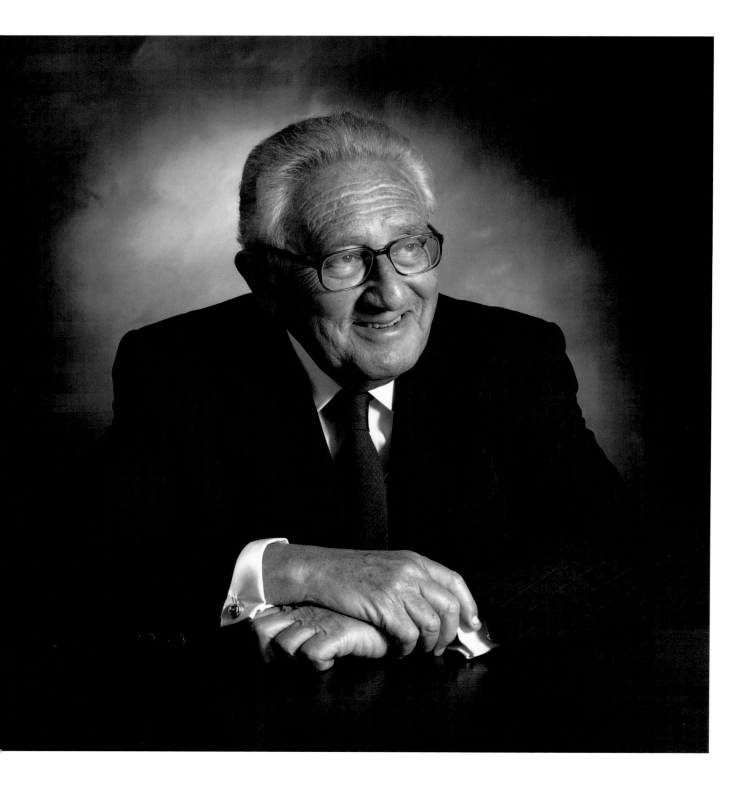

DR. HENRY A. KISSINGER

THE TOTALITARIAN HORRORS OF THE TWENTIETH CENTURY SHOULD have brought home to us the fragility of the restraints that embody civilization. The domestic experience of the United States—peaceful, stable, and content—inhibits our capacity to understand the vulnerabilities of other societies or international orders. Blessed by history and a benign environment, we are tempted to view our power as a dispensation and to use it to impose our preferences. Such an attitude runs the risk of being viewed as hegemonic by the rest of the world and will gradually be opposed by it. Excessive reliance on power and excessive insistence on our virtue may wind up corroding the very values in the name of which our policy is being conducted.

For this reason, I am made uneasy by foreign policies largely shaped by ideologues. For ideologues have a tendency to drive societies as well as international systems beyond their capacities. The alleged dichotomy of pragmatism and morality seems to me a misleading choice. Pragmatism without a moral element leads to random activism, brutality, or stagnation; moral conviction not tempered by a sense of reality leads to self-righteousness, fanaticism, and the erosion of all restraint. We must always be pragmatic about our national security. We cannot abandon national security in pursuit of virtue. But beyond this bedrock of all policy, our challenge is to advance our principles in a way that does not isolate us in the long run.

Each generation must discover that sense of proportion for itself. In that regard, the present generation, and even more its successors, encounter a special challenge. For we are living through not only an exceptional period of fluidity in international relations but through an even more profound upheaval in how publics and leaders view the world around them. In its scope and eventual impact, this intellectual change is comparable to, and probably exceeds, the consequences of the invention of the printing press five centuries ago.

The contemporary statesman is constantly seduced by tactics. The irony is that mastery of facts may lead to loss of understanding of the subject matter and, indeed, control over it. Foreign policy is in danger of turning into a subdivision of domestic politics instead of an adventure in shaping the future.

The problem of most previous periods was that purposes outran knowledge. The challenge of our period is the opposite: knowledge is far outrunning purposes. The task for the United States therefore is not only to reconcile its power and its morality but to temper its faith with wisdom. ■

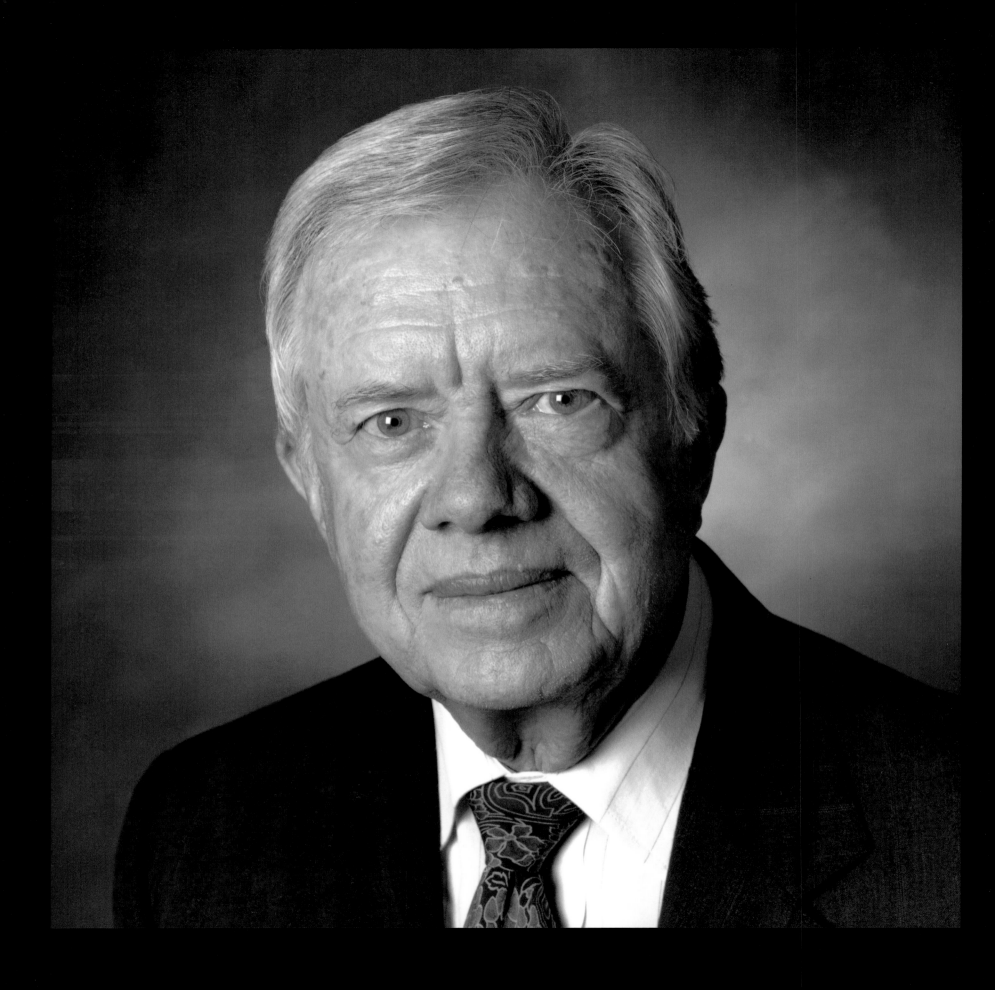

JIMMY CARTER

AFTER THE COLD WAR, MANY EXPECTED AN ERA OF UNPRECEDENTED peace and prosperity. For most Americans, this prediction has come true. Although our military has not been idle, since 1991 our country has been largely untouched by the ravages of war. And most of us—although not all—have a roof over our heads, access to jobs, and the opportunity to live healthy, productive lives.

But when we talk about prosperity, we are excluding more than 1.3 billion people in developing nations who live on less than one dollar per day. And let's consider just the most fundamental tenet of peace—the absence of war. At the nonprofit Carter Center, which my wife, Rosalynn, and I founded after leaving the White House, we monitor all serious conflicts in the world, and the sad reality is that the number of armed conflicts within countries increased dramatically. According to one estimate, more than 150,000 people—the majority of them civilians—lost their lives in 1997 alone. But these numbers don't begin to tell the whole story. That same year, some 20 million people were forced from their homes. And untold numbers suffered the indirect consequences of conflict, such as lack of health care and education, and emotional trauma—conditions that create an environment of fear and instability.

Although this has been the most violent century known to humankind, the world community pays little attention to many of the most destructive clashes. The United States and other industrialized nations focus mostly on those conflicts that directly affect them, such as those in Iraq, Bosnia, and Serbia. For example, while the war in Kosovo waged on and dominated the world's headlines, even more destructive conflicts in developing nations were systematically ignored by the United States and other powerful nations.

One can traverse Africa, from the Red Sea in the northeast to the southwestern Atlantic coast, and never set foot on peaceful territory. Fifty thousand people have recently perished in the war between Eritrea and Ethiopia, and almost two million have died during the seventeen-year conflict in neighboring Sudan. That war has spilled over into northern Uganda, whose troops have joined those from Rwanda to fight in the Democratic Republic of Congo (formerly Zaire). The other Congo (Brazzaville) is also ravaged by a civil war, and all attempts to bring peace to Angola have failed. Although formidable commitments

were made in the Balkans, where white Europeans were involved, no such concerted efforts are being made by leaders outside of Africa to resolve these and other disputes.

As long as these trends continue, there can be no peace and prosperity for a large percentage of the world's people. And while it is relatively easy to see and understand the direct impact of war on a people and a nation, it is more difficult to measure other factors that make for a peaceful and productive quality of life. At the Carter Center, we maintain that peace also includes the ability to feed one's family, the right to be free from preventable disease, the right to live without the fear of human rights abuses, and the right to determine one's own future. These are the seeds of peace.

All of these things require resources. In our travels, Rosalynn and I have witnessed the most appalling poverty and the results of religious, ethnic, and political persecution. These experiences have convinced me that the greatest challenge we face as a global community is how to reduce the growing disparity between rich and poor people.

Who are the rich? Rich people feel relatively safe in their own neighborhood, have adequate food and shelter, some education, and some expectation of gainful employment. They believe that there is an equal system of justice and think they can make decisions that will have a positive impact on their lives.

It is sobering that, even in the richest nation on earth, many do not enjoy these fruits of peace. This is even more evident in the developing world. At the beginning of this century, the ratio between per capita income between the richest and poorest nations was nine to one. By 1960, it had increased to thirty to one, and today it is more than sixty to one. Although capitalism and democracy are the best ways to promote these values, these systems are far from perfect. They can promote survival of the fittest—with serious consequences to the poor—if there is little social conscience or inadequate safety nets.

There is little doubt that most people, as individuals and as a society, want to lead lives that are satisfying, productive, and healthy. To make this possible, a nation or society must reach for justice. This includes providing for the basic human needs of both the rich and the poor. Until we meet this challenge as a global community, there can be no true and lasting peace. ∎

NADJA HALILBEGOVICH

SOMETIMES I TAKE MY DIARY AND READ THROUGH ITS PAGES; ITS white leaves unfold as gently as soft bandages revealing a scar of memories. Some of my memories are painful and dark. Some bring back the screams, sirens, and the dead bodies of innocent people on the streets. Some fill my eyes with tears and wound my soul with great pain. It hurts to read; my heart wants to leap out of my body, unwilling to experience all the horrifying things again. My diary was always far more than a notebook. It was my means to survive—to remain human and sane.

Today, by reading it, I strive to preserve the life I was surviving for. I was twelve years old when the war began. I was a cheerful and carefree girl when the bloody hands of war took my childhood away. Before the war, I lived happily with my dearest parents and brother. We were an upper-middle-class family, as were many others in Sarajevo. My mother was a business manager at the National Bank of Bosnia and Herzegovina. My father was a manager at a major book company. We had a beautiful fourteenth-floor apartment, a house in a village where we spent our weekends, a cottage and some land on the island of Brach on the Adriatic Sea, and two cars.

It saddens me to realize that most people know little about Bosnia. Bosnia and Herzegovina is a beautiful country located between Italy and Greece. The capital of my homeland is the beautiful city of Sarajevo. From the television news footage most people may picture my city with no electricity, water, gas, or food. Though we lived without these essentials during the war, before the war Sarajevo was as modern as any city in America. Surrounded by a gorgeous ring of mountains, Sarajevo hosted the 1984 Winter Olympics. It was truly an international place where people embraced every visitor, placing a Bosnian pie, a "Cevepi" meat roll, and a glass of pure mountain springwater in front of him. My dearest Sarajevo does not look like this today, but its spirit, its soul, and the hospitality and pride of its people have never failed. They will remain forever.

The war came quickly and suddenly. I remember the morning when I woke up and started getting ready for school. I entered our living room to find my parents' faces troubled and sad. They said I could

not go to school. Groups of armed men with sock masks had placed barricades throughout the city and blocked the streets.

Through the first few weeks of chaos and confusion, I believed that the craziness would soon be over and that everything would be just as it was before. I believed that the armed men would simply disappear. None of my hopes and wishes came true.

On May 31, 1992, I was frightened as never before. That day my trembling fingers opened the covers of an old notebook and I began writing my diary. I finally let my tears, frozen for so long, fall freely onto my face. I released emotions so long clutched inside. I realized that a prisoner of a city cannot remain a prisoner of his own mind and soul. The body can hurt and starve, but the mind and soul must be nourished.

Soon, we got used to living with the war. I know now that a human being can survive unimaginable conditions, because deep in the human soul lies an eternal desire to live, to be, and to become. I got accustomed to dragging water up the stairs to the fourteenth floor. I became used to not having the food we normally ate. I even found it normal to have grenades wake me up in the morning instead of the warm voice of my dearest mother. My family strove to make our lives easier, to make the sudden change a little softer. We planted vegetables on our balcony and were happy to decorate a dish of plain rice with a piece of lettuce or a slice of tomato.

My mother went to work even though she never got paid and had to walk twelve miles every day; with every step she was in danger of being killed by bombs or snipers. Countless mornings, I watched her brush her hair and put makeup on her pretty face, horrified by the thought of her getting killed. When, through my tears, I begged her not to go, she told me she couldn't stay home because the endless days would kill her.

My father was let go from his job because of our religion, so he volunteered for the Red Cross during the war. For a long time I could not comprehend the reason he was let go, as I never judged people by their religion. My family and I are believers of Islam. We believe in God solemnly, but we always embrace our friends and neighbors who are Christian, Jews, or Orthodox. I grew up with my father's saying: "One who doesn't respect the religion of others cannot respect one's own."

Being a child of peace, I never took a moment to think about everyday things that made my life so cheerful. I never thought what it would be like to wake up one morning and find them gone. The first things I was deprived of were school and my friends. Sometimes my friends from the building and I gathered in the basement with our teacher for a lesson. In the winter, each one of us would bring a piece of wood and try to warm up the little room with an old stove. Some mornings, when I got up only because I was so anxious to go to school and see my friends, the shelling would start and school would be canceled. My desire to learn in spite of everything never faded, so I often took out my books and studied on my own. I made a daily schedule and studied Bosnian, English, French, and math. I also practiced guitar and sang.

The war mercilessly stole four years of my life. Like every child would do, I acclimated to the new conditions of my life, forgetting what I had before. Every tear that stained my pillow at night, when all I could hear were sirens and grenades, was also a tear that mourned all the innocent citizens who lost their lives. I often felt sad because the war opened my eyes at such an early age. Even though I learned a great lesson, sometimes it hurt so bad that I wish I had never learned it. Only my dreams, so beautiful that they could resist all the ugliness of war, so invulnerable that no grenades ever harmed them, kept my head and my hopes bright and high. I realized that the soft and colorful paths of my dreams often intersected with the roads of cruel reality. That was when my dreams, my determination, and my faith were tested.

War taught me that every human being has a dark and bright side. It is our choice to fight the darker side and show our warm and beautiful feelings or to let ourselves be weak and hopeless, bitter and mean. I hope that the warm and brilliant colors of the morning dawn, the radiant light of midnight's stars on the sky of my dreams will always light up my soul with goodness and faith. I hope they will light the path of my existence with peace and righteousness. ∎

BIANCA JAGGER

THE UNITED STATES IS THE ONLY DEMOCRACY IN THE WESTERN world that continues to execute its citizens. It is ironic that a country that proclaims itself to be the world's most progressive force for human rights is the leading member of a far less distinguished circle of nations, whose claim to fame is that they execute people for crimes they committed as children. Saudi Arabia, Iran, Nigeria, Pakistan, and Yemen are the only other countries known to have executed juvenile offenders during the past decade, killing nine among them. The United States executed ten juvenile offenders in the 1990s, more than the rest of the world combined, and it is becoming increasingly isolated in this practice. Indeed, in 1994 Yemen abolished the execution of juveniles under age eighteen. Furthermore, China, which has the world's highest number of annual executions, has also abolished the death penalty for people who commit crimes as children.

Fifty years after the adoption of the Universal Declaration of Human Rights, with its vision of universal freedoms, more than half the countries in the world have abolished the death penalty in law and practice. The United Nations convention on the rights of the child in article 37(a) proscribes imposing the death penalty on persons for offenses they commit when still children. One hundred and ninety-two countries have ratified this human rights treaty, all except Somalia—a nearly collapsed state—and the United States.

More than 350 years have elapsed since the execution in 1642 of Thomas Graunger in Plymouth, Massachusetts. He was the first recorded person to be executed for offenses he committed at the age of sixteen. Although the methods of execution have changed, and some states would like us to believe their methods are more humane, nothing can mask the horror of a government taking the lives of its own children. It is a barbaric practice. More than 360 juvenile offenders have been executed since Thomas Graunger.

Since the reinstatement of the death penalty in 1976, the United States has proceeded in its wholesale expansion of state-sanctioned killing. According to the Death Penalty Information Center, sixteen people have been executed for crimes they committed when still children; this is in flagrant violation of international law, as well as evolving standards of humanity and decency. Currently the United States has the highest juvenile death row population in the world: sixty-nine. Sixty-four percent of them are minorities—black or Latino. In the first four months of 2000, the United States executed three people for crimes they committed when under age eighteen.

In 1988's *Thompson v. Oklahoma* ruling, the Supreme Court held that executions of offenders age fifteen and younger at the time of their crimes are unconstitutional. Yet individual states can set the minimum age below eighteen. According to Professor Streib at Ohio Northern University, of the thirty-eight states that allow the death penalty, fifteen set the age at eighteen, five at seventeen, and nineteen have a minimum age of sixteen.

For twenty years, I have campaigned for justice and human rights throughout the world, speaking on behalf of children's rights, women's rights, and victims of war crimes. I am a member of the executive director's leadership council of Amnesty International U.S.A. Four years ago, I received a call from their Chicago office to file a clemency petition for Guinevere Garcia, who was scheduled to be executed on January 17, 1996. Guinevere had withdrawn all her appeals. Her life had been scarred by violence; beginning at age six she had been sexually abused by her uncle. I moved to Chicago for a short while to work on her case with Amnesty International. I made a personal plea to Governor Edgar of Illinois to grant clemency to Guinevere and commute her sentence to life imprisonment without parole. Governor Edgar granted her clemency, stating that Guinevere's case was "not the kind of case I had in mind when I voted as a legislator to restore the death penalty and acted as governor to expand it. It also is not the kind of case that typically results in a death sentence in Illinois."

Since that time, I have spoken on behalf of many death row juveniles. On some of those cases, I worked with the Coalition to Abolish the Death Penalty's program called Stop Killing Kids. One case was that of Shareef Cousin, an innocent child sentenced to death in Louisiana at the age of sixteen. It took three long years before this miscarriage of justice was corrected. He was the eighth child sentenced to death in Louisiana. In each of these cases, the child facing execution was black. The death penalty has always been fraught with racial bias.

After Shareef, we have never been able to save another young person on death row. Sean Sellers, who suffered from a mental disorder and a

brain injury, was the first United States citizen in forty years to be executed for a crime committed at sixteen. His case illustrates the lack of meaningful appellate review. Sean was a compelling case for clemency, yet he was denied that relief. Clemency should be an essential part of our criminal justice system. It should be the state's mechanism by which to remedy legal errors and to recognize the extent of a person's growth, remorse, and rehabilitation. Sean met several of the humanitarian criteria. His execution only served to complete the cycle of violence.

Sean talked to me days before he was executed about the double standard of the legal system in the United States, which draws clear lines excluding juveniles from certain activities deemed appropriate only for adults. "In this country," he said, "a child of sixteen is barely old enough to drive, cannot vote or serve on a jury, cannot join the military. He is not allowed to purchase alcohol and cigarettes in most states until he reaches twenty-one."

Perhaps unsurprisingly, working with death penalty persons has changed my life. In many ways, it has brought me closer to God. I was very affected by the execution of Karla Faye Tucker. She was no longer a threat to society and was fully rehabilitated. When I met her at the Mountain View Prison near Austin, Texas, days before her execution by lethal injection, Karla was calm and ready to receive whatever God had in store for her. I will never forget the day she was executed. Hundreds of people clamored and celebrated outside the Huntsville, Texas, prison when it was announced she had lost her final appeal. When the loudspeaker declared that her execution had begun at 6:16 p.m., people cheered and applauded. It was an image reminiscent of public lynchings from the Middle Ages. I cannot understand how people can find pleasure in, or believe that civilized values are served by, the killing of another human being.

In spite of the merits of Sean Sellers's case, he received the ultimate penalty for his crime: death. I speak on behalf of Sean, and those like him, as a human rights advocate who recognizes that it is the human capacity for change and redemption that endows us all with the potential to become better people. Killing Sean, or killing Karla Faye Tucker, shuts out the light of redemption that exists in all of us. ∎

Dr. Mahbub ul-Haq

SIMPLY PUT, OUR CHALLENGE IS THIS—CAN WE MAKE THE twenty-first century a century of human development, when all people enjoy access to education and health, when each individual is enabled to utilize her or his full human potential, when all people have developed their basic capabilities and enjoy equal access to the opportunities of life? Now let us be clear. This is a vision of human competition, not state welfare. It is a vision of access to opportunities, not access to charity. It is a vision of the enrichment of human lives, not just the enrichment of national income or wealth, and the investment required to realize this vision is fairly modest.

We wish to move over the next fifteen years toward a society where there is universal basic education, primary health care for all, safe drinking water for all, adequate nutrition for all malnourished children, and family planning services for all willing couples. In other words, we wish to move toward a world society where basic social services are available to everyone, both men and women, and women before men; where the worst human deprivations curbing the potential of more than 1.3 billion people today have been finally overcome; where all essential ingredients for the full flowering of human potential are available in the form of adequate education, health, and nutrition. We wish to achieve all this.

What is the financial cost of achieving such a society? According to the best available estimates, the cost will be around an additional $34 billion a year—34 billion dollars. This cost is less than 1 percent of the total income if the poor nations bear all the burden themselves and this cost will be reduced to less than one-seventh of 1 percent of global income if the international community decides to share the cost along with the poor nations. That is the cost.

The question we face today is this: Can we persuade the leaders of the world to accept such a global compact for human development for the twenty-first century?

Let us again be very clear. Such a global compact is not yet another treaty requiring the formal approval of the governments of the world. It is, in fact, a shared vision of what the world can and must achieve. It requires global understanding, not a global treaty, because in the last analysis most action must begin at the national level, and often at the grassroots level, and such action must begin in the developing world itself.

These countries do not lack financial resources. What they lack is political courage. We need to ask the leaders of the Third World, and ask them bluntly, why they insist on spending $130 billion each year on the military when even a quarter of this expenditure can finance their entire essential social agenda. And we must ask them why they insist on having six soldiers for every one doctor when their people are dying of ordinary diseases, from internal disintegration, not from external aggression, from many threats to human security, not any threats to territorial security.

And we must also ask them why they are not convinced that everything they buy costs the immunization of four million children and every jet fighter they purchase costs the schooling of three million children and every submarine they store away in the waters denies safe drinking water to sixty million people. Why do we let them argue poverty of resources for human development when they have well-fed armies but unfed people and when many of these nations spend more on their armies every year than their total education and health budgets?

And at the same time, we must ask the leaders of the rich nations, why do you keep subsidizing your arms exports to poor lands when you argue against even food subsidies in these poor nations? Why is it that you refuse to close down your military bases, phase out your military assistance, and restrict the export of the sophisticated military weapons even now when the Cold War is over? What is your excuse? And why do you make such handsome profits on your exports of arms to poor, starved, disintegrating countries while giving them lectures all the time on respect for basic human rights? And we need to ask these leaders, why do they not invest in human development and instead make profits out of the future prosperity of poor lands and not out of the current state of human deprivation?

I believe, my friends, what we need to change is the mindset of our leaders in developing countries as well as in rich nations, because changes in policies will then follow and adequate resources for priority human development agendas will then be mobilized.

Let us spread the message to all world leaders that such a compact is not only desirable—it is eminently doable, it is feasible. And many years from now, we can look our grandchildren right in the eye and tell them quite proudly: "Yes, we tried." ■

GENERAL COLIN POWELL

IN 1780, DURING OUR STRUGGLE FOR INDEPENDENCE FROM Britain, patriot and future president John Adams wrote to his wife, Abigail: "I must study politics and war that my sons may have liberty to study mathematics and philosophy."

Today, more than two hundred years later, we still live in a world in which we must study politics and war. The good news is that we don't have to study war quite as much.

The century that just ended was the bloodiest ever recorded. Enormous sacrifices were required of our youth to preserve our free way of life. But because they were willing to make those sacrifices, our survival as a nation and as a free people is no longer threatened. Democracy and private enterprise, though not without their faults, have prevailed over the collectivist ideologies that threatened us with destruction.

So the world is a safer place. Many more of our young people have liberty to study mathematics and philosophy and the other arts of peace. But liberty is not quite the same thing as opportunity; the fact that young people are free to develop their abilities and talents in constructive ways does not necessarily mean that they will do so, unless they get help and support from adults.

For that reason, I decided that my next campaign after I retired from the army would be to take up the cause of the next generation. Currently, I chair a national crusade for young people called America's Promise—The Alliance for Youth. The mission of America's Promise is to endow our young people with the character and competence they need to be successful and contributing adult members of society.

We do this by keeping five basic promises to the youth of America. Every child and teenager needs:

An ongoing relationship with a caring adult—a parent, mentor, tutor, or coach;
A safe place with structured activities during nonschool hours;
A healthy start;
A marketable skill through effective education; and
An opportunity to give back through community service.

To keep these five promises, America's Promise is building a great national coalition of government, business, nonprofits, service groups, community activists, and people of faith. Working together, we are striving to give all our young people the opportunity to develop their full potential.

For thirty-five years of my life, I was committed to training young people for the day when they might have to risk their lives in defense of this country and the cause of freedom. Today, I am helping to train a slightly younger age group to prevail in a different struggle—a struggle against drugs, neglect, apathy, ignorance, irresponsible sex, and any other threats that might blight their lives and keep them from being all they were meant to be.

Winning the peace means more than defeating the enemies of freedom. It means seizing the great opportunity we have now to raise a generation that is strong and caring and capable enough to preserve peace and freedom in this new century. ■

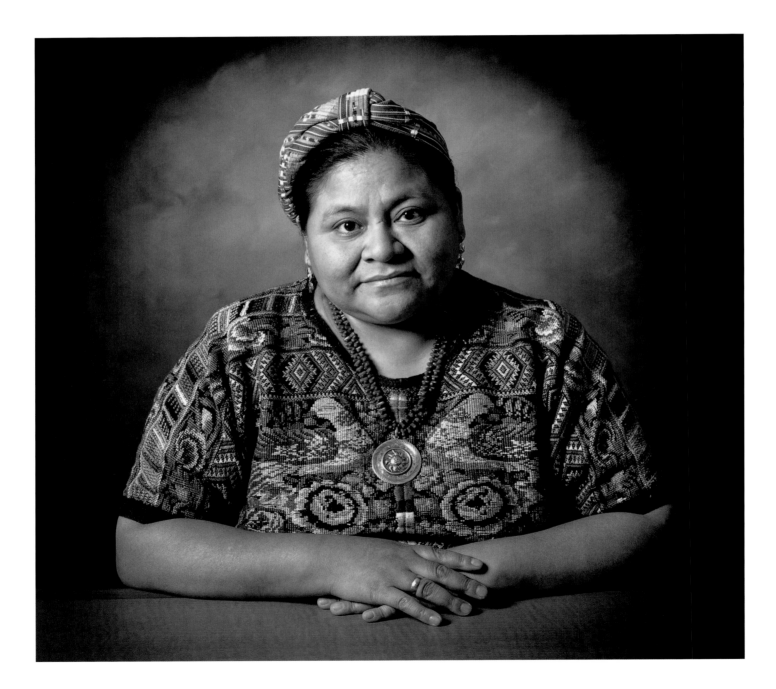

RIGOBERTA MENCHÚ TUM

IN EVERY CORNER OF THE GLOBE THE ANGUISHED CRIES FOR peace can be heard. Millions of people cry in silence, carrying on their shoulders the burden of our tragic, never-ending drive toward confrontation, conflict, and war. These same millions are also bearers of hope, of the unfulfilled quest for peace—a peace that will benefit us all by according dignity to all human beings.

This need for peace is universal. From north to south and east to west, each day, with increasing frequency, people are speaking of peace. In some it appears as a speech; in many it is a vague wish or hope; in so many more it manifests itself as the ever-present search by men and women, young and old, to attain humankind's most cherished principles. Yet despite this need, the utopia of peace continues to be little more than a distant point, barely visible on the horizon of our future, of our hope, of our vision.

For one of the threads that winds through the history of our peoples is, without a doubt, the recurring and chronic absence of peace. Be it because of greed, injustice, aggression, disrespect by some for the rights of others, or countless other reasons and causes, human beings, whole peoples, and countries have found themselves under attack— albeit in different ways in different places and times. War has been so prevalent that, if we add up all the armed conflicts and declared wars, we realize that throughout history humankind has blissfully enjoyed the silence of weapons for only a very short time.

Even so, the mere absence of armed conflict does not necessarily mean there is peace. Peace is not synonymous with the absence of war; it isn't just the silencing of weapons. For me, peace is a way of life, both for the individual and for all humankind; it is a form of coexistence among peoples, lands, and nations, the deeper meaning of which we might call mature human development, with total equality for everyone—men and women, children and adults. It is equal access to development for all nations and lands, so they may choose their own futures without anyone interfering and telling them what to do.

So peace is built on a collective basis; it is a utopia that daily grows stronger and more tangible. Everyone talks about it; everyone seems to want it. To build it, however, is a long, complicated, and difficult process, and peace cannot be without content. The absence of peace, and indeed all conflict, results from the terrible injustice that has characterized relations between countries, peoples, and cultures, between the ruling elite and the vast majority condemned to wretched poverty.

That is why building peace requires that we start by weaving a fabric out of the threads of equality, justice, participatory democracy, and respect for the rights of all peoples and cultures; we must establish intercultural relations that will promote harmonious coexistence through cultural pluralism.

Peace is not abstract; on the contrary, it must have profound social, political, economic, and cultural substance. Everyone's constant focus should be to fight for peace by helping to seek solutions to problems and to discover the causes of conflict. Peace, likewise, has profoundly ethical, human, and supportive substance.

I believe that peace is a condition, an essential requirement for the survival of humankind. For that reason, there must be an unshakable commitment, backed by the effort and contribution of everyone, to build a universal culture of peace sustained by a new code of ethics that incorporates the hopes and aspirations of all humankind as we face this new millennium:

There is no peace without justice;

There is no justice without fairness;

There is no fairness without development;

There is no development without democracy;

There is no democracy without respect for the identity and the dignity of all cultures and peoples.

I have said repeatedly that we must cross the threshold of this new millennium with the hope of those who have learned to resist, who have learned to build and dream of a brighter future—a future in which a sense of community and a respect for nature become parameters for coexistence, a future in which cultural and linguistic diversity is seen as the great wealth of humankind.

It is our deepest desire that this new millennium be based in equality, in justice at both the national and international levels, in the free self-determination of all peoples, and in a harmonious relationship with nature. Only then will it be possible to nurture sustainable development as well as an equitable distribution of wealth.

Thus will peace sustain itself. ■

INGRID WASHINAWATOK EL-ISSA

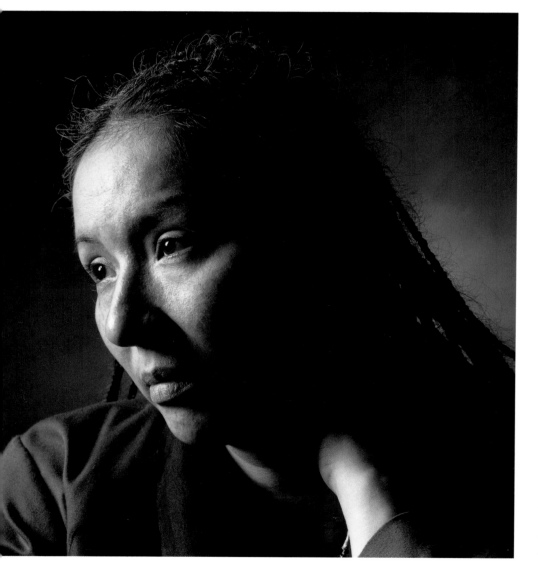

THE ROOTS OF WAR AND VIOLENCE GO DEEP, INTO THE EARTH herself. As an indigenous woman, I wish to simply state that until we make peace with earth, there will be no peace in the human community. Please allow me to explain.

As native peoples of the hemisphere, we have historically been the victims of violence and continue to be plagued by injustice and inequality. In our history we have had to go to war to protect our lands, as peace would simply mean our enslavement and extermination. And every course of action we sought—whether accommodation or resistance—had only one outcome, the theft of our lands. All this is well known.

What is not clearly understood is that all this was ostensibly done for our good, and the good of humanity. The underlying justification for the theft of our lands has always been that we were not making proper use of them, and that these lands could be put to better use. The wilderness that we cultivated and maintained was simply going to waste. It was selfish of us to padlock our vast forests and plains and deprive millions of hungry and millions of landless from their enjoyment. It was argued that stealing our land would provide for the common good of the world and all would become better off as a result. And of course during this process, we would be lifted from our less-than-civilized state and would eventually recognize the goodwill that had been lavished upon us.

Today, most of our lands and most of the wilderness are gone and yet there are more poor people than ever, more misery, more landlessness. And today there are those who still argue that tearing down the remaining stretches of lands benefits humanity, or in today's jargon, "creates jobs."

As we look upon the increasingly despoiled planet, we can only ask the question: "Has our land indeed been put to better use?" Could there have been another way?

Not only could there have been another way, there *must* be another way. Destroying natural resources, destroying the planet's ability to provide sustenance, only aggravates the world's misery and poverty, the

injustice and discontent. This is because, like everything, ultimately, the wealth of the world comes from the earth. We may fashion this wealth and remake it to perform marvelous things, but a barren planet does not create jobs, and wars for food and water could become a terrible epitaph for the human species. As we destroy the ability of the earth to sustain us, we lose our ability to address the chronic needs of the poor, the hungry, and the landless.

The current economic order—based upon an ideology that does not recognize the wealth of the natural order, that cannot place value on anything unless it is sold in the marketplace, that enshrines greed and avarice as the engines of development—is destroying the real wealth of the planet. While it pretends to create jobs and products, in reality, it is similar to burning furniture to provide heat: every bit of flame, like many of our jobs, is actually impoverishing humanity, not enriching it. For the longest time, only Indians and other natural peoples cried out against the war against nature. Today, we are allied with many environmental groups. Yet, still, the understanding of how we must fundamentally change the way we think about the planet is only now beginning to become a subject of discussion.

There are many definitions of sustainable development, and the word has become overused and almost meaningless. Moreover, it rings hollow unless the efforts of humankind are centered toward rebuilding the planet.

Indigenous peoples have long understood sustainable development. The wilderness that we inhabit is wilderness only to those who cannot grasp the complexity of our agricultural systems, which regenerate and produce in ways that work in accordance to natural laws—not against them. For this reason, our agriculture has existed with only little impact on the earth, for hundreds, if not thousands, of years—all the while producing for the needs of our people.

Among the technologies we use to produce in harmony with this earth are products such as corn developed and cultivated in this hemisphere. Corn is truly a product of our technology: it cannot live without people, just like our people could not live without corn. For this reason it was central in our spiritual and cultural existence. It was also developed in infinite varieties that were each adapted to the particular environment where it would have to exist, so that they would best fit in with the other life. And so it was designed to feed the maximum number of people with the minimum impact on the environment, and people lived close to their corn, their way of life.

Compare this to the new, genetically engineered varieties of corn, which require the habitat to be similarly engineered, and thus require tremendous inputs of pesticides, chemical fertilizers, and other agents that so change the environment and are so mechanized that people no longer live on the land and are forced to the cities. If one measures the yield, yes, it produces more corn per acre than Indian corn, but it is not sustainable and the chemicals eventually poison the land.

The true cost of working against nature is never factored into this equation, only how much money a bushel of corn brings. But the true environmental and social costs of this process far exceed the benefits for humanity, and in the end impoverish the planet further.

Yet, so often the world believes that some technological marvel will prevail and make things right. There is little consideration that maybe it is these technical marvels that are part of the problem. Development must take the path not of mitigating its impact on the environment but of enhancing the natural environment.

Instead of environmental impact statements for development, we need environmental enhancement statements. Rather than destroying the means of sustenance that this planet brings us, we need to increase it; the poverty and hunger of much of the world demand it.

We need a peace with earth. We must have it. We cannot pretend to have long-term sustainable development without it, for the very foundation of this development *is* a peace with earth. Our philosophy of development must be guided by the natural laws that have guided all living things, not some arbitrary, man-made illusion.

We indigenous people believe that development with a different focus would enrich the planet and, in so doing, alleviate some of the discontent and anger that surfaces as war and violence.

Yet for so long, indigenous peoples from across the globe have been unable to speak, to contribute to the solutions of the problems facing humanity. Many of us are ancient peoples; indeed many of our cultures are your elders, and yet you never turn to us for our opinion, even when the issues affect us directly.

As our cultures disappear with the wilderness that sustained us, we are a vast library, a repository of knowledge, intelligence, and an understanding of the earth that is being lost to the world. But we continue to be victimized and ignored. If we seek to embark on the elusive search for peace, we must first unlock the silence of our peoples, and other peoples like us. Ultimate peace lies in all of us working together, to make things better for future generations. Unlock the silence, let us speak to the world. ■

Ingrid Washinawatok (Flying Eagle Woman) had a contagious laugh and was full of life. The last time I saw her, she was telling me about how proud she was of her son. Within a few months, she was kidnapped and later murdered in the mountains of Colombia by leftist guerillas while on a mission to help the indigenous U'wa people.—M.C.

THEO COLBURN

OF ALL NATURE'S MASTERPIECES, THE NEWBORN, WHETHER FISH, bird, mammal, or human, is surely the most exquisite. This wondrous creature is testimony to the peace and harmony that existed in the womb, or the egg, prior to its entering the world. For centuries, humankind considered the womb environment sacred, free of violence and trespass. In that prenatal environment, with unbelievable precision, cells replicate, move about, and form buds and limbs and brains and sensory and reproductive organs, contributing to the most miraculous phenomenon on earth. From the moment the sperm enters the egg, embryonic development is orchestrated by the endocrine system using chemical messengers called hormones. With symphonic precision and harmony, constantly shifting hormonal blends instruct cells when to divide and where to move. Like the music from a grand organ, the tunes of these hormonal chords direct the formation of tissues and flesh, and even tell tissues when to die back after the tissue is no longer needed.

And now, within the past decade, chemists have been able to measure the infinitesimally small concentrations of hormones that conduct development from conception through birth. The endocrine system is so fine-tuned that it depends upon hormones in concentrations as little as a tenth of a trillionth of a gram to control the womb environment, as inconspicuous as one second in 3,169 centuries. The endocrine system also controls reproduction and thus assured the integrity and survival of species since life first evolved on earth—until humankind unwittingly produced synthetic chemicals that invade the security of the womb and create dissonance rather than harmony.

Peace begins in the womb. The newborn reflects this truth. Order is transferred from cell to tissue, to organs, to organisms, to families, communities, and nations. Unfortunately, when development is violated in the womb by man-made chemicals, the newborn is compromised. For animals in the wild, their survival is threatened. They can disappear without our ever knowing why. For humans, such exposure can lead to reduced intelligence, discontent, failure, and the inability to socially integrate. Man-made chemicals deprive societies of responsible leaders and thinkers. The social and economic impacts are incalculable. Widespread loss of security in the womb can lead to loss of stability at the national and international level.

Humans in their race to space have diverted attention and limited resources away from learning about the workings of the inner world from which life evolves. As we have searched in outer space, we seem to have forgotten the inner space, from which all humankind emerges. The thirst to learn more about the solar system than the system in which we all resided prior to birth has left humankind vulnerable. The same technology that made space exploration possible and created modern society has led to production of chemicals that invade the womb. In our ignorance we assumed that the womb was inviolable, while at the same time we produced more and more synthetic chemicals to improve the quality of our lives. We also assumed that since these man-made products did not rapidly induce cancer, they were safe. We also thought that the lakes, oceans, soil, and atmosphere would assimilate infinite amounts of waste from the new technologies.

Disregard for the environment has been rampant on a global scale. Now, as we begin the twenty-first century, we are suddenly faced with the realization that wherever we have destroyed the environment, we have left behind desperation, hunger, fear, and strife. To this we must add another legacy of the chemical industry: the invasion of the inner environment of all animals on earth, including humans. From the Arctic to the Antarctic, man-made chemicals are found in all animal tissue. No longer is the offspring secure in the womb. No child born today is free of man-made chemicals. Mothers share these chemicals through their blood with the babies developing in their wombs. There are no cures for a child whose vital physiological, immunological, and neurological systems did not develop normally. When society takes heed and spends more on infrastructures for prevention than on remediation and healing, stability and integrity can be restored in the womb. Nations of the world must unite with a single purpose to restore peace in the inner world, assuring every newborn the opportunity to reach his or her fullest potential. ■

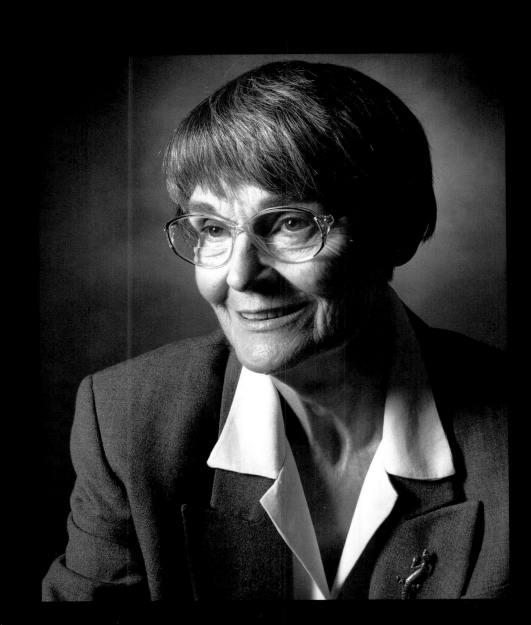

GEOFFREY CANADA

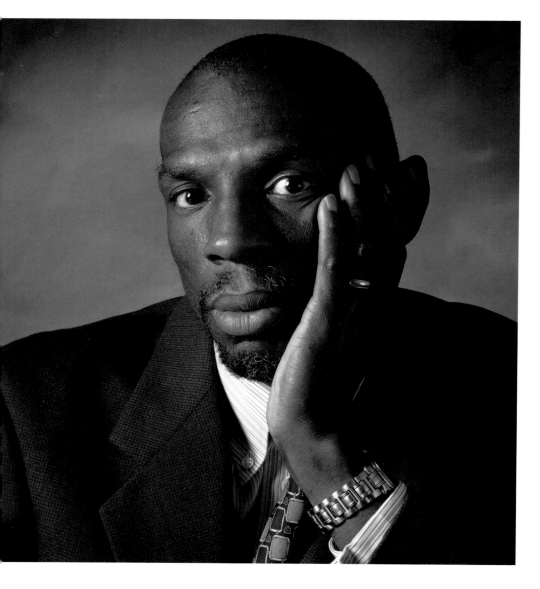

I STAND IN FRONT OF [MY MARTIAL ARTS CLASS], LOOKING unhappy and displeased. Everyone wonders who is out of place or not standing up straight. This is part of my act. Finally I begin class and then I'm lost in the teaching. I'm trying to bring magic into the lives of these kids. To bring a sense of wonder and amazement. I can feel the students losing themselves and focusing on me. They are finally mine. I have them all to myself. I have crowded all the bad things out of their minds. The test they failed, the father who won't come by to see them, the dinner that won't be on the stove when they get home. I've pushed it all away by force of will and magic.

This is my time and I know all the tricks. I yell, I scream, I fly through the air with the greatest of ease. I take my black belt students and I slam them on the floor and they pop up like those weighted wee-ble dolls that can't stay down. I throw them through the air as if they were feathers, and they land and roll and are back up unhurt and unafraid. The new students can't believe their eyes. And they begin to believe in magic again.

And by the time the class is ending their eyes are wide with amaze-ment and respect, and they look at me differently. And I line them up and I talk to them. I talk to them about values, about violence, about hope. I try to build within each one a reservoir of strength that they can draw from as they face the countless tribulations small and large that poor children face every day. And I try to convince each one that I know their true value, their worth as human beings, their special gift that God gave to them. And I hope they will make it to the next class with something left in that reservoir for me to add to week by week. It is from that reservoir that they will draw the strength to resist the drugs, the guns, the violence.

When class ends I dress, and now things are different. I speak to everyone. Students come up to shake hands and we bow in greeting. I am back to being Geoff to them, their friend. As a group of us walk up 108th Street together I scan the street for signs of danger. This, after all, is a neighborhood where more than ten adolescents have been killed

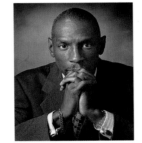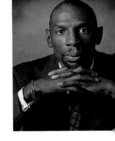

by guns this year alone. I call one of the youngest students over to me. He is only five and comes to class with his older brother. I see that his jacket is open and I stoop down to zip it up.

The jacket is old and beat-up, probably belonged to his brother last year. The zipper is broken. He believes I can fix it. Why not? After watching me in class he believes that I can do anything. His face is filled with anticipation. It's cold outside and the long blocks he has to walk in the cold will seem shorter if I fix his jacket. I try to fix the zipper. I can't. Instead, I show him how to use one hand to hold his jacket closed close around his neck. I readjust his hand several times so he understands that there is a certain way to do it that meets with my approval. This is also part of the act—all of the attention to detail keeps him from feeling ashamed. I notice his nose is running and take out the package of tissues that I keep in my pocket for just this purpose and wipe his nose. He doesn't object like most five-year-olds. He loves the care and concern. As I watch him cross the street with his brothers and friends, holding his jacket closed with his hand, the spell is broken for me. No more magic. Just little five-year-olds in raggedy jackets that won't close, trying to stay warm on a cold night. I scribble a note to myself to remember to find a way to get some jackets. Winter is coming.

My two black belts usually walk with me after class and stay with me until I catch a cab. I tell them it's not necessary, but they are there to make sure I get home all right. What a world. So dangerous that children feel that a third-degree black belt needs an escort to get home safely. The sad thing is, with all the guns and drugs in this community, they know I'm no safer than anyone else.

This community, like many across this country, is not safe for children and they usually walk home at night filled with fear and apprehension. But when I walk with them after class they are carefree, like children ought to be. They have no fear. They believe that if anything happens they'll be safe because I'm there. I'll fly through the air and with my magic karate I'll dispatch whatever evil threatens them. When these children see me standing on the corner watching them walk into their

buildings they believe what children used to believe, that there are adults who can protect them. And because of that belief they see me as larger than life, like Superman or Batman. And I let them believe this even if my older black belts and I know different. Because in a world that is so cold and so harsh, children need heroes. Heroes give hope, and if these children have no hope they will have no future. And so I play the role of hero for them even if I have to resort to cheap tricks and theatrics.

And if I could get the mayors, and the governors, and the president to look into the eyes of the five-year-olds of this nation, dressed in old raggedy clothes, whose zippers are broken but whose dreams are still alive, they would know what I know—that children need people to fight for them. To stand with them on the most dangerous streets, in the dirtiest hallways, in their darkest hours. We as a country have been too willing to take from our weakest when times get hard. People who allow this to happen must be educated, must be challenged, must be turned around.

If we are to save our children then we must become people they will look up to. Children need heroes now more than ever because the poor children of this nation live with monsters every day. Monsters deprive them of heat in the winter, they don't fix their sinks and toilets, they let garbage pile up in their hallways, they kick them out of their homes, they beat them, shoot them, stab them—sometimes to death—they rape their bodies and their minds. Sometimes they lurk under the stairs. They scuttle around in the dark; you hear them in the walls gnawing, squeaking, occasionally biting a little finger.

We have failed our children. They live in a world where danger lurks all around them and their playgrounds are filled with broken glass, crack vials, and sudden death. And the stuff of our nightmares when we were children is the common reality for children today. Monsters are out there and claiming children in record numbers. And so we must stand up and be visible heroes, fighting for our children. I want people to understand the crisis that our children face and I want people to act. ■

HAFSAT ABIOLA

My country, Nigeria, is home to 120 million people—one fifth of continental Africa's population—who come from more than two hundred ethnic groups. Each group has its unique way of being, of relating to others, and of contributing. My group is the Yoruba. We are generally found in western Nigeria and are famous for our arts, clothing, and music. I love being Yoruba, Nigerian, and African because I come from a rich heritage and yet, because so much needs doing in my home, I know I will be kept busy.

Of all the things that serve my growth, I love best the stories and myths told to me by my parents and the Nigerian people I meet. My thoughts on peace begin with a story my dad told when he was campaigning in Nigeria's 1993 presidential election:

> Sometimes a village is beset with problems—disease, famine, conflict, and floods. All these problems come at once and despite all the best efforts of members of the community, the problems are immune to solutions. In such a situation, the village believes they may have done something to upset the gods, so they will gather all their best possessions together to offer as gifts to the gods. They then ask one of their best sons to present the gifts on their behalf. When the gods are presented with the gifts, they may become pacified and allow peace and prosperity to reign in the land. But sometimes, they are so angry they will take the best son, as well as the gifts, after which they are pacified and allow peace and prosperity to reign.

From this story, I took the lesson that peace comes from contributing the best we have, and, often, all that we are, toward creating a world that supports everyone.

In much of precolonial Nigeria, and indeed Africa, ethnic nations organized people within communities into peer groups and trained them, from babyhood to old age, to serve their communities. When successful, this system provided all members of a community not only with a sense of belonging but also with a vehicle for helping to shape the community's direction and pace of change. In this system, people knew they were entitled to help resolve any issue that affected the community.

This sense of entitlement grows out of a series of rituals that begin the day a child is born. When a baby is born, after the first few seconds, it lets out a yelp, which announces its arrival, and which is met by expressions of joy. Among the Yoruba, the arrival is acknowledged with a naming ceremony where parents give names that express rich meaning and hopes for the baby. When I arrived, my parents named me Hafsat Olaronke, which means *the treasured one* and *honor is being cared for*. For my parents, they saw in me one who would be cherished and who would bring honor to her community. Many in other parts of the world are impressed when they discover my name's meanings, but the truth is that most African names have beautiful meanings.

Mark Nepo, an American poet, narrates the story of the Khoisan, a nomadic people found in southern Africa. According to Nepo, when a Khoisan returns from a journey and meets another from his community, he raises his hand and says, "I am here," and the other replies, "I see you." These practices are more than simple greetings; they affirm our belonging to the community and our right to contribute.

Nigeria is a place beset with problems, and all its members are needed if we are to meet the challenges we face. Unfortunately, until very recently, my country was controlled by a series of military governments who denied most Nigerians the right to make their contributions. Even in the period since the military relinquished power to a democratically elected government, many exclusionary attitudes—from class to ethnic and religious divisions—as well as a general lack of trust or sense of community, have effectively denied most people the freedom to engage with their country's challenges.

And yet, despite the obstacles, both individuals and groups are constantly announcing their presence, or asking the questions, Do I belong? Can I contribute? Am I accepted? Their queries are rarely met by affirmative or empowering replies. Instead they hear jeers, or expressions of disinterest, or obnoxious interrogations: "*Who* asks? *What* community? What have *you* ever done anyway?" Nothing about this process is enlightening, just humiliating.

This is because, unlike the small community, where every person lives in the illusion of having the same ideals, beliefs, and values as everyone else, in the larger context of plural communities—be it in

country, continent, or globe—we live in the illusion of absolute differ-
ence. So, fearing the possibility that the interaction will change us, we
magnify the threat involved in engaging with that which differs from
us. Change is stressful, and costly, because it requires learning to navi-
gate the unfamiliar. In the end, you cannot work with *anyone* who is
different, and problems that could be resolved if we allowed everyone
to contribute the best of themselves begin to look intractable.

The Persian poet Jalaludin Rumi wrote: "Out beyond ideas of
right and wrong doing there is a field. I will meet you there." If there
is to be space for us to speak into, we need to learn also to listen. We
are the creators of this space. We must each take responsibility for
examining our values, ideals, and beliefs and for learning to under-
stand those held by others, enough so that we can help them and our-
selves consider new possibilities.

In the end of my dad's story, he said that poverty, violent conflict,
malnutrition, and disease were all increasing across Nigeria. And he
asked to be able to bear our country's gifts, in order to secure for us
peace and prosperity. He won the election but served out his term in
solitary confinement, incarcerated by the military, and died on the eve
of his release in 1998. But here was the difference he made: across eth-
nic, religious, and class divides, the people said *yes!*

This search for validation is universal. It is beautiful when these
inquiries meet with affirmation, because it allows a person to stride
forward with all he has to give. There is a story told by the conductor
of the Boston Philharmonic Orchestra, Ben Zander: a maestro con-
ductor, after having conducted a brilliant symphony, races out of
the concert hall and into a waiting car, imperiously commanding the
driver, "Drive!" When the driver asks, "Where to?" the conductor
boldly responds, "Anywhere! The world needs me!"

Peace comes from being able to contribute the best that we have,
and all that we are, toward creating a world that supports everyone.
But it is *also* securing the space for others to contribute the best that
they have and all that *they* are. In case you are still wondering—no, it
was not a wrong turn that brought you here. You *do* belong here and
there *is* a contribution uniquely yours that is needed. Welcome and
good luck. ■

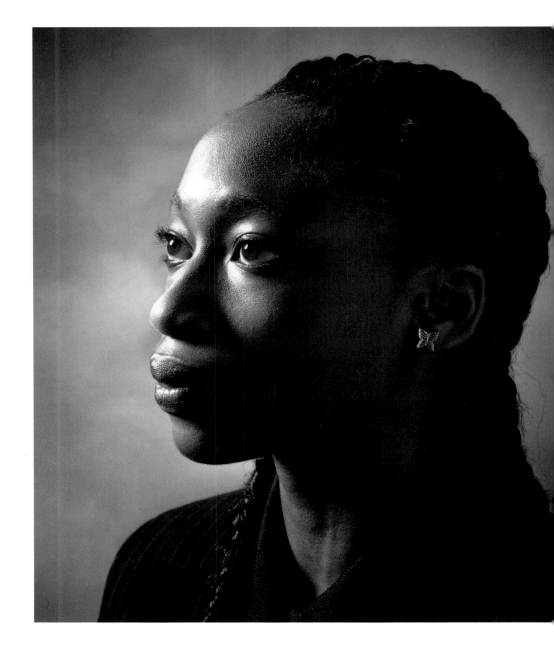

Reverend Benjamin Weir

There was only darkness. The blindfold over my eyes completely blocked out the light. I was lying on my back on a low bed. The unforgettable sound of adhesive tape being unwound from its roll filled the room. Strong hands wrapped this wide packing tape around my head, over my forehead, eyes, and mouth, and around my neck. Only a small space over my nostrils was left open.

Next, my arms and hands were held close to my sides, and the tape was wound slowly around my whole body, starting with the legs and moving up past my shoulders. I was being totally encased. Someone forced me into a sitting position, and another layer of tape was wound around my neck, under my chin, and over the top of my head. I was a hostage bound.

Arms lifted me from the bed and carried me out. My body was pushed into a long narrow container. I heard a lid being closed and bolted over me. I could feel solid metal through my shoeless feet. I raised my head a few inches and struck a solid metal top. I moved my hips from side to side as best I could and found metal on either side. I lay there like a corpse in a coffin. . . .

Life is divinely given. Each person is to be respected and deserves to be heard. The captors themselves need to be set free. We are all recipients of God's mercy and forgiveness. On that basis we can begin to trust each other and find the constructive things we can do together as Muslims and Christians.

While we become advocates for the homeless, the unemployed, the disenfranchised, and the discouraged within our own borders, we are called to look beyond our own society to the world and its needs. Faith lets you know that you can't just stand back and say, *I'm not here*, hoping the trouble will go away. We must learn to live together. ■

This portrait was taken on Good Friday. As evidenced by the yellow ribbon on his lapel, several hostages remained in Beirut, Lebanon, where Reverend Weir had been held for sixteen months. There was clearly a weight on his shoulders, but he also showed a tremendous faith that God would provide a peaceful solution in the end.—M.C.

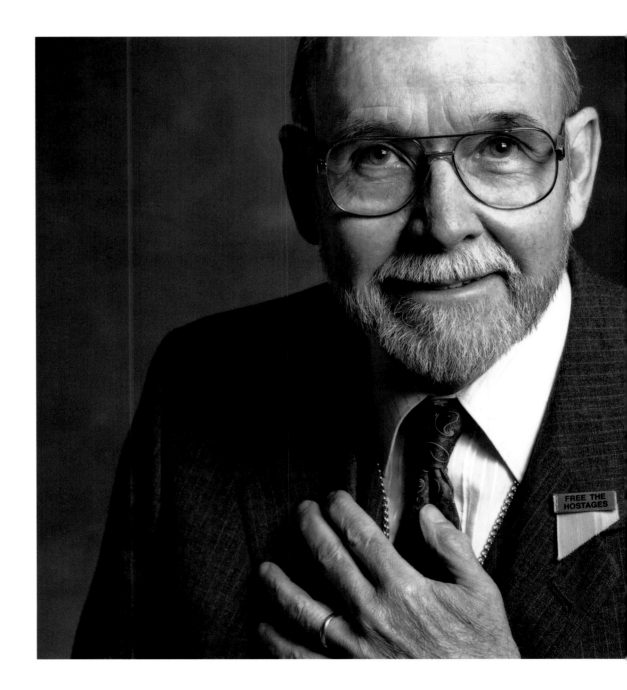

WEI JINGSHENG

DIFFERENCES BETWEEN CULTURES ARE EASY ENOUGH TO SEE. BUT I think the similarities are far greater and more important. No matter which culture they belong to, mothers everywhere love their children. Around the world, you, me, our families—we all feel love in the same way. If we are in a fight and get hurt, we all cry. We all feel pain in the same way. We all feel sorrow, anger, and disillusionment in the same way. We all hunger in the same way. And we all dream of freedom in the same way.

We need to pay attention to the true differences to make sure that those differences are not in actuality *discrepancies:* everyone around the world must be given the same rights and privileges.

Opening China to the world has dramatically affected the movement for democracy. The process of opening up is a process whereby the government loosens its control of the people. On the other hand, simply opening the economy is not enough. Very few people are actually able to enjoy the economic reforms. The privileged classes, or those who have connections with the privileged classes, enjoy more benefits from an open policy.

There are a billion people in China, and the majority of them do not enjoy the prosperity proclaimed by the media. Even according to official statistics from China, only one or two million people have personal wealth over one million yuan. Those few people, of course, are very comfortable. But China is a much bigger country than that. The majority of people in China are not content.

People ask me if I am discouraged that the Chinese democracy movement seems to have fallen off the media's radar screen. Believe it or not, I am not. China's democracy movement has matured since 1989, when it was mostly students. Today there are more workers and farmers involved in the movement; there are more ordinary people. But the government is also putting much more pressure on people involved in the democracy movement because more are involved. The kind of demonstration that happened in Tiananmen Square in 1989 is nearly impossible today.

In 1979 I was one of a number of people ready to voice their hope for a democratic China. The day after I issued my essay on the fifth modernization in China, thirteen people knocked on my door and asked me to organize a small group. This meant a great risk at the time. You had to risk your life. You faced a death sentence. So I asked those thirteen people if they were ready to make that decision. Only four of them were. Together we published the magazine *Exploration*.

I was first imprisoned in China for fifteen years. I later received another long sentence but served only three years before being released in 1997 thanks to diplomatic efforts on my behalf. During those first fifteen years, I knew nothing of the outside world. But I always believed that there were people who would struggle for me—that they would struggle for justice, and that justice would win over evil. And what happened to me tells me that my faith in people was right. I have a great belief in a better world.

Today, the first thing we must do is, of course, keep pressure on the Communist government. We need to call on the people who support democracy within the government. We need to call upon the strength of the poorest people in China. And we need to use the influence of foreign countries. We need to pressure the Communist Party the same way you try to get a child who doesn't want to study to study. You have to press him to do the right thing.

In a society where reason has no place—but force does—the army always has great influence over government. The Chinese army influences many aspects of Chinese society. Ordinary officers and soldiers, like ordinary Chinese people, also want more equal rights. They have had their voice heard. But of course there are also many corrupt officers in the army who favor a corrupt government.

I began expressing my hope for a democratic China in 1978. In the past twenty-two years, more and more Chinese people have come to agree with me. Tiananmen Square demonstrated that our people are willing to make enormous sacrifices for their country's democracy. The minority of people who do not know, or do not want to know, about democracy will not negate the desire of the people.

We must never forget that the dictatorship of Mao Zedong itself made it possible for the people to realize that no authoritarian government is good. Only democracy is good for the people. ■

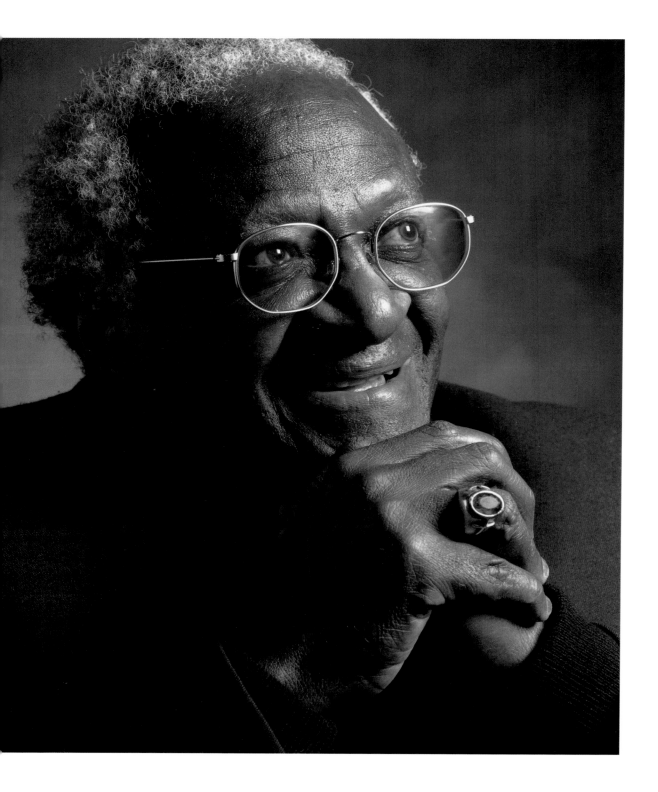

ARCHBISHOP DESMOND TUTU

WHEN I WAS A BOY IN SOUTH AFRICA, THOUSANDS OF BLACKS were arrested daily under the iniquitous pass-law system, which severely curtailed our freedom of movement. As a black person over the age of sixteen you had to carry a pass. It was an offense not to have it on your person when a police officer accosted you and demanded to see it. I remember vividly, when I would accompany my schoolteacher father to town, how sorry I felt for him when he was almost invariably stopped. Now there was something funny for you: Because my father was an educated man, he qualified for what was called an *exemption.* Ordinary pass laws did not apply to him in that he had the privilege denied to other blacks of being able to purchase the white man's liquor without running the risk of being arrested. But for the police to know he was exempted, he had to carry his superior document. His exemption, therefore, did not spare him the humiliation of being stopped and asked peremptorily and rudely to produce it in the street. This kind of treatment gnawed away at your very vitals.

Years later, after I was grown and married, and my wife, Leah, and our children returned from England, where I had gone to study theology, I faced an exquisite irony. My family was having a picnic on the beach. The portion of the beach reserved for blacks was the least attractive, with rocks lying around. Not far away was a playground, and our youngest, who was born in England, said, "Daddy, I want to go on the swings," and I said with a hollow voice and a dead weight in the pit of my stomach, "No, darling, you can't go." What do you say, how do you feel, when your baby says, "But Daddy, there are other children playing there?" How do you tell your little darling that she cannot go because though she is a child, she is not that kind of child. And you died many times and were not able to look your child in the eyes because you felt so dehumanized, so humiliated, so diminished. I probably felt as my father felt when he was diminished in the eyes of his young son.

When I became archbishop of Cape Town in 1986, I set myself three goals. Two had to do with the inner workings of the Anglican Church. The third was the liberation of all our people, black and white. That was achieved on April 27, 1994, when Nelson Mandela became South Africa's first democratically elected president. The world probably came to a standstill on May 10, the day of his inauguration. If it did not stand still then, it ought to have, because nearly all the world's heads of state and other leaders were milling around in Pretoria.

A poignant moment that day came when Mandela arrived with his elder daughter as his companion, and the various heads of the security forces, the police, and the correctional services strode to his car, saluted him, and then escorted him as head of state. It was poignant because only a few years earlier he had been their prisoner. What an extraordinary turnaround! President Mandela invited his white jailer to attend his inauguration as an honored guest, the first of many gestures he would make in his spectacular way, showing his breathtaking magnanimity and willingness to forgive. This man, who had been vilified and hunted down as a dangerous fugitive and incarcerated for nearly three decades, would soon be transformed into the embodiment of forgiveness. He would be a potent agent for the reconciliation he would urge his compatriots to work for, and which would form part of the Truth and Reconciliation Commission he would appoint to deal with our country's past.

Since that day, our nation has sought in various ways to rehabilitate and affirm the dignity and personhood of those who for so long have been silenced, have been turned into anonymous, marginalized ones. I have been privileged to be involved in the rehabilitation effort through the Truth and Reconciliation Commission, to which the president appointed me and sixteen others in September 1995. It was the commission's goal to reach out to as many South Africans as possible, offering amnesty to all, both those who had been victims and those who had been perpetrators during apartheid's long reign. Our slogan was: The truth hurts, but silence kills. Our aim was to engage all South Africans in the work of the commission, ensuring that all would have the chance to be part of any serious and viable proposal for healing and reconciliation.

At first we feared that few would come forward, but we need not have worried. We ended up obtaining more than twenty thousand statements. People had been bottled up for so long that when the chance came for them to tell their stories, the floodgates opened. I never ceased to marvel, after these people had told their nightmarish tales, that they looked so ordinary. They laughed, they conversed, they went about their daily lives looking to all the world to be normal, whole persons with not a single concern in the world. And then you heard their stories and wondered how they had survived for so long carrying such a heavy burden of grief and anguish so quietly, so unobtrusively, with dignity and simplicity. How much we owe them can never be computed.

The hearings were particularly rough on the interpreters, because they had to speak in the first person, at one time telling a victim's story and at another telling a perpetrator's. "They undressed me. They opened a drawer and then they stuffed my breast in the drawer, which they slammed repeatedly on my nipple until a white stuff oozed. We

abducted him and gave him drugged coffee and then I shot him in the head. We then burned his body . . ." It could be rough as they switched identities in this fashion. Even those physically distant from the testimony were deeply affected. The head of our transcription service told me that one day, as she was typing the manuscripts of the hearings, she did not know she was crying until she saw the tears on her arms.

In January 1997, while still sitting on the commission, I learned that I had prostate cancer. It probably would have happened whatever I had been doing. But it seemed to demonstrate that we were engaging in something costly. Forgiveness and reconciliation were not to be entered into lightly, facilely. My illness seemed to dramatize the fact that it is a costly business to try to heal a wounded and traumatized people and that those engaging in this crucial task may bear the brunt themselves. It may be that we have been a great deal more like vacuum cleaners than dishwashers, taking into ourselves far more than we knew of the pain and devastation of those whose stories we had heard.

But suffering from a life-threatening disease also helped me have a different attitude and perspective. It has given a new intensity to life, for I realize how much I used to take for granted—the love and devotion of my wife, the laughter and playfulness of my grandchildren, the glory of a splendid sunset, the dedication of my colleagues. The disease has helped me acknowledge my own mortality, with deep thanksgiving for the extraordinary things that have happened in my life, not least in recent times. What a spectacular vindication it has been, in the struggle against apartheid, to live to see freedom come, to have been involved in finding the truth and reconciling the differences of those who are the future of our nation. ■

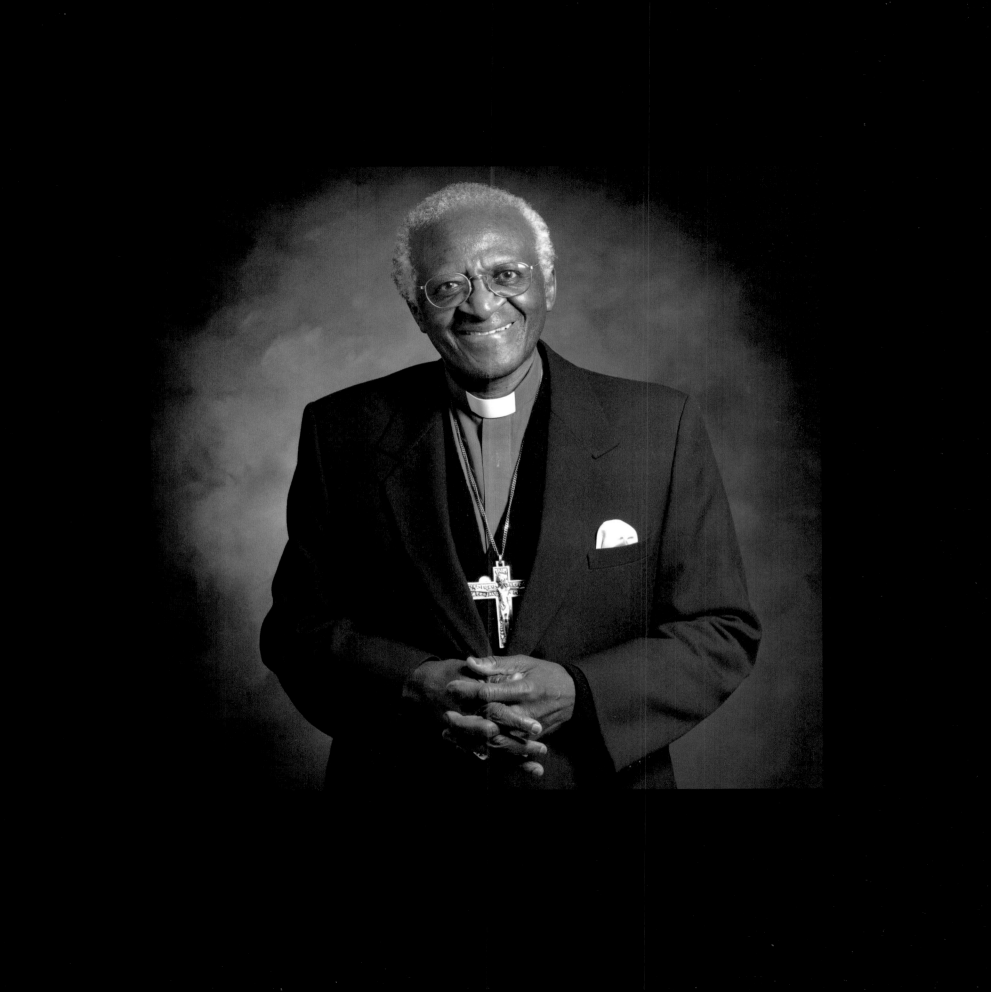

MAIREAD CORRIGAN MAGUIRE

ALL OF US NEED TO TAKE RESPONSIBILITY FOR THE WORLD'S violence and, like Gandhi, pledge our lives to the nonviolent transformation of the world in order to resolve these insane crises through the wisdom of nonviolence.

Gandhi taught that nonviolence does not mean passivity. No. It is the most daring, creative, and courageous way of living, and it is the only hope for our world. Nonviolence is an active way of life which always rejects violence and killing, and instead applies the force of love and truth as a means to transform conflict and the root causes of conflict. Nonviolence demands creativity. It pursues dialogue, seeks reconciliation, listens to the truth in our opponents, rejects militarism, and allows God's spirit to transform us socially and politically.

Getting to the root cause of the conflict continues to be the greatest challenge facing people in Northern Ireland. We need now to build a culture of genuine nonviolence and real democracy. This can only happen through consensus politics built by the people, and courageous political leadership by the government on human rights issues.

Thirty years ago, if the Northern Ireland government had implemented civil rights instead of responding to conflict with ever increasing oppression, emergency legislation, and outright militarization, the savage violence we have known would never have erupted. Today, while we are thankful that the peace process has begun, we are deeply conscious that many of the same problems that were there in 1968 still remain awaiting a solution in an atmosphere of mistrust deepened by thirty years of unnecessary violence.

The only thing we have learned is that violence makes things worse. . . .

To enable consensus politics to develop we need to empower people where they live. This means devolving financial resources and political power down to the community level. One of the greatest blocks to movement is fear. This fear can only be removed when people feel their voices are being heard by government and when they have a say in their own lives and communities.

But Gandhi's challenge of nonviolence is not only a necessity for ourselves and for Northern Ireland; it is a challenge placed before the whole of humanity. Fifty years after his death Gandhi challenges us to pursue a new millennium of nonviolence. This is not an impossible dream. . . .

I have come to believe, with Gandhi, that through our own personal conversion, our own inner peace, we are sensitized to care for God, for ourselves, for each other, for the poor, and for the earth, and then we can become true servants of peace in our world. Herein lies the power of nonviolence.

As our hearts are disarmed by God of our inner violence, they become God's instruments for the disarmament of the world. Without this inner conversion we run the risk of becoming embittered, disillusioned, despairing, or simply burnt out, especially when our work for peace and justice appears to produce little or no result, or seems trifling in comparison with the injustice we see around us. With this conversion we learn to let go of *all desires*, including our destructive desire to see results.

For many people this ancient wisdom of the heart, this wisdom of nonviolence, may seem too religious and too idealistic in today's hardheaded world of politics and science. But I believe, with Gandhi, that we need to take an imaginative leap forward toward fresh and generous idealism for the sake of all humanity—that we need to renew this ancient wisdom of nonviolence, to strive for a disarmed world, and to create a culture of nonviolence.

As we enter the third millennium we need to apply this ancient wisdom of nonviolence to politics, economics, and science. For many, particularly in the West, increased materialism and unprecedented consumerism have not led to inner peace and happiness. Although technology has given us many benefits, it has not helped us to distinguish between what enhances life and humanity, and what destroys life and humanity. The time has come to return to the ancient wisdom of nonviolence. ∎

LEAH RABIN

WE HAVE LIVED THROUGH DAYS OF SERIOUS THREATS TO OUR existence, to the survival of Israel. We have known how to cope with the pain of loss of life. We have buried our dead, mourned for them, and continued in our struggle. There is no alternative to the peace process. We are on the way, and these mines, these obstacles have to be overcome. The train of peace will go on and arrive at its destiny. Those who try to stop it should not be given a chance. Having lived with Yitzhak all my life, I know that . . . would have been his conviction. Don't give in. Don't stop. Just go on. ■

YAËL DAYAN

WHAT WE HAVE TO DO IS JUST FOLLOW IN THE FOOTSTEPS OF Anwar Sadat, of my late father, Moshe Dayan, and of Yitzhak Rabin. Those who were assassinated, those who devoted their lives to the one peace possible, believed in a homeland for all peoples and the equality and dignity of human beings, not the expression of false weapons and power. It is possible.

My father as well as Anwar Sadat and Yitzhak Rabin have all been great heroes at war and maybe it takes the heroism of war to know what the price of peace is. It is necessary to understand the real price of war in order to understand what we gain by signing peace. . . .

We can really turn this part of the world again into the fertile crescent, again into a source of so much that is of humanitarian value, and be a contribution to the world the way that Anwar Sadat saw it and the way that Yitzhak Rabin saw it. We are not going in any way to reward their assassins. We are going to prove them wrong. We are going to carry on in their footsteps. ■

Reverend Billy Graham

[Peace] is not a mere cessation of hostilities, a momentary halt in a hot or cold war. Rather, it is something positive. It is a specific relationship with God into which a person is brought. It is a spiritual reality in a human heart which has come into vital contact with the infinite God. ■

After I photographed Reverend Graham, he entered a press conference with hundreds of reporters and photographers. As he was leaving, one of the inter-viewers asked him to pray for his ailing mother. Reverend Graham stopped immediately and prayed with the man as if he were the only person in the room, and as if it were the most important task of his day.—M.C.

HIS HOLINESS POPE JOHN PAUL II

AT THE DAWN OF THE NEW MILLENNIUM, WE WISH TO PROPOSE once more the message of hope which comes from the stable of Bethlehem: God loves all men and women on earth and gives them the hope of a new era, an era of peace. His love, fully revealed in the Incarnate Son, is the foundation of universal peace. When welcomed in the depths of the human heart, this love reconciles people with God and with themselves, renews human relationships, and stirs that desire for brotherhood capable of banishing the temptation of violence and war. . . .

To everyone I affirm that peace is possible. It needs to be implored from God as his gift, but it also needs to be built day by day with his help, through works of justice and love.

To be sure, the problems which make the path to peace difficult and often discouraging are many and complex, but peace is a need deeply rooted in the heart of every man and woman. The will to seek peace must not therefore be allowed to weaken. This seeking must be based on the awareness that humanity, however much marred by sin, hatred, and violence, is called by God to be a single family. This divine plan needs to be recognized and carried out through the search for harmonious relationships between individuals and peoples, in a culture where openness to the Transcendent, the promotion of the human person, and respect for the world of nature are shared by all.

In the century we are leaving behind, humanity has been sorely tried by an endless and horrifying sequence of wars, conflicts, genocides, and "ethnic cleansings" which have caused unspeakable suffering: millions and millions of victims, families, and countries destroyed, an ocean of refugees, misery, hunger, disease, underdevelopment, and the loss of immense resources. At the root of so much suffering there lies a logic of supremacy fueled by the desire to dominate and exploit others, by ideologies of power or totalitarian utopias, by crazed nationalisms or ancient tribal hatreds. At times brutal and systematic violence, aimed at

the very extermination or enslavement of entire peoples and regions, has had to be countered by armed resistance.

The twentieth century bequeaths to us above all else a warning: wars are often the cause of further wars because they fuel deep hatreds, create situations of injustice, and trample upon people's dignity and rights. Wars generally do not resolve the problems for which they are fought and therefore, in addition to causing horrendous damage, they prove ultimately futile. War is a defeat for humanity. Only in peace and through peace can respect for human dignity and its inalienable rights be guaranteed. . . .

"Peace on earth to those whom God loves!" The Gospel greeting prompts a heartfelt question: will the new century be one of peace and a renewed sense of brotherhood between individuals and peoples? We cannot of course foresee the future. But we can set forth one certain principle: there will be peace only to the extent that humanity as a whole rediscovers its fundamental calling to be one family, a family in which the dignity and rights of individuals—whatever their status, race, or religion—are accepted as prior and superior to any kind of difference or distinction.

This recognition can give the world as it is today—marked by the process of globalization—a soul, a meaning, and a direction. Globalization, for all its risks, also offers exceptional and promising opportunities, precisely with a view to enabling humanity to become a single family, built on the values of justice, equity, and solidarity.

For this to happen, a complete change of perspective will be needed: it is no longer the well-being of any one political, racial, or cultural community that must prevail, but rather the good of humanity as a whole. The pursuit of the common good of a single political community cannot be in conflict with the common good of humanity, expressed in the recognition of and respect for human rights sanctioned by the Universal Declaration of Human Rights of 1948. It is necessary, then, to abandon ideas and practices—often determined by powerful economic interests—

the political, cultural, and institutional divisions and distinctions by which humanity is ordered and organized are legitimate insofar as they are compatible with membership in the one human family, and with the ethical and legal requirements which stem from this.

This principle has an immensely important consequence: an offense against human rights is an offense against the conscience of humanity as such, an offense against humanity itself. The duty of protecting these rights therefore extends beyond the geographical and political borders within which they are violated. Crimes against humanity cannot be considered an internal affair of a nation. Here an important step forward was taken with the establishment of an International Criminal Court to try such crimes, regardless of the place or circumstances in which they are committed. We must thank God that in the conscience of peoples and nations there is a growing conviction that human rights have no borders, because they are universal and indivisible.

From the problem of war, our gaze naturally turns to another closely related issue: the question of solidarity. The lofty and demanding task of peace, deeply rooted in humanity's vocation to be one family and to recognize itself as such, has one of its foundations in the principle of the universal destination of the earth's resources. This principle does not delegitimize private property; instead it broadens the understanding and management of private property to embrace its indispensable social function, to the advantage of the common good and in particular the good of society's weakest members. Unfortunately, this basic principle is widely disregarded, as shown by the persistent and growing gulf in the world between a North filled with abundant commodities and resources and increasingly made up of older people, and a South where the great majority of younger people now live, still deprived of credible prospects for social, cultural, and economic development.

No one should be deceived into thinking that the simple absence of war, as desirable as it is, is equivalent to lasting peace. There is no true peace without fairness, truth, justice, and solidarity. Failure awaits every plan which would separate two indivisible and interdependent rights: the right to peace and the right to an integral development born of solidarity. "Injustice, excessive economic or social inequalities, envy, distrust, and pride raging among men and nations constantly threaten peace and cause wars. Everything done to overcome these disorders contributes to building up peace and avoiding war."

At the beginning of a new century, the one issue which most challenges our human and Christian consciences is the poverty of countless millions of men and women. This situation becomes all the more tragic when we realize that the major economic problems of our time do not depend on a lack of resources but on the fact that present economic, social, and cultural structures are ill-equipped to meet the demands of genuine development.

Rightly then the poor, both in developing countries and in the prosperous and wealthy countries, "ask for the right to share in enjoying material goods and to make good use of their capacity to work, thus creating a world that is more just and prosperous for all. The advancement of the poor constitutes a great opportunity for the moral, cultural and even economic growth of all humanity." Let us look at the poor not as a problem, but as people who can become the principal builders of a new and more human future for everyone.

In this context we also need to examine the growing concern felt by many economists and financial professionals when, in considering new issues involving poverty, peace, ecology, and the future of the younger generation, they reflect on the role of the market, on the pervasive influence of monetary and financial interests, on the widening gap between the economy and society, and on other similar issues related to economic activity.

Perhaps the time has come for a new and deeper reflection on the nature of the economy and its purposes. What seems to be urgently needed is a reconsideration of the concept of "prosperity" itself, to

prevent it from being enclosed in a narrow utilitarian perspective which leaves very little space for values such as solidarity and altruism.

Here I would like to invite economists and financial professionals, as well as political leaders, to recognize the urgency of the need to ensure that economic practices and related political policies have as their aim the good of every person and of the whole person. This is not only a demand of ethics but also of a sound economy. Experience seems to confirm that economic success is increasingly dependent on a more genuine appreciation of individuals and their abilities, on their fuller participation, on their increased and improved knowledge and information, on a stronger solidarity.

These are values which, far from being foreign to economics and business, help to make them a fully "human" science and activity. An economy which takes no account of the ethical dimension and does not seek to serve the good of the person—of every person and the whole person—cannot really call itself an "economy," understood in the sense of a rational and constructive use of material wealth.

The very fact that humanity, called to form a single family, is still tragically split in two by poverty—at the beginning of the twenty-first century, more than 1.4 billion people are living in a situation of dire poverty—means that there is urgent need to reconsider the models which inspire development policies.

In this regard, the legitimate requirements of economic efficiency must be better aligned with the requirements of political participation and social justice, without falling back into the ideological mistakes made during the twentieth century. In practice, this means making solidarity an integral part of the network of economic, political, and social interdependence which the current process of globalization is tending to consolidate.

These processes call for rethinking international cooperation in terms of a new culture of solidarity. When seen as a sowing of peace, cooperation cannot be reduced to aid or assistance, especially if given with an eye to the benefits to be received in return for the resources made available. Rather, it must express a concrete and tangible commitment to solidarity which makes the poor the agents of their own development and enables the greatest number of people, in their specific economic and political circumstances, to exercise the creativity which is characteristic of the human person and on which the wealth of nations too is dependent.

In particular it is necessary to find definitive solutions to the long-standing problem of the international debt of poor countries, while at the same time making available the financial resources necessary for the fight against hunger, malnutrition, disease, illiteracy, and the destruction of the environment.

Today more than in the past there is an urgent need to foster a consciousness of universal moral values in order to face the problems of the present, all of which are assuming an increasingly global dimension. The promotion of peace and human rights, the settling of armed conflicts both within states and across borders, the protection of ethnic minorities and immigrants, the safeguarding of the environment, the battle against terrible diseases, the fight against drug and arms traffickers, and against political and economic corruption: these are issues which nowadays no nation is in a position to face alone. They concern the entire human community, and thus they must be faced and resolved through common efforts.

A way must be found to discuss the problems posed by the future of humanity in a comprehensible and common language. The basis of such a dialogue is the universal moral law written upon the human heart. By following this grammar of the spirit, the human community can confront the problems of coexistence and move forward to the future with respect for God's plan.

The encounter between faith and reason, between religion and morality, can provide a decisive impulse towards dialogue and cooperation between peoples, cultures, and religions. ▪

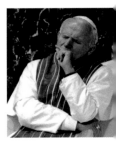

LECH WALESA

I'M AN IDEALIST, IN THE SENSE THAT I WOULD LIKE TO SEE US move toward an ideal that I believe in. But I know how each of us has his own set of standards, formed by childhood, school, living conditions, and experiences in adult life. Though private standards differ they must also share common points of reference. We're never going to go back to the time when men fought with daggers and swords and went to war to settle personal disputes. Already the young people of every nation are coming to resemble each other more and more, and are slowly becoming strangers to chauvinism and racism.

Organizing a set of basic personal values to which one can refer is a long and difficult process: it took me years and is today still incomplete. I know who I am and what I stand for. Now I am able to devote my time and energy to other problems.

This kind of spiritual equilibrium doesn't exempt one from fear. Fear takes many forms: there's fear in the face of suffering, fear of not having enough time, fear of not being able to explain oneself, fear of not doing well enough, fear of death. How is one to cope? I once knew a priest who was putting money to one side so that he would be able to afford a nurse when he was no longer able to care for himself. "You saved your millions for nothing," I told him. "If you're struck down by some terrible disease, no one will come to care for you despite your money. But if you've been kind and generous when you were in good health, many will help you for nothing."

A life devoted to the exchange of ideas doesn't mean freedom from loneliness. Most of my tasks involve group effort, and [my wife] Danuta has always stood by and supported me in my work. I am almost always in the company of others, but that doesn't prevent me from feeling almost always alone.

I sometimes feel as if I belong to a past age, the age which is evoked in our national anthem, "Poland has not perished." The conditions in which this anthem saw the light of day are much the same as those we live under today, and the same can be said of the hopes and values it expresses: courage, defiance, pride. But there will come a time, which I won't live to see, when narrow Polish problems have been brushed aside, replaced by harmony and peace over our entire planet, and I expect that our children or our children's children will then be able to sing another, more positive song. Until that time we have work to do. ■

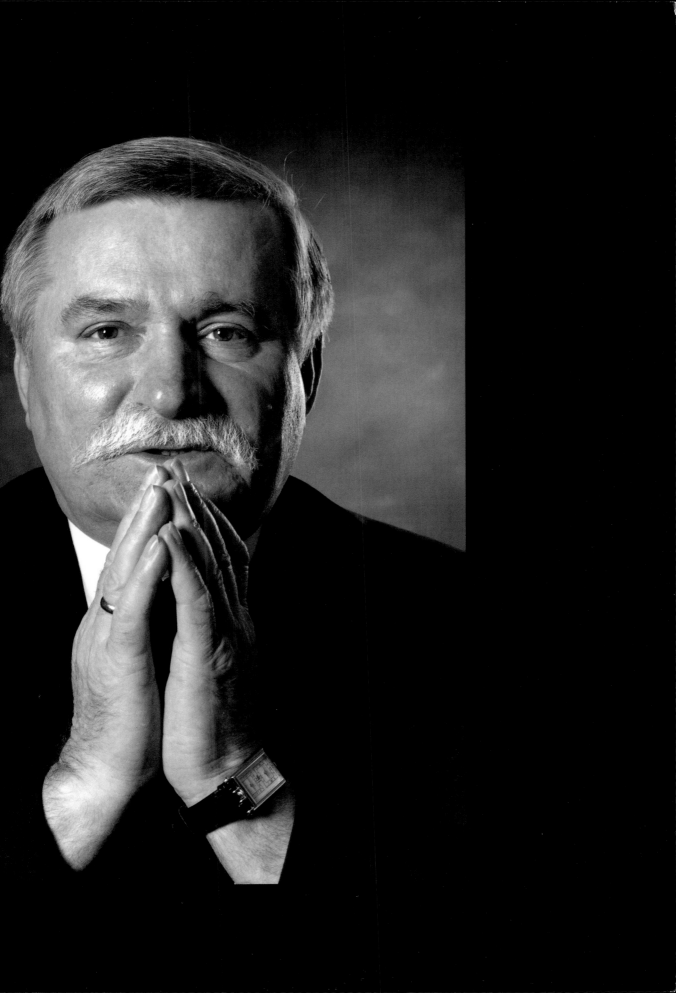

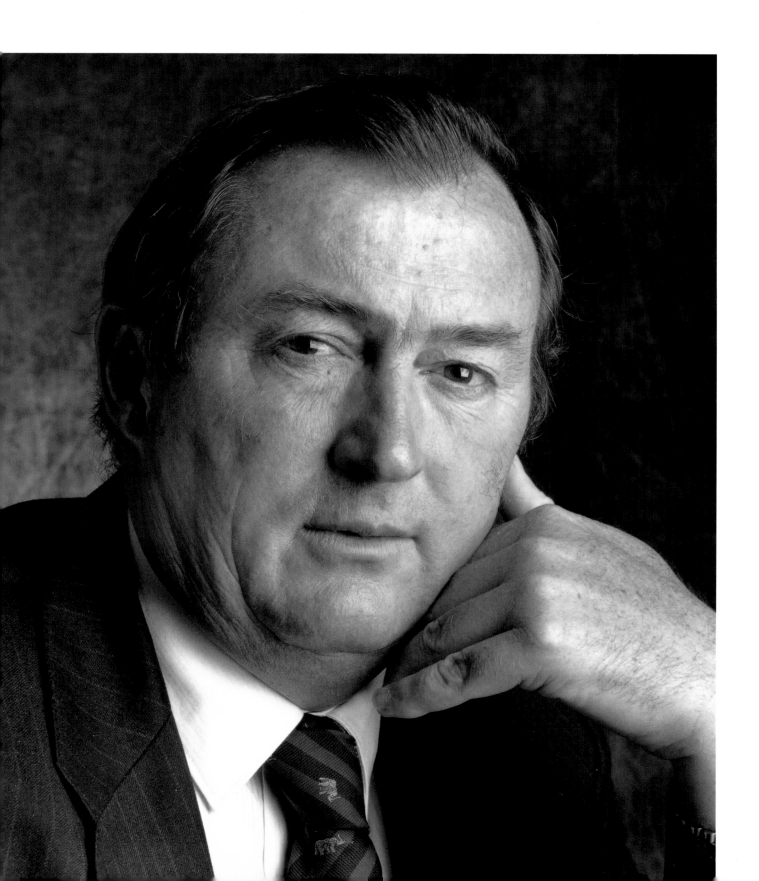

RICHARD LEAKEY

My dual careers as paleontologist and conservationist have given me a unique view on the value of life's diversity and the way it changes through time. But I also have a practical view, which derives from seeing people struggle to survive by exploiting the only resources available to them—namely, the natural world around them. Aiding their struggle while halting the destruction of those resources is humanity's greatest challenge. . . . It can be done, but only if the different needs of rich and poor countries are acknowledged. It will fail if the richer nations try to impose solutions that effectively freeze the citizens of the less-developed nations in permanent poverty. ■

R.E. TURNER

As a businessman who has spent the last quarter of the century involved in creating television networks and producing and airing programming, I have tremendous respect for the power of the medium, and even greater interest in its future. One of the measures that people of my generation use to mark personal milestones and the passage of time is the advent of television, its growth, and its increasing sophistication. It amazes me to think that my children grew up—quite literally—with global breaking news coverage provided by CNN, and that their children will forever regard this remarkable window on the world as a simple fact of life, like computers and routine space travel. Just yesterday, it seems, our worldview was shaped almost entirely by radio, Franklin Delano Roosevelt, and the notion of American invincibility.

The more complex our world becomes, the more we rely on that electronic window to help us process it all. And the greater the responsibility we must shoulder to see that it is used as fairly as it is fearlessly. If we entertain, we must also enlighten. In reporting the news, we must shed light on the conflicts that create it. As our businesses grow, so must we grow as human beings. We have a duty to embrace humanity with the same vision and daring that we do technology.

I have experienced more professional success than any man has a right to expect, and have enjoyed most every minute of it. Yet nothing I have achieved in business is ultimately as important as the smallest thing I can do to promote understanding across our world. More and more people are concerned about the environment, about resource conservation and population growth, about poverty and pollution. More and more, people see that squandering the planet's assets, which took billions and billions of years to create, is not our birthright. We are not entitled to greed or complacency when the future of the world is at stake.

I believe television is a great tool for uniting people behind the cause of our planet. Pictures and human stories are always more compelling than numbers. The earth's population is soon expected to reach six billion. Most demographers agree that it could reach eight billion within the next fifteen to twenty years. It is inconceivable that in my lifetime, I will be part of a world that labors to support a population of nearly ten billion people. Yet, as staggering as those numbers are, they can never tell the story as immediately, as indelibly, as one picture of a starving child, of one ancient tree felled for building lumber, of one bird driven to extinction. Television can open a dialogue. It can frighten, outrage, and mobilize. It can quicken the pace of change. It can, and it is up to us to see that it is given the opportunity.

What happens then is up to each of us. I have chosen to support an organization that shares my concerns and is not afraid to take up the challenges the world faces. The United Nations has the reach, resources, and membership to effect change in everything from land-mine warfare and nuclear armament to inoculating children and saving forests. It is my responsibility, as someone with strong convictions, to be part of the solution, whether through the United Nations or a grassroots neighborhood group with a common interest.

We cannot expect anyone else to solve our problems. Now is the time to set our minds to international cooperation and communication. It is a difficult course, but it is the right thing to do. The hour is late. The task may well be beyond us. But I, for one, have always enjoyed a challenge. ■

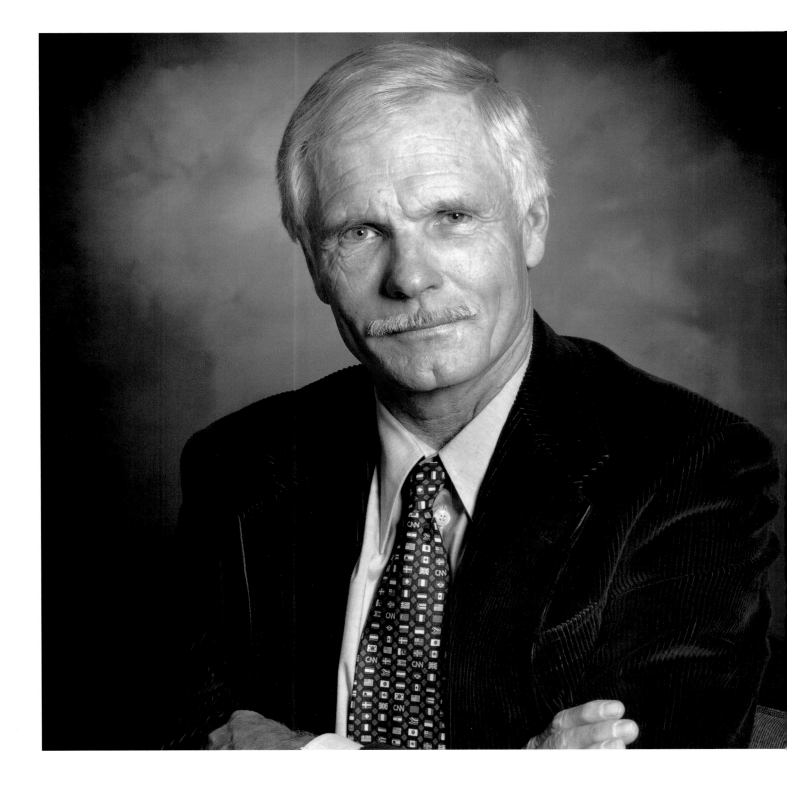

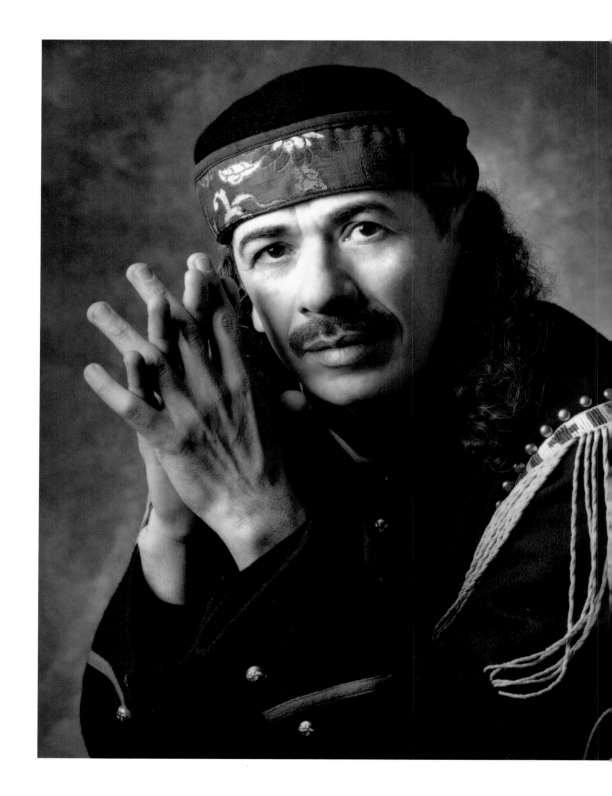

CARLOS SANTANA

THERE'S ONLY ONE TRUTH ON THIS PLANET: THAT WE ARE ALL
one. What I'd like to do before I die is bring people closer to the same
reality that John Coltrane and Bob Marley were trying to bring people
to—a reality of no borders, one race, one body—where we all take
responsibility that nobody starves to death tomorrow morning. To do
that with music is more important than becoming Jimi Hendrix or
Beethoven. When you connect with people through music, you affect
the whole wheel of life in such a way that, even though you are only
one person, you make a difference, like Martin Luther King Jr. or
Mahatma Gandhi. Then songs become windows for people to look
inside or look outside. That's why we love Jimi Hendrix—because his
songs are beautiful windows. When we look through them, we like
what we see.

Music, more than almost anything else, has the power to bring
people together—people of different ages, races, religions. So I'm more
clear now as to why I play. It's not just to make people happy or to
make them dance—it's to change things: change myself, change the
people in my band, change people all over the world, so we can have
a clearer vision about life and about ourselves, so we can bring more
harmony to the world. ■

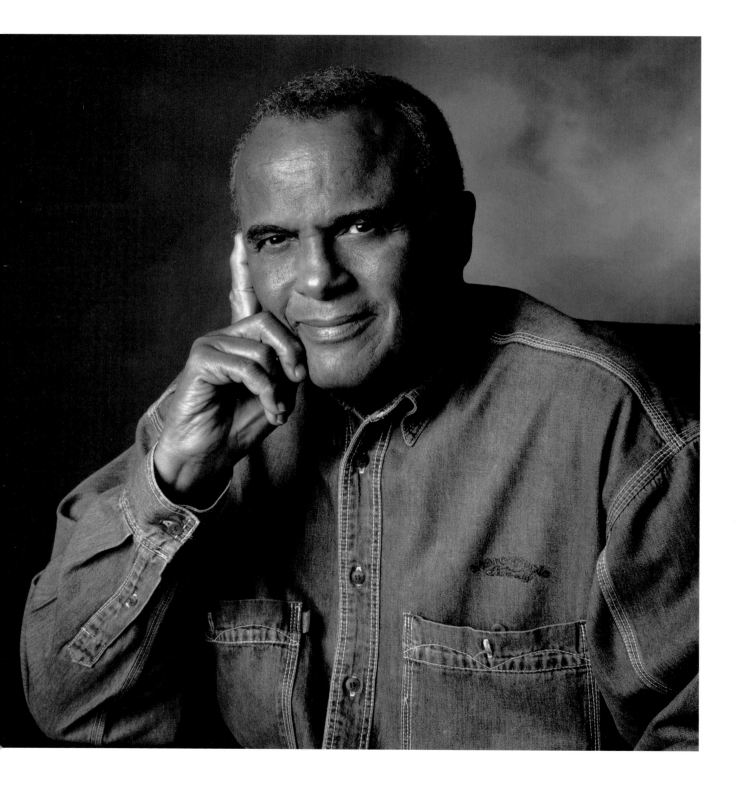

HARRY BELAFONTE

Midway through the Civil Rights movement, Dr. Martin Luther King Jr. realized that the struggle for integration would ultimately become a struggle for economic rights. I remember the last time we were together, at my home, shortly before he was murdered. He seemed quite agitated and preoccupied, and I asked him what the problem was. "I've come upon something that disturbs me deeply," he said. "We have fought hard and long for integration, as I believe we should have, and I know that we will win. But I've come to believe we're integrating into a burning house."

That statement took me aback. It was the last thing I would have expected to hear, considering the nature of our struggle, and I asked him what he meant. "I'm afraid that America may be losing what moral vision she may have had," he answered. "And I'm afraid that even as we integrate, we are walking into a place that does not understand that this nation needs to be deeply concerned with the plight of the poor and disenfranchised. Until we commit ourselves to ensuring that the underclass is given justice and opportunity, we will continue to perpetuate the anger and violence that tears at the soul of this nation."

I would like to see black America honestly examine where we are at this point in history. We must stop relying on Democrats or Republicans or institutions that oppress us, and take responsibility for ourselves. Whenever we've stepped out to assume responsibility for our future, we've succeeded in our mission. White America didn't give us the gains we've made. Through various movements we went out and fought for our liberation and made ourselves a better people, and the world a better place. I am far from disillusioned. Deep in my soul, I know there are more Rosa Parks, more Dr. Kings, and more Ella Bakers ready to emerge. Perhaps we are the firefighters who can save the burning house. Martin would have embraced such a thought. ■

Andrew Young

Ultimately, the success of a community and a nation requires sound, positive values. A community cannot succeed economically without political power, education, and a basic religious awareness of who one is as a child of God. The religious values of the black community in America sustained us through generations of slavery and segregation. Hard work, education, and faith in God did not prevent the oppression of black people, but they allowed us to resist the dehumanization that could have resulted. Our movement emphasized the importance of those fundamental values.

One of the great tragedies today is that absent a strong personal faith, young people anesthetize their pain with narcotics. In a society that grants them more freedom than ever before, they are prisoners of the poverty of their own spirits.

The young people that marched in Birmingham had far fewer material comforts than almost any young American today. But they were far richer in spiritual resources. They believed that they were children of God and that gave them the strength, courage, and discipline to overturn segregation. Values prepare a person or community to take full advantage of the opportunities a society provides.

At the same time one must question the values of a society that tolerates the kind of poverty that exists in the United States. Policies that deprive workers of a living wage, undermine educational opportunity, and seek to balance budgets by cutting assistance to the poor, the sick, and the vulnerable do not reflect the values of the America I love. The model set by such policies is "everyone for himself" rather than a democratic community working for the common good. ▪

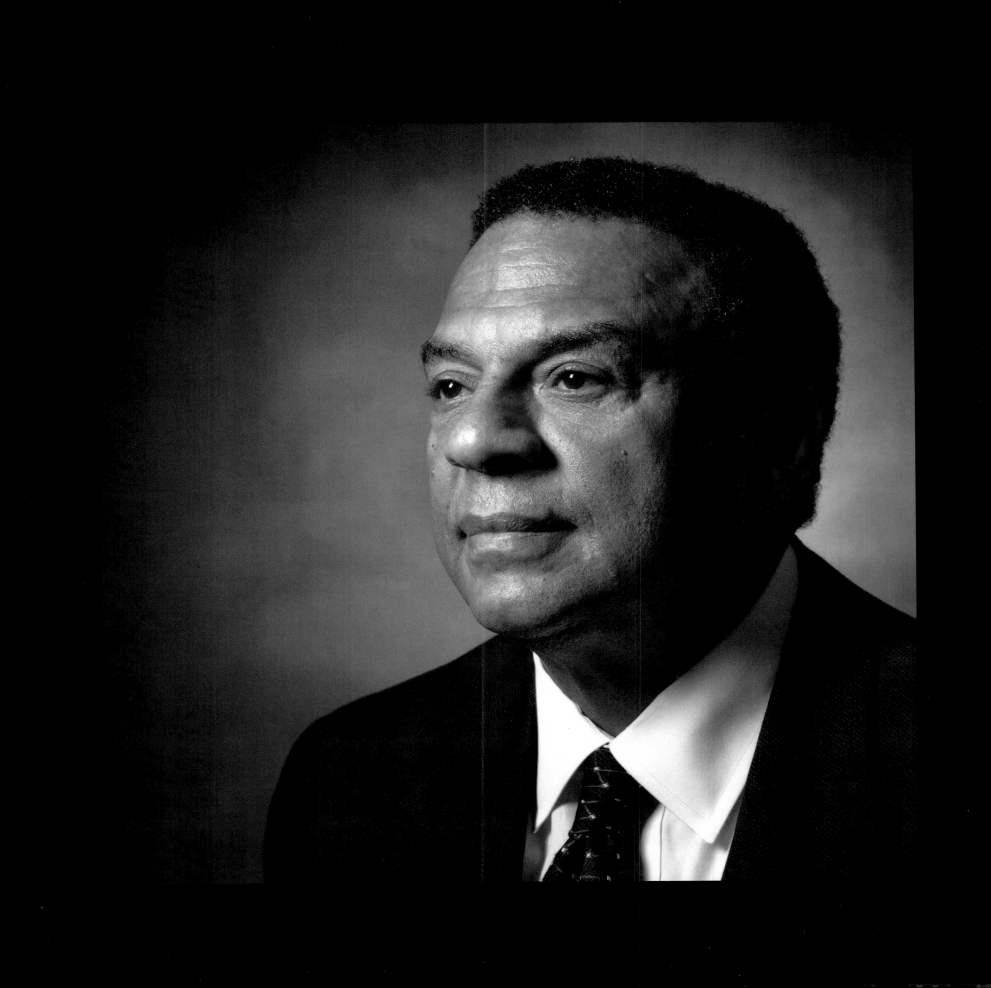

SISTER HELEN PREJEAN

THE MOST DIRECT ROAD THAT I HAVE FOUND TO GOD IS IN THE faces of poor and struggling people. For me, it was the connection with people in the St. Thomas housing projects, then with people on death row and in prison, and then with the murder victims' families.

I was forty years old before I realized the connection between the Jesus who had said, "I was in prison and you came to me, I was hungry and you gave me to eat" and real-life experience where I was actually with people who were hungry and people who were in prison and people who were struggling with the racism that permeates this society. And it was like the feeling of coming home. Finding God in the poor was like coming home, because you just say, "Where have I been all my life?"

I remember being in a soup kitchen. My job was to serve the red Kool-Aid at the beginning of the line when people came for a meal. It was the first conscious act I did where I needed to be in touch with poor and struggling people. This young man came up, a beautiful kid, he looked like Mr. Joe College. He was handsome, with blond hair and blue eyes, and his hand was shaking as he handed me the cup. And he whispered, "You have to help me, it's my first time here." The tears welled up in my eyes. I was thinking, "My God, what is this young guy doing here?" It draws out of you this tremendous energy and gifts that you don't even know you have.

My image of finding God is that our little boats are always on the river. We often are in a stall, and we wait and nothing moves, and everything seems the same in life. But when we get involved in a situation like this—for me it was getting involved with poor people—it's like our boat begins to move on this current. The wind starts whistling through our hair and the energy and life is there. And that brought me straight into the execution chamber. You see, it was very quick from getting involved with poor people in the St. Thomas housing projects to writing to a man on death row, to visiting a man on death row, and then being there for him at the end, because he had no one to be there with him. And that experience of being there with him, it's really life up against it: It's life or death. It's compassion or vengeance. All life is just distilled to its essence.

In that situation, I experienced a tremendous strength and presence of God, that God was in this man that society wanted to throw away and kill. And the words of Jesus—"the last will be first"—came home to me. That is what those words meant: that God dwells in the people in the community that we most want to throw away. It's what builds the human family and human community. Because what makes things like the death penalty possible, what makes things like the racism that continues in our society, the oppression of the poor, is that there's this disconnection with people.

To me, to find God is to find the whole human family. No one can be disconnected from us. Which is another way of talking about the Body of Christ, that we are all part of this together.

I feel that everybody needs to be in contact with poor people— that in fact, as Jim Wallis of the Sojourners community has said, we need to accept that one of the spiritual disciplines—just like reading the Scriptures and praying and liturgy—is physical contact with the poor. It's an essential ingredient. If we are never in their presence, if we never eat with them, if we never hear their stories, if we are always separated from them, then I think something really vital is missing.

The other thing I would want to add to the whole question of finding God is that the journey, wherever it takes us—to me it has been to the poor and the struggling—must be coupled with a reflection and a centeredness that comes from prayer and meditation. It's very important to assimilate what's happening in our lives. I find that I can't function if I don't have that sense of being at the center of myself and in the soul of my soul, so that I am truly operating from the inside out. And it's important to be very self-directed, because it is so possible to be caught on other people's eddies in the river and to get into a stimulus/response situation. It's so possible not even to realize that we are really moved by other people's vision of life, other people's insights, other people's agendas, and just to be caught on one current to another, that we have no rudder on our own boat.

When you hit something big like this, and you know that it's bigger than you—like working for justice in the world, or trying to connect faith with going against powerful and entrenched systems—you have this sense of "Yes, I am doing my part." But then you also need to be able to put it down and let God run the universe, so you can play a clarinet or be with your friends or work in a garden.

To be whole is very important. Wholeness, I think, is part of godliness. I don't think it's cleanliness anymore that's next to godliness—I think it's wholeness! To have a well-rounded life. To have a good intellectual life, where you're reading and thinking and discussing. To have a strong emotional life where you can give and receive intimacy with people. To develop friendships like a garden. Because there's just no room for these Lone Rangers who go and try to save the world by themselves. ∎

HARRY WU

EVERY TYRANNY NEEDS A SUPPRESSION MACHINE TO MAINTAIN ITS rule. Hitler had his concentration camps; Stalin, his. Yet some people think that Communist China has no need of a suppression machine. They think that China gets along with a normal, even a Western-style judicial and penal system, perhaps with a few Eastern variants.

But this is untrue. The regime in Beijing has exactly the kind of suppression machine it needs to enforce its will. No professor of recent Germany history would fail to speak of the Holocaust. And no scholar of the Soviet Union would omit the Gulag. Yet many so-called China experts, who use terms like "Great Leap Forward" and "Cultural Revolution," make no mention whatsoever of the Laogai. But "Laogai" is part of the everyday language of the Chinese people. Almost everyone in China has family or friends with personal knowledge of this hated system—if he does not himself.

I realize it is difficult to discuss the Laogai. How many people in 1937 were interested in hearing about the Nazi camps? Germany's economy was growing steadily. The West cooperated with German companies. There was no splashy boycott of the 1936 Berlin Games. Few people were willing to believe even the reports of escapees. It was not until the end of World War II that people generally came to grips with the evil that the Germans and their partners had committed.

Today, the blood, tears, and lives of millions of Chinese men and women testify to the awful truth about the Laogai. What is the Laogai? It is, quite simply, the Chinese Communist version of Hitler's camps and Stalin's. In the words of a Chinese government document, "Marxism holds that the state is a machine of violence made up of army, police, court, prison, and other compulsory facilities." As for Mao, he made himself unmistakably clear: "The Laogai facilities are one of the violent component parts of the state machine. Laogai facilities of all levels are established as tools representing the interests of the proletariat and the people's masses and exercising dictatorship over a minority of hostile elements originating from exploiter classes."

Listen to the words of another government document, this one explaining why it is necessary to force Chinese prisoners into labor: "Our economic theory holds that the human being is the most fundamental productive force. Except for those who must be exterminated physically out of political consideration, human beings must be utilized as productive forces, with submissiveness as the prerequisite. The Laogai system's fundamental policy is 'Forced Labor as a means, while Thought Reform is our basic aim.'" The goal of the system, according to the government, is to "reform prisoners into new, socialist people."

Incredibly, Western scholars make casual comparisons of their own prisons to the Chinese. But if they bothered to learn the least thing about the Laogai, they would never utter such comparisons, which are not only ignorant but insulting.

Hitler's ideology divided people by race and religion. Stalin and Mao's divides mainly by class. All three constructed labor camps to destroy the human being. Entrances to the Nazi camps bore signs proclaiming, "Labor Makes Freedom." Laogai camps have signs that read, "Labor Makes New Life." While the German signs are long gone, China's remain, along with the camps. Everyone knows the word "Holocaust." And everyone knows the word "Gulag." It is time for Westerners to learn the word that springs naturally and fearfully to the lips of a billion Chinese: "Laogai." ▪

F. W. de Klerk

The greatest peace, I believe, is the peace which we derive from our faith in God Almighty; from certainty about our relationship with our Creator. Crises might beset us, battles might rage about us—but if we have faith and the certainty it brings, we will enjoy peace—the peace that surpasses all understanding.

IT WAS A DAY OF JOY. IT WAS A DAY OF LIBERATION—NOT ONLY for black South Africans but also for us white South Africans. Suddenly, the burden of three hundred and fifty years had been lifted from our shoulders. For the first time we could greet all our countrymen without guilt or fear as equals and as fellow South Africans. When I awoke that morning I was still the president of South Africa. When I went to bed the mantle had passed from me to Nelson Mandela. Few heads of government could ever have laid aside their high office with a greater sense of accomplishment, regardless of the uncertainties of the future.

Five months earlier, when Nelson Mandela and I had received the Nobel Peace Prize at the City Hall in Oslo, I had quoted a verse from the foremost Afrikaans poet, N. P. van Wyk Louw:

The new era which is dawning in our country, beneath the great southern stars, will lift us out of the silent grief of our past and into a future in which there will be opportunity and space for joy and beauty—for real and lasting peace. ■

BENAZIR BHUTTO

Of trying to make peace, I know a little. To make peace, one must be an uncompromising leader. To make peace, one must also embody compromise.

Throughout the ages, leadership and courage have often been synonymous. Ultimately, leadership requires action: daring to take steps that are necessary but unpopular, challenging the status quo in order to reach a brighter future.

And to push for peace is ultimately personal sacrifice, for leadership is not easy. It is born of a passion, and it is a commitment. Leadership is a commitment to an idea, to a dream, and to a vision of what can be. And my dream is for my land and my people to cease fighting and allow our children to reach their full potential regardless of sex, status, or belief.

In pursuit of peace in my land and more broadly between East and West, I must travel the world. As a leader, the travel is necessary. As a woman and a mother, I miss my children. It is difficult to explain to a nine-year-old why his mother can't be at home for his birthday.

But leadership involves making family sacrifices. Pursuing peace means rising above one's own wants, needs, and emotions. Leadership is tough. There is no question of being tired; there are no holidays.

Peace is most often seen as resolving struggles between individuals. More broadly, finding peace means resolving struggles between ideologies, religions, and cultures. As the first woman leader of an Islamic nation, peace has been for me first and foremost resolving a struggle between the sexes.

Through much of history, women's roles in making peace have been confined within the family. Reaching peace and understanding, and finding compromise between families, between villages, and between nations has been the responsibility of men. I dare say that families have been more peaceful than nations.

Women leaders have had to pay a high price. We are often viewed as interim rallying points in times of crisis, and then have to fight men who view us as rubber stamps for their own authority.

Women leaders seeking peace pay a high price to attain and hold leadership. When I was expecting my first child, my opponents called fresh elections. They thought that childbearing would prevent a woman from campaigning. They were wrong.

Yes, I could not openly share the joy of expecting a child—to go shopping for baby clothes or afford morning sickness.

The first generation of women leaders felt a need to show they were stronger than men. They often fought wars or tried to sound as warlike as men. Twenty years later, I see a change. Women leaders are now more associated with social development, with nurturance and a sensitivity to human problems.

For women leaders, the obstacles are greater, the demands are greater, the barriers are greater, and the double standards are more pronounced. Ultimately, the expectations of those who look at us as role models are greater as well. And for all women, it is critical that we succeed.

Leadership is to do what is right by educating and inspiring an electorate, empathizing with the moods, needs, wants, and aspirations of humanity.

Making peace is about bringing the teeming conflicts of society to a minimal point of consensus. It is about painting a new vision on the canvas of a nation's political history. Ultimately, leadership is about the strength of one's convictions, the ability to endure the punches, and the energy to promote an idea.

And I have found that those who do achieve peace never acquiesce to obstacles, especially those constructed of bigotry, intolerance, and inflexible tradition. ■

Margaret Thatcher

It is important to understand that the moral foundations of a society do not extend only to its political system; they must extend to its economic system as well. America's commitment to capitalism is unquestionably the best example of this principle. Capitalism is not, contrary to what those on the left have tried to argue, an amoral system based on selfishness, greed, and exploitation. It is a moral system based on a biblical ethic. There is no other comparable system that has raised the standard of living of millions of people, created vast new wealth and resources, or inspired so many beneficial innovations and technologies. The wonderful thing about capitalism is that it does not discriminate against the poor, as so often has been charged; indeed, it is the only economic system that raises the poor out of poverty. Capitalism also allows nations that are not rich in natural resources to prosper. If resources were the key to wealth, the richest country in the world would be Russia, because it has abundant supplies of everything from oil, gas, platinum, gold, silver, aluminum, and copper to timber, water, wildlife, and fertile soil.

Why isn't Russia the wealthiest country in the world? Why aren't other resource-rich nations in the Third World at the top of the list? It is because their governments deny citizens the liberty to use their God-given talents. Man's greatest resource is himself, but he must be free to use that resource.

In his encyclical, *Centesimus Annus*, Pope John Paul II wrote that the collapse of communism is not merely to be considered as just a "technical problem." It is a consequence of the violation of human rights. He specifically referred to the rights to private initiative, to own property, and to act in the marketplace.

The pope also acknowledged that capitalism encourages important virtues, such as diligence, industriousness, prudence, reliability, fidelity, conscientiousness, and a tendency to save in order to invest in the future. It is not material goods, but all of these great virtues, exhibited by individuals working together, that constitute what is called the "marketplace."

Freedom, whether of the marketplace or any other kind, must exist within the framework of law. Otherwise, it means only freedom for the strong to oppress the weak. Whenever I visit the former Soviet Union, I stress this point with students, scholars, politicians, and businessmen—in short, with everyone I meet. Over and over again, I repeat: Freedom must be informed by the principle of justice in order to make it work between people. A system of laws based on solid moral foundations must regulate the entire life of a nation.

This is an extremely difficult point to get across to people with little or no experience with laws except those based on force. The concept of justice is entirely foreign to communism. So, too, is the concept of equality. For more than seventy years, Eastern Europe and the Soviet Union had no system of common law. There were only the arbitrary and often contradictory dictates of the Communist Party. There was no independent judiciary. There was no such thing as truth in the communist system.

What is freedom without truth? I have been a scientist, lawyer, and politician, and from my own experience I can testify that it is nothing. The third-century Roman jurist Julius Paulus said, "What is right is not derived from the rule, but the rule arises from our knowledge of what is right." In other words, the law is founded on what we believe to be true and just. It has moral foundations. Once again, it is important to note that the free societies of America and Great Britain derive such foundations from a biblical ethic.

Democracy never is mentioned in the Bible. When people are gathered together—whether as families, communities, or nations—their purpose is not to ascertain the will of the majority, but the will of the Holy Spirit. Nevertheless, I am an enthusiast of democracy because it is about more than the will of the majority. If this were not so, it would be the right of the majority to oppress the minority. The Declaration of Independence and Constitution make it clear that this is not the case. There are certain rights that are human rights and which no government can displace. When it comes to how Americans exercise their rights under democracy, their hearts seem to be touched by something greater than themselves. Their role in democracy does not end when they cast their votes in an election. It applies daily. The standards and values that are the moral foundations of society are also the foundations of their lives.

Democracy is essential to preserving freedom. As British historian Lord Acton stated, "Power tends to corrupt, and absolute power corrupts absolutely." If no individual can be trusted with power

indefinitely, it is even more true that no government can be. It has to be checked, and the best way of doing so is through the will of the majority, bearing in mind that this will never can be a substitute for individual human rights.

I often am asked whether I think there will be a single international democracy, known as a "new world order." Though many may yearn for one, I do not believe it ever will arrive. We are misleading ourselves about human nature when we say, "Surely we're too civilized, too reasonable, ever to go to war again," or "We can rely on our governments to get together and reconcile our differences." Tyrants are not moved by idealism. They are driven by naked ambition. Idealism did not stop Adolf Hitler or Joseph Stalin. Sovereign nations' best hope is to maintain strong defenses. Indeed, that has been one of the most important moral as well as geopolitical lessons of the twentieth century. Dictators are encouraged by weakness; they are stopped by strength. By strength, I do not merely mean military might, but the resolve to use that power against evil.

The West did show sufficient resolve against Iraq during the Persian Gulf War, but failed bitterly in Bosnia. In this case, instead of showing resolve, it preferred "diplomacy" and "consensus." As a result, more than 250,000 people were massacred. This was a horror that I, for one, never expected to see again in my lifetime, but it happened. Who knows what tragedies the future holds if we do not learn from the repeated lessons of history? The price of freedom still is—and always will be—eternal vigilance.

Free societies demand more care and devotion than any others. They are, moreover, the only ones with moral foundations, and those are evident in their political, economic, legal, cultural, and, most importantly, spiritual life.

We who are living in the West today are fortunate. Freedom has been bequeathed to us. We have not had to carve it out of nothing; we have not had to pay for it with our lives. Others before us have done so. Yet, it would be a grave mistake to think that freedom requires nothing of us. Each of us has to earn freedom anew in order to possess it. We do so not just for our own sake, but for that of our children, so they may build a better future that will sustain the responsibilities and blessings of freedom over the wider world. ■

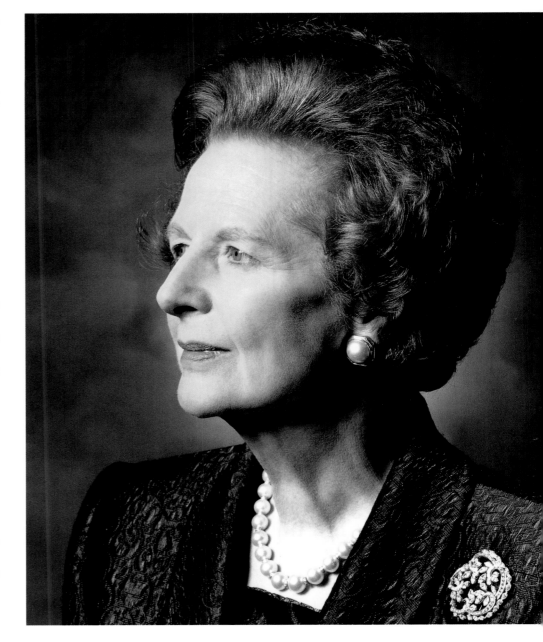

Bella Abzug

Women are still regarded by many male politicians and the media as a special-interest group, as if we were peanut or chicken-feed lobbyists. That description makes me angry. Let us remember who we are.

We are a majority of this nation. From its founding, we have worked in its fields, homes, shops, and factories. We have borne and raised its generations. We have nursed the sick and cared for the old; we have taught the children. We have cooked, cleaned, done all the household chores, and worked without pay as family chauffeurs, seamstresses, laundresses, hostesses, and all-purpose nurturers. We have given millions of hours in volunteer work to countless organizations and institutions that provide human services. We have served in the armed forces and given our lives for our country. We have paid taxes and created wealth by our labor. We have enriched our national culture and been the most public-minded citizens and do-gooders. We have done all this in the face of discrimination and wage exploitation, yet when we sought to get a guarantee of equal rights into our Constitution, the men who hold effective power would not give it to us.

As in other nations, the United States, throughout its history, has been marked by conflict between classes and social groups, between male rule and female subordination, between those who would reserve power only for the moneyed elite and those who say democracy must be shared by all the people. Today, those of us who place humane, predominantly female values and democratic rights in the foreground are being attacked . . . for offering what they ridicule as "old ideas." But eating every day, having work, shelter, clothing, education, and health care are ideas that will never go out of style, no matter how much heads of corporations hope that robots will replace human beings and that women will meekly continue to accept lower wages and inferior status. . . .

The gender gap is not an unresolvable war between the sexes and it may very well reflect the different ways in which men and women are acculturated. According to national polls, men support our quest for equality on the more narrowly defined women's issues but seem much less willing to examine critically the premises of society and governmental decisions in the same way that women are unafraid to do.

As long as male voters continue to accept and defend the status quo, there will continue to be a gender gap. That voting and opinion gap does not reflect the views of all women, but its breadth and depth is unquestionable, and it will continue to grow until the majority views of women prevail. I believe that eventually the different thinking of women will register in the consciousness of men as well, and then the gap will narrow. I look forward to that day.

In the meantime, participating in politics, registering, and voting are the minimum that we can do. It is an opportunity that millions of women and men in many other nations do not have. Some have died for this basic democratic right. You don't have to die for it. You just have to walk into a voting booth in your neighborhood and pull the lever.

That is . . . the first and easiest step toward making possible our dream of equality for women in a more peaceful world. ▪

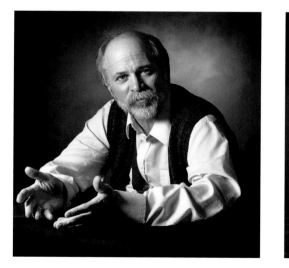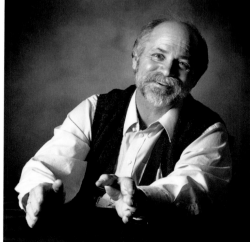

RON KOVIC

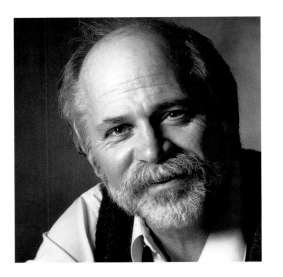

IN MANY WAYS, THE VIETNAM VETERANS AGAINST THE WAR MAY have been ahead of our time. We were fighting for a more truthful dialogue. We fought for a new country, and millions of people joined us in that struggle. We who opposed the war were good citizens, just like the Czechs who filled Wenceslas Square.

When a system goes astray, it is the right and obligation of citizens to oppose it and change it—for themselves and for generations to come. ◼

While covering a press conference in San Francisco, I was impressed by a man in a wheelchair at the back of the room whose questions were more eloquent and insightful than the speaker's presentation. As I was packing up my gear, we struck up a conversation that ended up lasting several hours. It wasn't until late in our captivating talk that I realized that this humble man had written Born on the Fourth of July.*—M.C.*

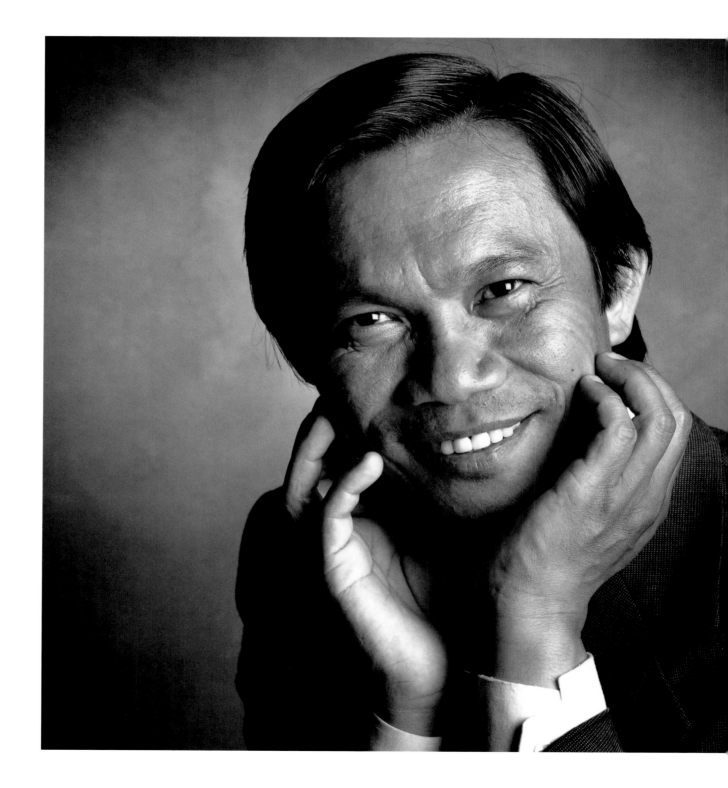

DITH PRAN

On April 17, 1975, the communist Khmer Rouge came to power. At first, everyone was happy because we thought peace had finally come. But we were wrong. The Khmer Rouge pointed guns at us and forced us to leave the cities. Families were separated from each other. People died along the way to the forced labor camps. At the camps we worked fourteen to sixteen hours a day, every day, and were given one bowl of watery rice to eat. People were dying everywhere around me. We lived in constant fear. I prayed to Buddha that if I survived, I would tell the world what the Khmer Rouge did to their own people. They took away our families, freedom, our lives. They starved, beat, tortured, and killed us. One thing they couldn't take away was our spirit.

I'm not a politician. I'm not a hero. I'm a messenger. It's very important that we study genocide because it has happened again and again. We made a mistake because we didn't believe Cambodians would kill Cambodians. We didn't believe that one human being would kill another human being. That's why we allowed them to kill us. I want you to know that genocide can happen anywhere on this planet. Together we can prevent genocide from happening again. Together we can make a better future for our children. ■

JODY WILLIAMS

THE DESIRE TO BAN LAND MINES IS NOT NEW. IN THE LATE 1970s, the International Committee of the Red Cross, along with a handful of nongovernmental organizations (NGOs), pressed the world to look at weapons that were particularly injurious and/or indiscriminate. One of the weapons of special concern was land mines. People often ask why the focus on this one weapon. How is the land mine different from any other conventional weapon?

Land mines distinguish themselves because once they have been sown, once the soldier walks away from the weapon, the land mine cannot tell the difference between a soldier or a civilian—a woman, a child, a grandmother going out to collect firewood to make the family meal. The crux of the problem is that while the use of the weapon might be militarily justifiable during the day of the battle, or even the two weeks of the battle, or maybe even the two months of the battle, once peace is declared the land mine does not recognize that peace. The land mine is eternally prepared to take victims. In common parlance, it is the perfect soldier, the eternal sentry. The war ends; the land mine goes on killing.

Since World War II most of the conflicts in the world have been internal conflicts. The weapon of choice in those wars has all too often been land mines—to such a degree that what we find today are tens of millions of land mines contaminating approximately seventy countries around the world. The overwhelming majority of those countries are found in the developing world, primarily in those countries that do not have the resources to clean up the mess, to care for the tens of thousands of land mine victims. The end result is an international community now faced with a global humanitarian crisis. . . .

Estimates range between one and two hundred million mines in stockpiles around the world.

When the ICRC pressed in the seventies for the governments of the world to consider increased restrictions or elimination of particularly injurious or indiscriminate weapons, there was little support for a ban of land mines. The end result of several years of negotiations was the 1980 Convention on Conventional Weapons (CCW). What that treaty did was attempt to regulate the use of land mines. While the Convention tried to tell commanders in the field when it was okay to use the weapon and when it was not okay to use the weapon, it also allowed them to make decisions about the applicability of the law in the midst of battle. Unfortunately, in the heat of battle, the laws of war do not exactly come to mind. When you are trying to save your skin you use anything and everything at your disposal to do so.

Throughout these years the Cold War raged on, and internal conflicts that often were proxy wars of the superpowers proliferated. Finally with the collapse of the Soviet Bloc, people began to look at war and peace differently. Without the overarching threat of nuclear holocaust, people started to look at how wars had actually been fought during the Cold War. What they found was that in the internal conflicts fought during that time, the most insidious weapon of all was the antipersonnel land mine—and that it contaminated the globe in epidemic proportion. . . .

It was the NGOs, the nongovernmental organizations, who began to seriously think about trying to deal with the root of the problem. To eliminate the problem, it would be necessary to eliminate the weapon. The work of NGOs across the board was affected by the land mines in the developing world. Children's groups, development organizations, refugee

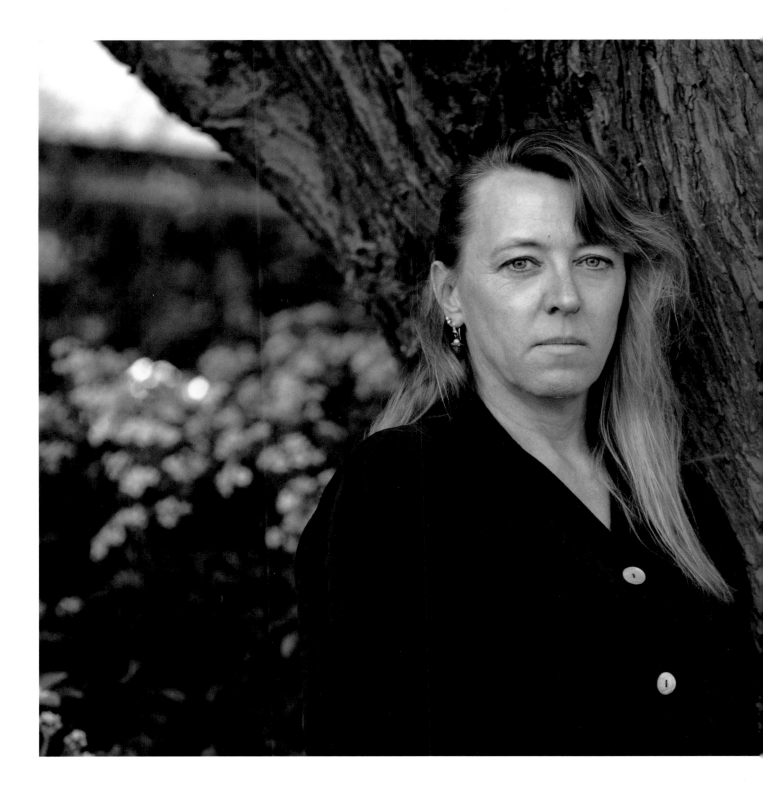

organizations, medical and humanitarian relief groups—all had to make huge adjustments in their programs to try to deal with the land mine crisis and its impact on the people they were trying to help. It was also in this period that the first NGO humanitarian demining organizations were born—to try to return contaminated land to rural communities.

It was a handful of NGOs, with their roots in humanitarian and human rights work, which began to come together in late 1991 and early 1992 in an organized effort to ban antipersonnel land mines. In October of 1992, Handicap International, Human Rights Watch, Medico International, Mines Advisory Group, Physicians for Human Rights, and Vietnam Veterans of America Foundation came together to issue a Joint Call to Ban Antipersonnel Land mines. These organizations, which became the steering committee of the International Campaign to Ban Landmines, called for an end to the use, production, trade, and stockpiling of antipersonnel land mines. The call also pressed governments to increase resources for humanitarian mine clearance and for victim assistance.

From this inauspicious beginning, the International Campaign has become an unprecedented coalition of one thousand organizations working together in sixty countries to achieve the common goal of a ban of antipersonnel land mines. And as the Campaign grew, the steering committee was expanded to represent the continuing growth and diversity of those who had come together in this global movement. We added the Afghan and Cambodian Campaigns and Radda Barnen in 1996, and the South African Campaign and Kenya Coalition early [in 1997] as we continued to press toward our goal. And in six years we did it. In September of [1997], 89 countries came together in Oslo and finished the negotiations of a ban treaty based on a draft drawn up by Austria. . . .

[In November 1997,] 121 countries came together again to sign that ban treaty. . . .

The Oslo negotiations gave the world a treaty banning antipersonnel land mines which is remarkably free of loopholes and exceptions. It is a treaty which bans the use, production, trade, and stockpiling of antipersonnel land mines. It is a treaty which requires states to destroy their stockpiles within four years of its entering into force. It is a treaty which requires mine clearance within ten years. It calls upon states to increase assistance for mine clearance and for victim assistance. It is not a perfect treaty—the Campaign has concerns about the provision allowing for antihandling devices on antivehicle mines; we are concerned about mines kept for training purposes; we would like to see the treaty directly apply to nonstate actors and we would like stronger language regarding victim assistance. But, given the close cooperation with governments which resulted in the treaty itself, we are certain that these issues can be addressed through the annual meetings and review conferences provided for in the treaty.

As I have already noted . . . 121 countries signed the treaty. Three ratified it simultaneously—signaling the political will of the international community to bring this treaty into force as soon as possible. It is remarkable. Land mines have been used since the U.S. Civil War, since the Crimean War, yet we are taking them out of arsenals of the world. It is amazing. It is historic. It proves that civil society and governments do not have to see themselves as adversaries. It demonstrates that small and middle powers can work together with civil society and address humanitarian concerns with breathtaking speed. It shows that such a partnership is a new kind of superpower in the post–Cold War world. ■

HER MAJESTY QUEEN NOOR AL-HUSSEIN

IN MY WORK SUPPORTING REFUGEES AND THOSE PLUNGED INTO poverty and despair by conflict, and in my work with the International Campaign to Ban Landmines, I have witnessed the devastation of war in the Middle East, in the former Yugoslavia, and in Asia. I have seen it in the faces of the women of Srebrenica, struggling to carry on without their husbands, fathers, and sons, and even without certain knowledge of what happened to them. I have seen it in the supposedly "temporary" Palestinian refugee camps in Jordan, and elsewhere in our region, where people endeavor to make a life and hang on, even half a century later, to the hope of returning to their homeland one day. And, I have seen it in those striving to overcome the devastation land mines have wrought on their bodies and their lives in rural Jordan, in Lebanon, in Cambodia, and in Vietnam.

As we enter a new era, it is time to create a new culture—a culture of peace rather than war. The world is becoming both more global and more fragmented; in the first half of the twentieth century, our wars were mammoth struggles between superpowers and their allies. Now, long-standing ethnic tensions have escaped the restraints of larger state control, and are escalating into conflicts—smaller, more localized, but no less devastating to those caught up in them.

As we see all too vividly in the Middle East, where the spending on armaments is the highest per capita in the world, this is a colossal waste of valuable resources—monetary, material, and human. The presence and availability of these vast arsenals, from nuclear weapons to land mines to handguns, rather than acting as a deterrent, actually makes it harder to recover from conflict and establish a lasting peace.

Land mines pose one of the chief threats to recovery and progress because they continue killing after the conflict has stopped. When war ends, the guns and mortars are stilled, but no one turns off the mines. And because they are small, and destroy lives one by one, their horrific consequences can go as unnoticed as the mines themselves.

We have made much progress. A new sense of possibility is taking hold, producing a new coalition activism. Through a groundbreaking series of international conferences on issues such as population, social development, women's and children's rights, water and environment, and others, the international community has defined global norms of

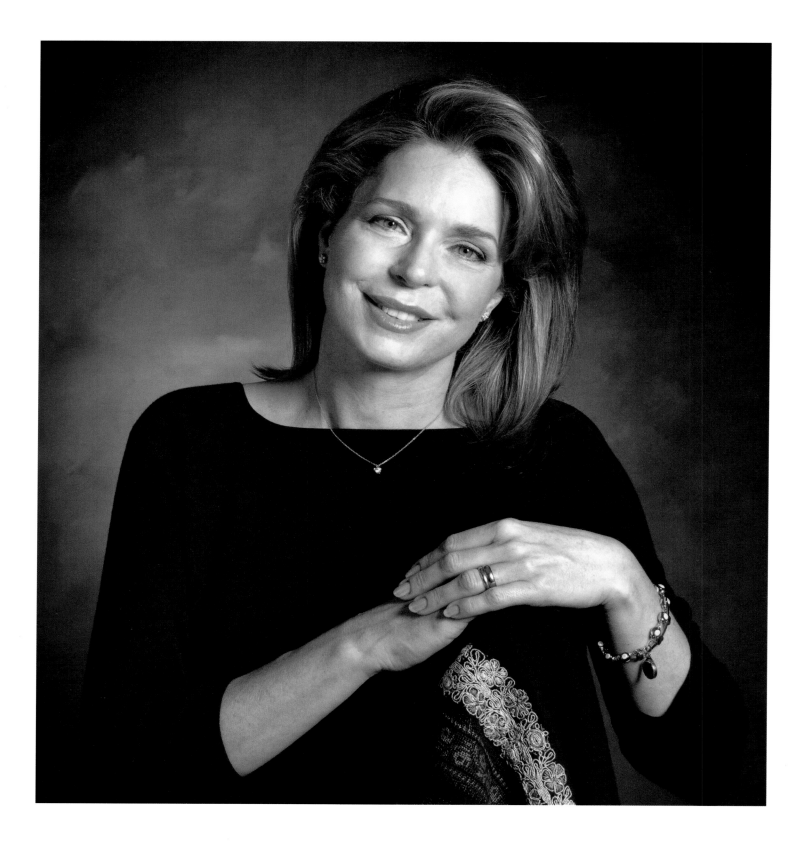

fundamental human rights and needs. For example, in a few short years the fight to eradicate land mines has gone from a noble dream to international law. But land mines are only the tip of an iceberg in the problem of armaments of every kind.

The real issue is security. As long as a nation, or a community, or an individual feels threatened, violence and recourse to weapons are never far from the surface. But like so much else, the definition of security is changing. Threats today come not only from war, but also from economic and social inequities, human rights abuses, marginalization, and poverty.

True security is not simply a matter of protecting borders from military aggression, but of providing a stable environment for all citizens, women and men, of all races and creeds, to participate fully in commercial and political life. Peace is not merely the absence of hostilities, but a positive human security founded in equity.

As King Hussein described it, the purpose of peace "is to promote the security and the prosperity of peoples. Without security, there can be no assured prosperity. And without prosperity, there can be no assured security."

In my development work in the Middle East over the past twenty-four years, I have seen clearly that providing the prosperity that underpins peace requires moving beyond traditional, ineffective, centralized social welfare schemes, to projects that empower the poor to help themselves. As we have enabled individuals, women in particular, to become active participants and decision makers in the affairs of their communities, they also become genuine economic and political forces, increasing their status and influence. They build stable, healthy, and prosperous communities, which in turn can engage in regional partnerships in the wider pursuit of peace. These models for sustainable economic growth and political participation are an essential component of our larger quest for justice, peace, and understanding in the Middle East.

We have also seen over the past decades that it is not enough simply to sign a peace treaty. Reconciliation can be one of the greatest challenges of conflict recovery, but it is essential in order to prevent conflicts from recurring. As the recent history of our region has demonstrated, such reconciliation is possible, but often laborious and lengthy.

It takes courage to hold one's hand out to an old adversary. Often, the most powerful way to overcome the enmity of previous generations is to encourage the next generation, the future guardians of peace, to understand both their opportunities in a changing world and their duties toward themselves and others. In recent years we have witnessed in our region and elsewhere that with education and opportunity, even children can be a force for peace out of proportion to their years, breaking down the barriers of ignorance and prejudice through mutual respect and understanding.

If we can bring to education for peace the same level of commitment, expertise, and resources that previous generations devoted to their military academies, I am certain that we will be well on the way to achieving a more lasting security than the arsenals of war could ever provide.

These ideas were fundamental to my beloved mentor King Hussein—one of the great Architects of Peace. A devout Muslim, he believed, deeply and passionately, in authentic Islamic values such as education, tolerance, and consensus building, and above all, in peace. He achieved remarkable progress in modernizing a conservative developing society through initiatives such as promoting the role of women, universal education, and a participatory and pluralistic system of governance—all within the framework of traditional Arab and Islamic principles.

By personal example, he inspired the different people of our region to understand what he felt so deeply: that real peace is made not only among governments but among peoples, that it is written not only on pieces of paper but must be enshrined in the hearts of those who live together side by side. ■

Mahnaz Afkhami

THE CENTURY JUST PASSED WAS MARKED BY UNPRECEDENTED violence and cruelty. Most nations suffered or contributed to war, destruction, and genocide, the most egregious of which—the two world wars and the Holocaust—began and occurred mainly in the West. Untold numbers were sacrificed at the altar of ideology, religion, or ethnicity. Innocent people were led in droves to destruction in various gulags—prisons large enough to pass for cities and cities confined enough to pass for prisons.

Women and children everywhere suffered most from violence not of their making, perpetrated against them in national wars, in ethnic animosities, in petty neighborhood fights, and at home. Many of us have lived most of our lives under the threat of total annihilation because mankind achieved the technological know-how to self-destruct. The end of the Cold War removed the immediate causes of wholesale destruction—but not the threat contained in our knowledge. We must tame this knowledge with the ideals of justice, caring, and compassion summoned from our common human spiritual and moral heritage, if we are to live in peace and serenity in the twenty-first century.

The promotion of a culture of peace requires more than an absence of war. In the past two hundred years most of the world lived directly or indirectly within a colonial system. This system reflected an increasingly divided world of haves and have-nots. The modernizing elite in the technologically and economically poor nations responded to colonialism by seizing the power of the state and using it to change their societies, hoping to achieve justice at home and economic and cultural parity abroad. The politics of changing traditional social structures and processes by using state power did not always result in social progress and economic development, but it did lead to state supremacy and autocracy. In the more extreme cases autocratic regimes were transformed to either forward-looking or reactionary totalitarianism—of socialist-Marxist, fascist, or religious-fundamentalist types. These systems clearly failed or are failing. But at the time they were adopted, to many they represented hope and a promise of economic change, distrib-

utive justice, and a better future. As we move forward in the first decades of the new millennium, economic and political globalization is likely to weaken the state. Deprived of the protection of the state, a majority of the people in the developing countries will have to fend for themselves against overwhelming global forces they cannot control. The most vulnerable groups, among them women and children, will suffer most. Clearly, any definition of a culture of peace must address the problem of achieving justice for communities and individuals who do not have the means to compete or cope without structured assistance and compassionate help.

As we move into the twenty-first century, women's status in society will become the standard by which to measure our progress toward civility and peace. The connection between women's human rights, gender equality, socioeconomic development, and peace is increasingly apparent. International political and economic organizations invariably state in their official publications that achieving sustainable development in the global South, or in less-developed areas within the industrialized countries, is unlikely without women's participation. It is essential for the development of civil society, which, in turn, encourages peaceful relationships within and between societies. In other words, women, who are a majority of the peoples of the earth, are indispensable to the accumulation of the kind of social capital that is conducive to development, peace, justice, and civility. Unless women are empowered, however, to participate in the decision-making processes—that is, unless women gain political power—it is unlikely that they will influence the economy and society toward more equitable and peaceful foundations.

Women's empowerment is intertwined with respect for human rights. But we face a dilemma. In the future, human rights will be increasingly a universal criterion for designing ethical systems. On the other hand, the "enlightened" optimism that spearheaded much of the humanism of the nineteenth and twentieth centuries is now yielding to a pessimistic view that we are losing control over our lives. We sense a

growing cynicism engulfing our view of government and political authority. In the West, where modern technology is invented and domiciled, many people feel overwhelmed by the speed with which things both moral and material change around them. In non-Western societies, the inability to hold on to some constancy that in the past provided a cultural anchor and therefore a bearing on one's moral and physical position today often leads to normlessness and bewilderment. In the West or East, no one wishes to become a vessel for a technology that evolves uncontrolled by human will. On the other hand, it is becoming increasingly difficult for any one individual, institution, or government to exert its will meaningfully, that is, to ethically mold technology to human moral needs.

This seemingly uncontrollable technology, however, will be a harbinger of great promise, if we agree on the shared values contained in our major international documents of rights, and if we adopt a method of decision making that justly reflects our common values. After all, we have gained almost magical powers in science and technology. We have overcome the handicaps of time and space on our planet. We have uncovered many secrets of our universe. We can feed and clothe the peoples of our world, protect and educate our children, and provide security and hope for the poor. We can cure many of the diseases of body and mind that were deemed scourges of humanity only a few decades ago. We seem to have passed the era of absolutes, where leaders assumed the right to incarcerate, slaughter, or otherwise constrain their own people and others in the name of some imagined good. We have the ability to achieve, if we master the necessary goodwill, a common global society blessed with a shared culture of peace that is nourished by the ethnic, national, and local diversities that enrich our lives. To achieve this blessing, however, we must assess our present situation realistically, assign moral and practical responsibility to individuals, communities, and countries commensurate with their objective ability and, most importantly, we must subordinate power in all its manifestations to our shared humane values. ■

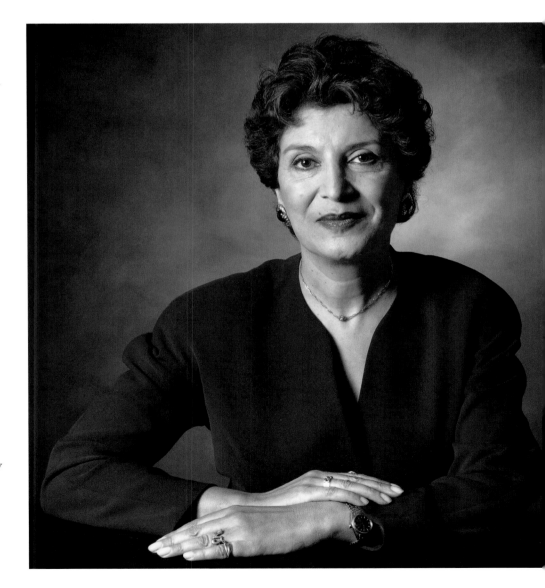

DR. HELEN CALDICOTT

THE ONLY CURE IS LOVE. I HAD JUST WALKED AROUND MY garden. It is a sunny, fall day, and white fleecy clouds are scudding across a clear, blue sky. The air is fresh and clear with no taint of chemical smells, and the mountains in the distance are ringed by shining silver clouds. I have just picked a pan full of ripe cherry guavas to make jam, and the house is filling with the delicate aroma of simmering guavas. Figs are ripening on the trees and developing that gorgeous deep red glow at the apex of the fruit. Huge orange-colored lemons hang from the citrus trees, and lettuces, beetroots, and cabbages are growing in the veg-etable garden. The fruit and vegetables are organically grown, and it feels wonderful to eat food that is free of man-made chemicals and poisons.

It is clear to me that unless we connect directly with the earth, we will not have the faintest clue why we should save it. We need to have dirt under our fingernails and to experience that deep, aching sense of physical tiredness after a day's labor in the garden to really understand nature. To feel the pulse of life, we need to spend days hiking in forests surrounded by millions of invisible insects and thousands of birds and the wonder of evolution. Of course, I realize that I am very fortunate indeed to be able to experience the fullness of nature so directly—literally in my own backyard. For many people—especially those living in urban areas who are unable to travel out of them regularly—such an experience is difficult to come by. Still, I urge all to try in some way to make a difficult connection with the natural world.

Only if we understand the beauty of nature will we love it, and only if we become alerted to learn about the planet's disease processes can we decide to live our lives with a proper sense of ecological respon-sibility. And finally, only if we love nature, learn about its ills, and live accordingly will we be inspired to participate in needed legislative activ-ities to save the earth. So my prescription for action to save the planet is, Love, learn, live, and legislate. ■

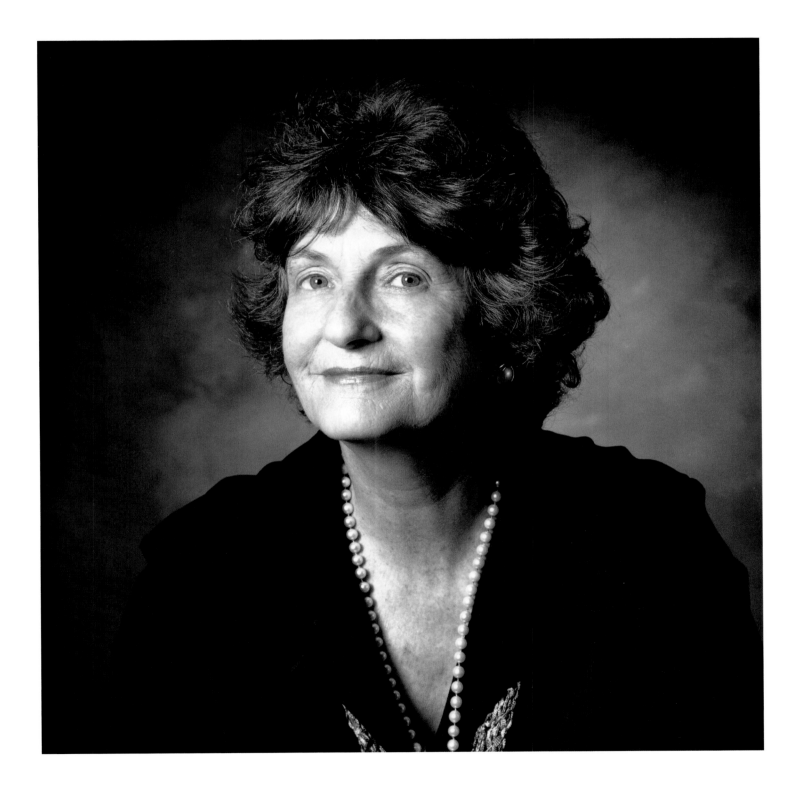

CHIEF LEONARD GEORGE

OUR MOTHER THE EARTH IS SUFFERING. WE HAVE PEOPLE WITH the vision and understanding who care. Their wish is to save wildlife and ecosystems, to stop the suffering of indigenous people. But we fail to realize that the first step in healing is within ourselves. We must face the worst in ourselves in order to be our best. We have to shed the tears of oppression and learn to love, honor, and respect ourselves. Once we have it within, then we have to give it away. Our children must inherit a better way. ∎

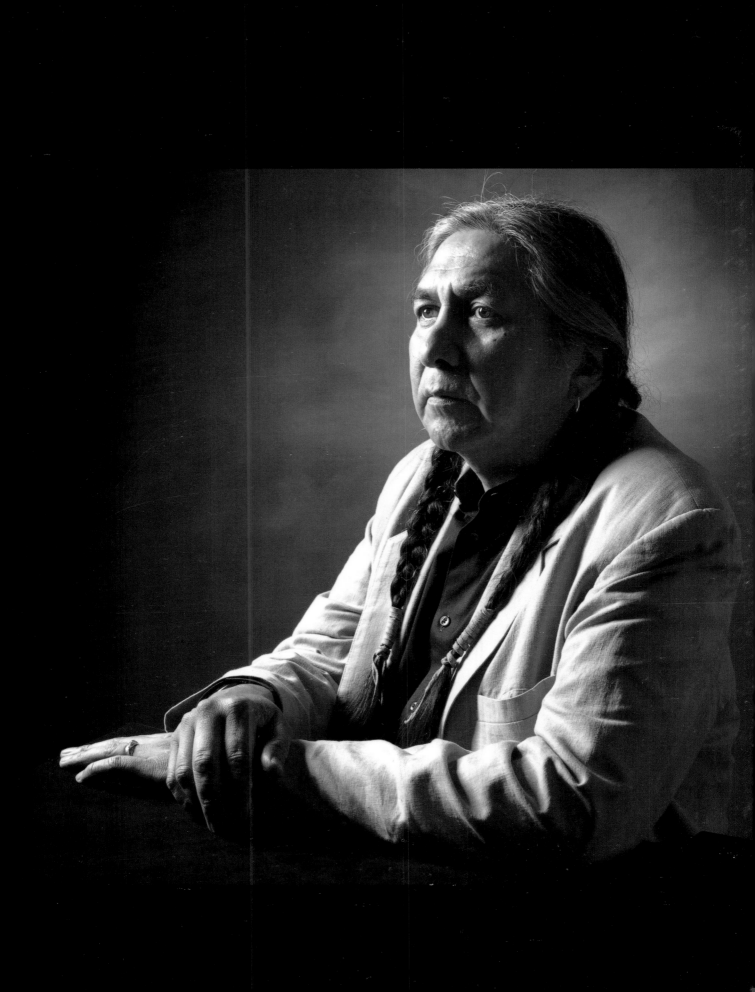

PAUL HAWKEN

WE ARE BEGINNING A MYTHIC PERIOD OF EXISTENCE, RATHER LIKE the age portrayed in the Bhagavad Gita or in other ancient tales of darkness and light. We live at a time where every living system on earth is in decline, and the rate of decline is accelerating as our economy grows. The very practices that bring us the goods and services we desire are destroying the earth. Given current corporate practices, not one wildlife reserve, wilderness, or indigenous culture will survive the global market economy. We are losing our forests, fisheries, coral reefs, topsoil, water, biodiversity, and climatic stability. The land, sea, and air have been functionally transformed from life-supporting systems into repositories for waste.

To feel the momentum of loss is to want to close one's eyes. Yet, to close one's eyes is to do the very thing that will bring forth the fruits of ignorance. I believe in rain, in odd miracles, in the intelligence that allows terns and swallows to find their way across the earth. And I believe we are capable of creating a remarkable future for humankind. As much as people are causing damage, each person contains within them the basis for hope. None of us individually wants what we are doing collectively.

Worldwide, more than one hundred thousand nongovernmental organizations, foundations, and citizens' groups are addressing the issue of social and ecological sustainability in the most complete sense of the word. Together they address a broad array of issues, including environmental justice, ecological literacy, public policy, conservation, women's rights and health, population, renewable energy, corporate reform, labor rights, climate change, trade rules, ethical investing, ecological tax reform, water, and much more. These groups follow Gandhi's imperatives: Some resist, while others create new structures, patterns, and means. The groups tend to be local, marginal, poorly funded, and overworked. It is hard for most groups not to feel palpable anxiety—that they could perish in a twinkling. At the same time, a deeper pattern is emerging that is extraordinary.

If you ask each of these groups for their principles, frameworks, conventions, models, or declarations, you will find they do not conflict. This has never happened before in history. In the past, movements that became powerful started with a unified or centralized set of ideas (Marxism, Christianity, Freud) and disseminated them, creating power struggles over time as the core mental model or dogma was changed, diluted, or revised. The sustainability movement did not start this way. It does not agree on everything, nor should it ever, but remarkably it shares a basic set of fundamental understandings about the earth, how it functions, and the necessity of fairness and equity for all people in partaking of the earth's life-giving systems.

These groups believe that self-sufficiency is a human right; they imagine a world where the means to kill people is not a business but a crime, where families do not starve, where fathers can work, where children are never sold, where women cannot be impoverished because they choose to be mothers. They believe that water and air belong to us all, not to the rich. They believe seeds and life itself cannot be owned or patented by corporations. They believe that nature is the basis of true prosperity and must be honored. This shared understanding is arising spontaneously, from different economic sectors, cultures, regions, and cohorts. And it is absolutely growing and spreading, with no exception, worldwide. No one started this worldview, no one is in charge of it, no orthodoxy is restraining it. As external conditions continue to change and worsen socially, environmentally, and politically, organizations working toward sustainability increase, deepen, and multiply.

There is a difference between blind and heady optimism, and the deep conviction that no force can counter the truths we share and hold so deeply. This is the work of peace, and it is rapidly becoming the work of the world. ■

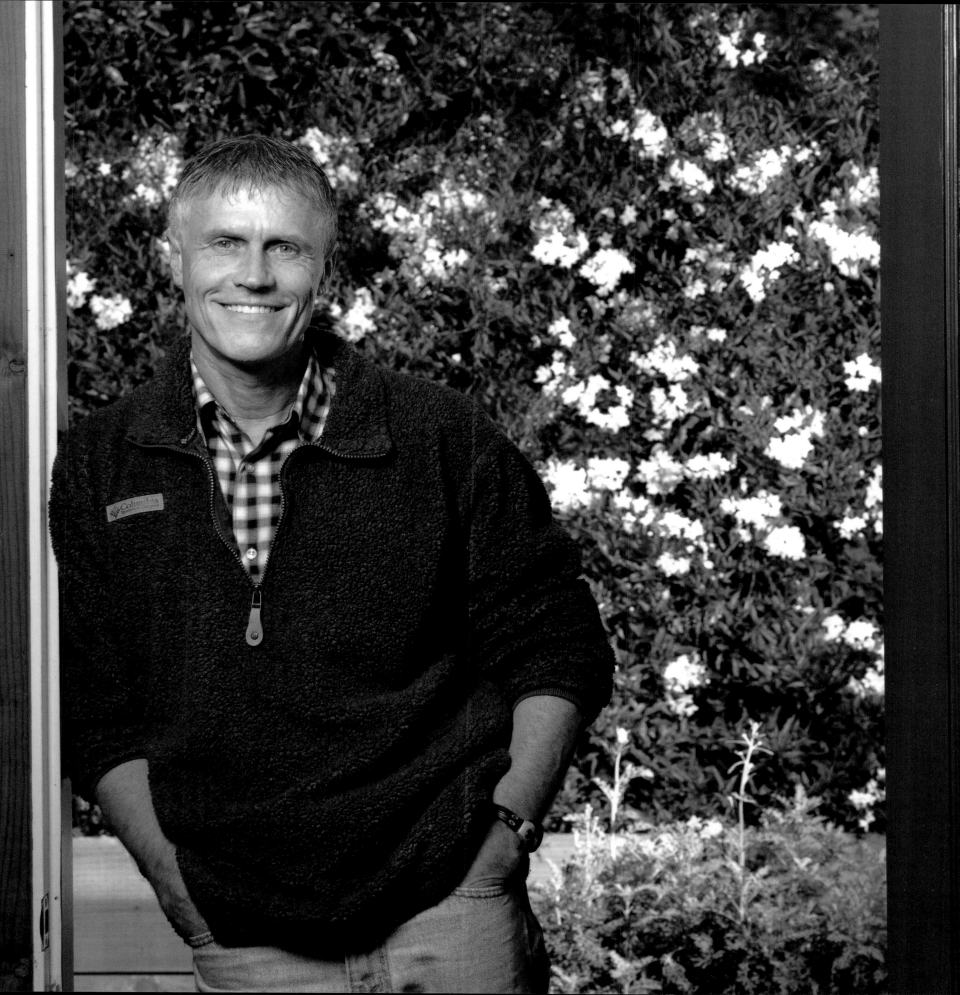

ROBERT REDFORD

As Aldous Huxley's perceived vision of a Brave New World descends upon us with alarming speed, we might ask ourselves how to be with it. Do we accept the shift from human values to cosmetic and material ones without resistance? Or do we labor to maintain our human values by adjusting to these seemingly inevitable changes through creating new paradigms for sustainability?

What new formulas await to preserve our environment, if not repair the damage already done? What solutions will save public education, now endangered in underprivileged areas by the greed and ignorant ambitions of faulty leadership—or support and sustain art as a vital part of any society or culture?

When I look about and see what the information age has wrought, I see a culture rich in materials for pleasure and excess communication but poor in depth of feeling and imagination—dull and flat and rich.

I vote for the fight. For if our humanity—our soul as a society—is overtaken by the material and cosmetic, there will be no hope of peace. ■

I photographed Robert Redford on a stunning sunny afternoon at his home in the mountains. After a warm welcome, we felt right at home—enough to completely rearrange his dining room to accommodate my lights. I usually gravitate toward the dining room table because it is most often the central meeting point of the house. I like to work face-to-face with subjects, rather than from behind the camera, engaging in conversation to evoke emotions. Bob's genuine candor and charm made this shoot especially memorable.—M.C.

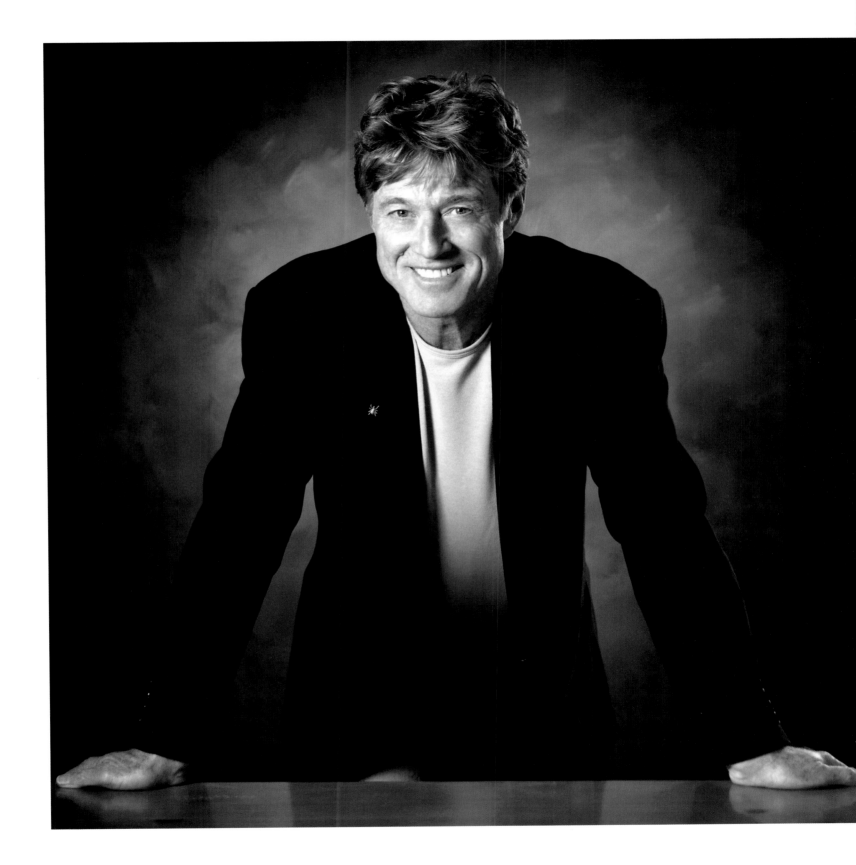

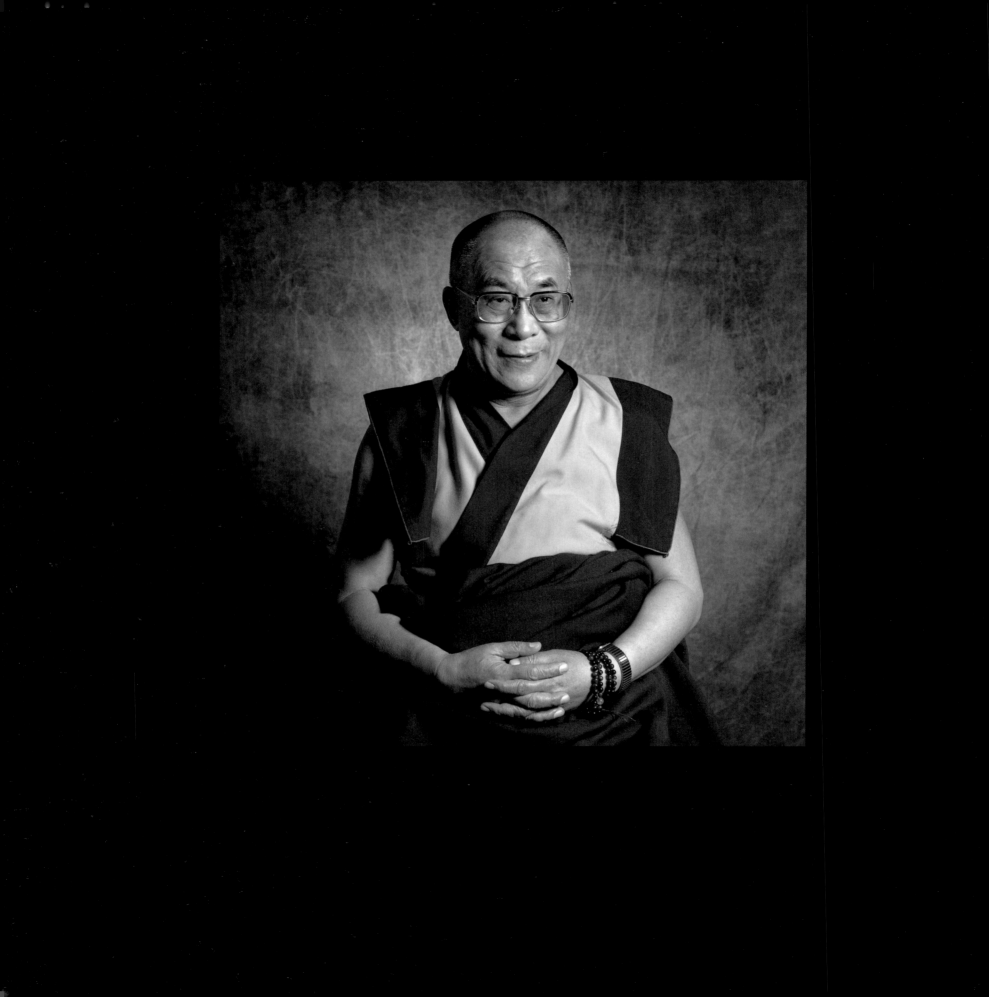

His Holiness the Dalai Lama

TODAY'S WORLD REQUIRES US TO ACCEPT THE ONENESS OF HUMANITY. In the past, isolated communities could afford to think of one another as fundamentally separate. Some could even exist in total isolation. But nowadays, whatever happens in one region eventually affects many other areas. Within the context of our new interdependence, self-interest clearly lies in considering the interest of others.

Many of the world's problems and conflicts arise because we have lost sight of the basic humanity that binds us all together as a human family. We tend to forget that despite the diversity of race, religion, ideology, and so forth, people are equal in their basic wish for peace and happiness.

Nearly all of us receive our first lessons in peaceful living from our mothers, because the need for love lies at the very foundation of human existence. From the earliest stages of our growth, we are completely dependent upon our mother's care and it is very important for us that she express her love. If children do not receive proper affection, in later life they will often find it hard to love others. Peaceful living is about trusting those on whom we depend and caring for those who depend on us. Most of us receive our first experience of both these qualities as children.

I believe that the very purpose of life is to be happy. From the very core of our being, we desire contentment. In my own limited experience I have found that the more we care for the happiness of others, the greater is our own sense of well-being. Cultivating a close, warmhearted feeling for others automatically puts the mind at ease. It helps remove whatever fears or insecurities we may have and gives us the strength to cope with any obstacles we encounter. It is the principal source of success in life. Since we are not solely material creatures, it is a mistake to place all our hopes for happiness on external development alone. The key is to develop inner peace.

Actions and events depend heavily on motivation. From my Buddhist viewpoint all things originate in the mind. If we develop a good heart, then whether the field of our occupation is science, agriculture, or politics, since the motivation is so very important, the result will be more beneficial. With proper motivation these activities can help humanity; without it they go the other way. This is why the compassionate mind is so very important for humankind. Although it is difficult to bring about the inner change that gives rise to it, it is absolutely worthwhile to try.

When you recognize that all beings are equal and like yourself in both their desire for happiness and their right to obtain it, you automatically feel empathy and closeness for them. You develop a feeling of responsibility for others: the wish to help them actively overcome their problems. True compassion is not just an emotional response but a firm commitment founded on reason. Therefore, a truly compassionate attitude towards others does not change even if they behave negatively.

I believe that we must consciously develop a greater sense of universal responsibility. We must learn to work not just for our own individual self, family, or nation, but for the benefit of all humankind. Universal responsibility is the best foundation both for our personal happiness and for world peace, the equitable use of our natural resources, and, through a concern for future generations, the proper care for the environment. . . .

A new way of thinking has become the necessary condition for responsible living and acting. If we maintain obsolete values and beliefs, a fragmented consciousness, and a self-centered spirit, we will continue to hold to outdated goals and behaviors. Such an attitude by a large number of people would block the entire transition to an interdependent yet peaceful and cooperative global society.

If we look back at the development in the twentieth century, the most devastating cause of human suffering, of deprivation of human dignity, freedom, and peace has been the culture of violence in resolving differences and conflicts. In some ways the twentieth century can be called the century of war and bloodshed. The challenge before us, therefore, is to make our new century a century of dialogue and of peaceful coexistence.

In human societies there will always be differences of views and interests. But the reality today is that we are all interdependent and have to coexist on this small planet. Therefore, the only sensible and intelligent way of resolving differences and clashes of interests, whether between individuals or nations, is through dialogue. The promotion of a culture of dialogue and nonviolence for the future of humankind is thus an important task of the international community. It is not enough for governments to endorse the principle of nonviolence or hold it high without any appropriate action to promote it.

It is also natural that we should face obstacles in pursuit of our goals. But if we remain passive, making no effort to solve the problems we meet, conflicts will arise and hindrances will grow. Transforming these obstacles into opportunities for positive growth is a challenge to our human ingenuity. To achieve this requires patience, compassion, and the use of our intelligence. ■

ROBERT F. KENNEDY JR.

GOD HAS GIVEN US A COMPLICATED WORLD IN WHICH WE
sometimes must choose between peace and goodness. The only place to
find true peace is inside ourselves. It is a product of faith and surrender
to God. ∎

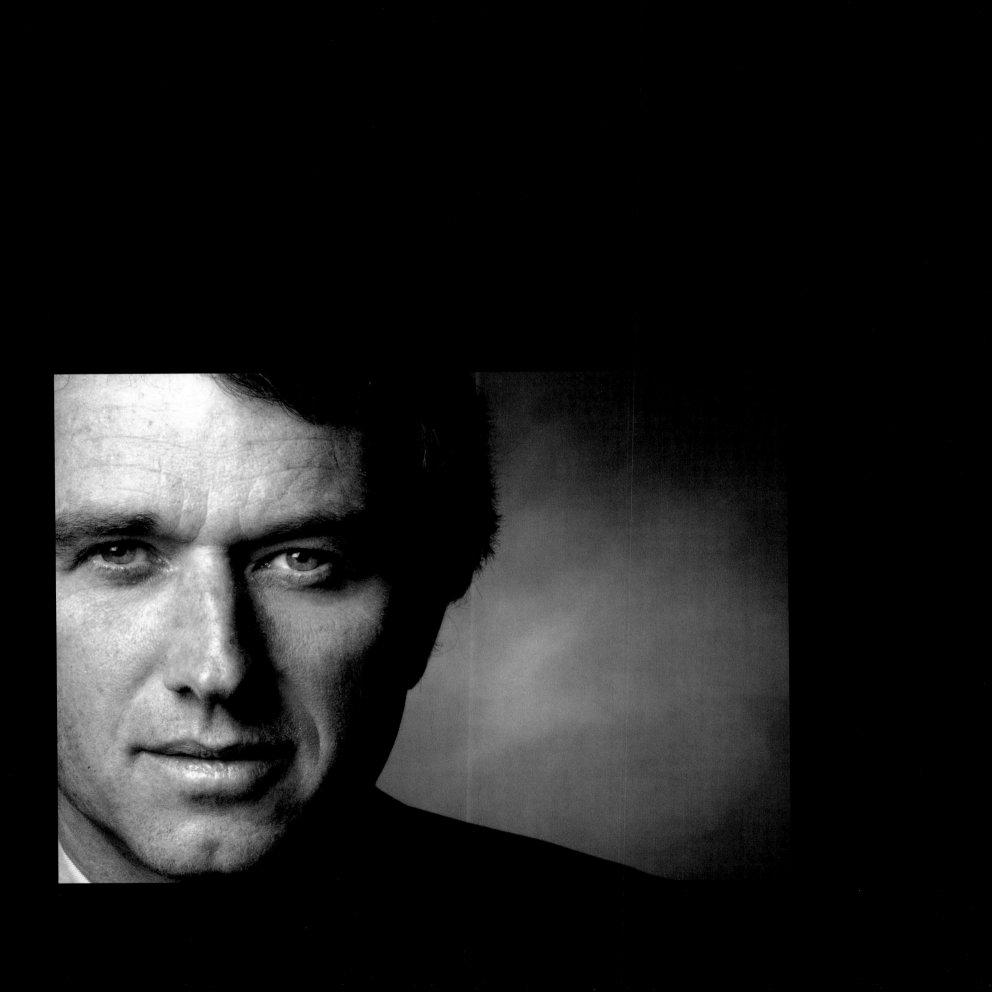

page 108

In 1993, **Hafsat Abiola**'s father, Moshood Abiola, won Nigeria's first democratic presidential election in ten years. The election was subsequently annulled by a ruling military council and he was incarcerated. He died on the eve of his release in 1998. Hafsat Abiola's mother, Kudirat, who mobilized pro-democracy groups during her husband's imprisonment, was assassinated in the streets of Lagos in 1996. Born and raised in Lagos, Hafsat Abiola attended Philips Academy and Harvard University. She founded and runs the Kudirat Initiative for Nigerian Democracy (KIND), which is dedicated to promoting democracy and strengthening civil society in Africa. | Kudirat Initiative for Nigerian Democracy, www.igc.org/kind, (301) 883-0169

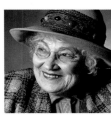
page 152

Bella Abzug was born in the Bronx on July 24, 1920, one month after the passage of the Nineteenth Amendment, giving women the right to vote. After attending Columbia University Law School, she practiced civil rights and labor law for twenty-three years. In 1970, she became the first Jewish woman elected to Congress. On her first day she introduced a resolution calling for the withdrawal of troops from Southeast Asia. Throughout her career, she was known as one of the most vocal proponents of civil rights for women, as well as for gays and lesbians. She died in 1998 and is survived by two daughters. | Women's Environment and Development Organization, www.wedo.org, (212) 973-0325

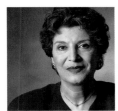
page 164

Born in Kerman, Iran, **Mahnaz Afkhami** is a leading proponent of women's rights in the Islamic world. She is president of Women's Learning Partnership (WLP) and executive director of the Foundation for Iranian Studies. She chaired the English department at the National University of Iran, founded the Association of Iranian University Women, and served as secretary general of the Women's Organization of Iran and minister of state for women's affairs prior to the Islamic revolution. She is the author of many books on women's roles in the Islamic world, including *Safe and Secure: Eliminating Violence Against Women and Girls in Muslim Societies.* Women's Learning Partnership, www.learningpartnership.org, (301) 654-2774

page 14

Dr. Maya Angelou is an acclaimed poet, historian, author, actress, playwright, civil rights activist, director, and producer. She has written ten best-selling books, which have earned her Pulitzer Prize and National Book Award nominations. Beginning her career in drama and dance, she worked for civil rights in the United States during the 1960s and spent five years in Egypt and Ghana, where she taught and edited for English-language publications. In addition to her many television credits as producer, writer, and director, she received an Emmy nomination for acting in the miniseries *Roots*. Angelou teaches at Wake Forest University in North Carolina.

page 72

Born in 1941, **Oscar Arias Sanchez** studied law and economics in his native Costa Rica, the United States, and England. He began his political career in 1970 in the left-wing National Liberation Party and was elected president of Costa Rica in 1986. He immediately set about working for peace in Central America, bringing the leaders of Guatemala, El Salvador, Honduras, and Nicaragua together for negotiations. Arias won the 1987 Nobel Peace Prize for his continuing efforts to foster democracy and peace among his war-torn neighbors. Since leaving office in 1990, he has continued his work through the Arias Foundation for Peace and Human Progress. | Arias Foundation for Peace and Human Progress, www.arias.or.cr

page 66

Joan Baez, the daughter of Quaker parents of Scottish and Mexican descent, began dual careers as a folksinger and political activist in the late 1950s. After her breakthrough appearance at the 1959 Newport Folk Festival, Baez recorded her first album, *Joan Baez,* which peaked at number three on the national charts. As her singing career took off, she used her newfound celebrity to promote equal rights for women and minorities and to protest the Vietnam War. She was arrested twice in 1967 for her opposition to the draft. She continues to focus public attention on human rights abuses and inequities.

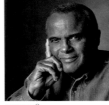
page 138

An icon of popular American music, **Harry Belafonte** was born in Harlem in 1927, and lived from age eight to fifteen in Jamaica, where he was influenced by the calypso and folk music he would later popularize in the 1950s. An active voice in the fight for civil rights, Belafonte introduced the first integrated television program in 1960 with his Emmy Award–winning "Tonight with Belafonte" and became the first black television producer at the same time. In 1985, he earned a Grammy Award for producing the *We Are the World* album. He was named UNICEF's goodwill ambassador in 1987. | United Nations Children's Fund, www.unicef.org, (212) 326-7000

page 148

On December 2, 1988, **Benazir Bhutto** was sworn in as prime minister of Pakistan, becoming the first woman to head the government of an Islamic state. Born in Karachi in 1953, she attended Harvard and Oxford Universities. Her father, Zulfikar Ali Bhutto, served as prime minister during the mid 1970s and was overthrown and executed in 1979. In the following period of political struggle, Bhutto spent nearly six years either in prison or under house arrest for her leadership of the then-opposition Pakistan People's Party. Bhutto's first period as prime minister ended in 1990. She returned to power in 1993 for three years. Pakistan People's Party, www.pakcyber.com/ppp

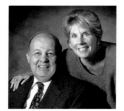

page 34

Sixty days after becoming White House press secretary in 1981, **James Brady** was shot by John Hinckley Jr. during an assassination attempt on President Ronald Reagan. Since leaving the White House, he has worked to prevent handgun violence with his wife, **Sarah**, chair of Handgun Control, Inc., the nation's largest citizens' gun control lobbying organization. In 1993, President Clinton signed the "Brady Bill" into law, which requires a five-day wait and background check on all handgun purchases through licensed dealers. The law has prevented hundreds of thousands of previously convicted felons and mentally ill people from purchasing guns. | Handgun Control, Inc., www.handguncontrol.org, (202) 898-0792

page 22

Born in Berkeley, California, in 1912, **David Brower** has been fighting conservation battles since 1938. Mr. Brower joined the Sierra Club in 1933 and was its first executive director from 1952 to 1969. In one of his more famous campaigns, he prevented the Grand Canyon from being dammed. Brower saw the club's membership grow from two thousand to seventy-seven thousand before leaving on request in 1969, after which he founded Friends of the Earth, the League of Conservation Voters, and Earth Island Institute. As a climber and mountaineer, Brower made seventy first ascents. He has been nominated for the Nobel Peace Prize three times. | Earth Island Institute, www.earthisland.org, (415) 788-3666

page 24

Retired **General Lee Butler** spent thirty-three years as an officer in the United States Air Force, attaining the rank of general in 1991. He served as commander in chief of the Strategic Air Command and commander in chief of the United States Strategic Command, where he was in charge of the air force and navy's strategic nuclear arsenal. Butler attended the United States Air Force Academy and the University of Paris, where he received a master's degree in international affairs. Butler is now president of the Second Chance Foundation in Omaha, Nebraska, a nonprofit organization dedicated to reducing nuclear danger. Second Chance Foundation, www.secondchancefdtn.org, (402) 334-0100

page 166

Dr. Helen Caldicott, a leading antinuclear activist and physician, first alerted the Australian public to the potential health risks of fallout from French nuclear weapon testing in the South Pacific. After moving to America to practice medicine at Children's Hospital Medical Center in Boston and to teach pediatrics at Harvard Medical School, she revived Physicians for Social Responsibility to focus on the hazards of nuclear power and founded Women's Action for Nuclear Disarmament. Caldicott is the author of several books; she was featured in the Oscar-winning film *If You Love This Planet,* which was declared political propaganda by the United States Department of Justice. | Star Foundation (Standing for Truth About Radiation), www.noradiation.org, (516) 324-0655

page 106

Geoffrey Canada grew up in poverty in the South Bronx. He has since dedicated his life to helping at-risk children and families secure educational and economic opportunities. Canada received his bachelor's degree from Bowdoin College and his master's in education from Harvard University. In 1990, he became president and CEO of Harlem's Rheedlen Centers for Children and Families. The recipient of many awards, he is founder and chief instructor of the Chang Moo Kwan Martial Arts School, which promotes "antiviolence" and conflict resolution. His most recent book is *Reaching Up for Manhood: Transforming the Lives of Boys in America.* | Rheedlen Centers for Children and Families, www.harlemoverheard.org, (212) 866-0700

page 90

Jimmy Carter served as the thirty-ninth president of the United States from 1977 to 1981. His administration's accomplishments include the peace treaty between Egypt and Israel and the SALT II treaty with the Soviet Union. After leaving the White House, President Carter and his wife, Rosalynn, founded the Atlanta-based Carter Center, a nonprofit organization that works to promote peace, democracy, and human rights. President Carter also teaches Sunday School and is a deacon at the Maranatha Baptist Church. He builds homes one week each year for Habitat for Humanity and is the author of fourteen books. | The Carter Center, www.cartercenter.org, (404) 331-3900

page 40

In 1962, **César Chávez** founded the National Farm Workers Association, later to become the United Farm Workers (UFW), which under Chavez's nonviolent leadership effectively unionized the produce industry. In 1965, the UFW called for a boycott of California table grapes, eventually winning a major victory five years later when growers accepted union contracts. During his lifelong tenure as UFW president, Chavez went on three hunger strikes—the longest lasting thirty-six days—and in 1966 marched 340 miles from Delano to Sacramento, California, to focus attention on the farmworkers' plight. When Chavez died in 1993, fifty thousand mourners attended his funeral. | United Farm Workers, www.ufw.org, (661) 822-5571

page 104

Theo Colburn is senior scientist and director of the Wildlife and Contaminants project at the World Wildlife Fund. She started her career as a zoologist late in life, after she and her husband retired from a successful pharmacy business to raise sheep. She became alarmed by pollution in the Gunnison River near their ranch in Colorado. Her involvement in Western water issues led her to seek a master's degree in ecology and a Ph.D. in zoology. Her pioneering work on the effects of synthetic chemicals on the endocrine system has led some to compare her to Rachel Carson, who warned the world about the dangers of DDT. | World Wildlife Fund, www.worldwildlife.org/toxics, (800) CALL-WWF

page 44

The eldest son of the late ocean explorer Jacques Cousteau, **Jean-Michel Cousteau** is a leading defender of marine environments. Trained at the Paris School of Architecture, Cousteau is an architect whose projects include artificial floating islands, schools, and an advanced marine studies center. He is the award-winning producer of dozens of his father's television and film programs, as well as many other educational multimedia programs. He now guides the Ocean Futures Society, a nonprofit organization in Santa Barbara, California, which merged the Jean-Michel Cousteau Institute and the Free Willy Keiko Foundation to protect the world's oceans. | The Ocean Futures Society, www.oceanfutures.org, (805) 899-8899

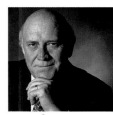

page 146

An attorney who held a number of South African ministerial posts, **F. W. de Klerk** became both the leader of South Africa's National Party and the country's president in 1989. Previously known as a political centrist, upon becoming president, de Klerk lifted the ban on the African National Congress and other political parties, released Nelson Mandela from prison, and essentially brought apartheid to an end, making possible a new constitution guaranteeing the principle of one person, one vote. He now heads the F. W. de Klerk Foundation, which works for peace in societies divided along cultural, ethnic, religious, or linguistic lines. F. W. de Klerk Foundation, www.fwdklerk.org.za

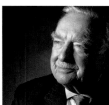

page 10

Identified in polls as the most trusted man in America, **Walter Cronkite** helped start the CBS Evening News in 1962 and anchored its half-hour broadcast until he retired in 1981. Cronkite began work as a journalist for the *Houston Post* in 1935, and later worked in radio news and sports before covering several fronts during World War II for the United Press. He served as the UP's chief correspondent at the Nuremberg Trials after the war and joined CBS News in 1950. Throughout his long career, Cronkite was known as a voice of objectivity and moderation in his coverage of presidential politics, the Vietnam War, and Watergate.

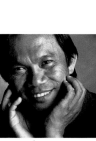

page 156

Dith Pran's wartime story of covering Cambodia's takeover by the communist Khmer Rouge with reporter Sidney Schanberg was told in the award-winning film *The Killing Fields*. Dith endured four years of starvation and torture in the Khmer Rouge's forced labor camps before escaping to Thailand in 1979. Schanberg represented Dith in accepting a 1976 Pulitzer Prize for their coverage. A photojournalist for the *New York Times* since 1980, Dith now runs the Dith Pran Holocaust Awareness Project. He lost more than fifty relatives to the Khmer Rouge, including his father, three brothers, one sister, and their families. | Dith Pran Holocaust Awareness Project, www.dithpran.org

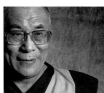

page 174

His Holiness the Dalai Lama, Tenzin Gyatso, is the head of state and spiritual leader of the Tibetan people. Born to a peasant family, His Holiness was recognized at the age of two, in accordance with Tibetan tradition, as the reincarnation of his predecessor, the thirteenth Dalai Lama, and thus an incarnation of Avalokiteshvara, the Buddha of Compassion. In 1959, nine years after China invaded Tibet, he fled to Dharamsala, India, where he lives today as leader of the Tibetan government in exile. He travels throughout the world teaching Tibetan Buddhism's central tenet of compassion. He won the Nobel Peace Prize in 1989. Tibetan Government in Exile, www.tibet.com, (212) 213-5010

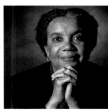

page 32

Marian Wright Edelman, founder and president of the Children's Defense Fund, has been an advocate for disadvantaged Americans her entire career. A graduate of Spelman College and Yale Law School, Mrs. Edelman began her career in the mid-1960s when, as the first black woman admitted to the Mississippi Bar, she directed the NAACP Legal Defense and Educational Fund office in Jackson, Mississippi. In 1968, she moved to Washington, D.C., as counsel for Martin Luther King Jr.'s Poor People's March. She founded the Washington Research Project, a public interest law firm, and served as director of the Center for Law and Education at Harvard University. | Children's Defense Fund, www.childrensdefensefund.org, (202) 628-8787

page 122

Writer and journalist **Yaël Dayan** was elected a Labor Party member of the Knesset, Israel's parliament, in 1992. In 1993, she became the first member of the Israeli Knesset to meet with Palestinian Liberation Organization Chairman Yasir Arafat in Tunis. An outspoken proponent in both the Knesset and the press of equal rights for women, as well as gay and lesbian rights, she is chairperson of the Knesset's Advancement of Women's Status Committee. She is the daughter of the late Israeli statesman and general Moshe Dayan, and has two daughters. In 1991, she was awarded the Bruno Kreisky Human Rights Award.

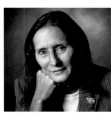

page 38

Born in 1934 in Durban, South Africa, **Arun Gandhi** is the fifth grandson of India's late spiritual leader Mohandas Karamchand "Mahatma" Gandhi. In 1946, just before India gained independence from Britain, Arun's parents took him to live with his grandfather for eighteen months. At twenty-three, Arun returned to India, worked as a reporter for *The Times* of India, and cofounded India's Center for Social Unity, whose mission is to alleviate poverty and caste discrimination. Arun and his wife, Sunanda, came to the United States in 1987 and in 1991 founded the M. K. Gandhi Institute for Nonviolence in Memphis, Tennessee. | M. K. Gandhi Institute for Nonviolence, www.gandhiinstitute.org, (901) 452-2824

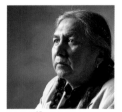

page 168

Chief Leonard George is the primary leader and elected chief of the Tsleil-Waututh Nation (which translates as "people of the inlet") in Burrard Inlet, British Columbia, native territories. A Coast Salish Aboriginal American, George is a lecturer, humorist, film and script consultant, and actor in such films as *Americathon*, *Shadow of the Hawk*, *White Fang*, and *Little Big Man*. He is also a traditional native singer and dancer. He worked for seven years as executive director of the Vancouver Aboriginal Centre, which provided support for urban Native Americans. He now works for TAKaya Developments. | Healing Our Spirit, (604) 983-8774

page 70

Jane Goodall is the world's foremost authority on chimpanzees, having closely observed their behavior for the past quarter century in the jungles of the Gombe Stream Game Reserve in Tanzania. The recipient of dozens of awards, Dr. Goodall received her Ph.D. from Cambridge University in 1965 and has been the scientific director of the Gombe Stream Research Center since 1967. Dr. Goodall has expanded her global outreach with the founding of the Jane Goodall Institute, based in Ridgefield, Connecticut. She now teaches and encourages young people to appreciate all creatures through the institute's Roots & Shoots program. The Jane Goodall Institute, www.janegoodall.org, (301) 565-0086

page 27

Mikhail Gorbachev worked his way up in the Communist Party to become general secretary in 1985 and president of the Soviet Union in 1990. His reforms of *glasnost*, meaning more open discussion of political and social issues, and *perestroika*, the reorganization of the Soviet economic and political system, were largely responsible for dismantling the Soviet Union. He has received the Nobel Peace Prize, the Orders of Lenin, the Red Banner of Labour, and the Badge of Honour. After stepping down from power in 1991, he has served as president of both the Gorbachev Foundation and Green Cross International, where he works to create a sustainable future. | The Gorbachev Foundation, www.gorbachevfoundation.neu.edu, (617) 262-4122

page 124

The son of a North Carolina dairy farmer, **Reverend Billy Graham** became one of the most influential Christian evangelists in American history. A graduate of Wheaton College in Illinois, he was ordained a Southern Baptist minister in 1939. He built his reputation after World War II through radio broadcasts, tent revivals, and rallies in the United States and Britain. He was first invited to the White House in 1949 by President Truman and provided counsel to every subsequent administration. From the pulpit, he spoke out against apartheid and segregation in the American South. He received the Congressional Gold Medal in 1996. | Billy Graham Evangelistic Association, www.theway.billygraham.org, (877) 2GRAHAM

page 78

In 1969, **Dr. Lorraine Hale** cofounded Hale House with her mother, the legendary Clara "Mother" Hale, who died in 1992. As Hale House's president and CEO, Hale has been at the fore-front of infant care in America for thirty years, caring for babies born addicted to drugs or infected with HIV while their parents go through rehab. The recipient of master's degrees in special education and psychology, and a Ph.D. from New York University, she worked throughout the New York City school system as a teacher, counselor, and psychologist before cofounding Hale House in Harlem. She and her mother have been recognized internationally for their work. | Hale House, www.halehouse.org, (212) 663-0700

page 92

Since gaining international recognition for her diaries of life in wartime Bosnia, **Nadja Halilbegovich** has spoken to and performed choral concerts for audiences throughout North America and Europe. As a thirteen-year-old, she was nearly killed when, upon leaving her house to play for the first time in six months, a bomb exploded seven feet from her. During the war, she hosted "Music Box," a program on the National Radio Station of Bosnia, and performed in internationally broadcast solo and choir performances. Her diaries have been published in Bosnia and Turkey. She now lives in Indianapolis, Indiana. | YES! (Youth for Environmental Sanity), www.yesworld.org, (877) 293-7226

page 96

Described as "the most articulate and persuasive spokesman" for the developing world, **Dr. Mahbub ul-Haq** pioneered many economic policies to help the poor. He served as chief economist of Pakistan's National Planning Commission during the 1960s, director of the World Bank's Policy Planning Department in the 1970s, and in various Pakistani cabinet posts during the 1980s. As special advisor to the United Nations Development Program, he developed the Human Development Index, which measures development by people's well-being, rather than by their income alone. Haq was the author of six books on poverty and development. He died in 1998 in New York. | Human Development Centre, http://undp.un.org.pk/hdc

page 170

Paul Hawken is an entrepreneur and sustainability advocate who founded several companies, including Smith & Hawken, the retail and catalog gardening company. Among his books are the best-selling *Growing a Business*, which accompanied a seventeen-part PBS series; *The Ecology of Commerce*, which shows the potential of business and markets to aid the environment; and most recently *Natural Capitalism*, with Amory Lovins and L. Hunter Lovins. He has served as cochair of the Natural Step, which sets environmental standards for businesses, and currently works as a consultant on sustainability with corporations, governments, and institutions.

page 84

Dr. David Ho is scientific director and CEO of the Aaron Diamond AIDS Research Center at the Rockefeller University in New York City. Under Ho's direction, the center's researchers have published groundbreaking studies about how HIV replicates and how certain individuals are naturally resistant to HIV infection. They have also led the way in developing revolutionary combination drug therapies for AIDS. Ho serves on numerous advisory councils and boards and is a reviewer for nineteen peer-reviewed medical journals. He is the recipient of four honorary degrees and was *Time* magazine's Man of the Year in 1996.
Aaron Diamond AIDS Research Center, www.adarc.org, (212) 448-5100

page 94

For the past two decades, **Bianca Jagger** has campaigned for human rights throughout the world. Born in Nicaragua, she received her formal education at the Institute of Political Science in Paris. During the 1980s, she documented human rights violations and death squad activities in Guatemala, El Salvador, Honduras, and Nicaragua. She has more recently participated in fact-finding missions to the former Yugoslavia to document mass rapes of Bosnian women and other atrocities. The recipient of many humanitarian and environmental awards, she has also petitioned Latin American governments to protect their rain forests and the indigenous tribes who live in them.
Amnesty International, www.amnesty.org, (212) 807-8400

page 161

Her Majesty Queen Noor al-Hussein was born Lisa Najeeb Halaby into a prominent Arab-American family in Washington, D.C. Her father served as head of the Federal Aviation Administration under President Kennedy. A graduate of Princeton University's School of Architecture, she met Jordan's King Hussein while working on a redesign of facilities for Jordan's national airline. In 1978, they married and she became the first American-born queen of an Arab country. She has since sensitively balanced Arab and Western cultures in her work for development, education, women's rights, and the land mine ban with her Noor Al Hussein Foundation (NHF). King Hussein died of cancer in 1999.
Noor Al Hussein Foundation, www.nhf.org.jo

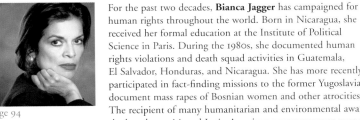

page 126

The first non-Italian Roman Catholic pope in 456 years, **His Holiness Pope John Paul II** was born Karol Wojtyla in Wadowice, Poland, in 1920. Ordained a priest in 1946, he became a professor of philosophy at the Catholic University of Lublin and the University of Kraków. In 1978, he began his reign as one of the most active pontiffs in history. After surviving a 1981 assassination attempt by Mehmet Ali Agca, he visited Agca in his cell and forgave him. A conservative on social issues, His Holiness has traveled throughout both the Catholic and non-Catholic world—including in recent years Cuba and the Middle East—as a vocal proponent of human rights and peace. | The Roman Catholic Church, www.vatican.va

page 68

Born in Vicksburg, Mississippi, in 1902, **Ida Jackson** was the first certified African-American high school teacher in California. She completed her master's degree at the University of California, Berkeley, a rarity for an African-American woman in the 1920s, and coursework toward her Ph.D. at Berkeley and Columbia University. She later became dean of women at Tuskeegee Institute in Alabama and national president of the Alpha Kappa Alpha sorority, which she mobilized to create the Mississippi Health Project, the first mobile health clinic system in the United States. The project's volunteer doctors served more than four thousand people in the rural South. | Ida Jackson Housing and Education Foundation, (510) 530-5130

page 176

A pioneer in environmental law, **Robert F. Kennedy Jr.** serves as chief prosecuting attorney for the Hudson Riverkeeper organization and as senior attorney for the National Resources Defense Council. He is also clinical professor and supervising attorney at the Environmental Litigation Clinic at Pace University School of Law in New York. Among his many cases, he has successfully prosecuted water polluters in the New York City area and assisted several indigenous tribes negotiate treaties protecting their traditional homelands in Latin America and Canada. An avid white-water paddler, he has led first descents on remote rivers in Peru, Colombia, and Venezuela. | Riverkeeper, www.riverkeeper.org, (800) 21-RIVER

page 62

Born in South Carolina in 1941, Baptist minister **Reverend Jesse Jackson** is one of America's most influential civil rights leaders. After rejecting an athletic scholarship because of the preferential treatment of whites, he joined Martin Luther King Jr.'s Southern Christian Leadership Conference (SCLC) as an undergraduate. In 1967, he was named head of SCLC's Operation Breadbasket. Jackson was present when King was assassinated in 1968. In later years he founded Operation PUSH (People United to Save Humanity) and the Rainbow Coalition. Jackson campaigned for president in 1984 and 1988, and has mediated international disputes throughout his career. | Rainbow Push Coalition, www.rainbowpush.org, (773) 373-3366

page 48

Craig Kielburger became an advocate for children's rights when he was twelve years old and read about the murder of a Pakistani child who had been sold into bondage. His organization Free the Children has since expanded into twenty countries, where it initiates such projects as opening schools and rehabilitation centers, and providing alternative income programs for families to relieve children from hazardous work. In the past four years, Kielburger has traveled to more than thirty countries visiting and working with street children and speaking to groups on children's rights. The recipient of many awards, he is the author of *Free the Children*.
Free the Children International, www.freethechildren.org, (905) 760-9382

page 18

Born near Marion, Alabama, in 1927, **Coretta Scott King** attended Antioch College and the New England Conservatory of Music, where she met her future husband, Martin Luther King Jr., a graduate theological student at Boston University. They married in 1953 and moved to Montgomery, Alabama, where Dr. King became pastor of the Dexter Avenue Baptist Church. Throughout the 1950s and 1960s, Mrs. King accompanied her husband in his campaign for civil rights. After her husband's assassination in 1968, she founded the Martin Luther King Jr. Center for Nonviolent Social Change in Atlanta, Georgia, to continue their work. | The King Center, www.thekingcenter.com, (404) 524-1956

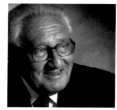

page 88

Born and raised in Bavaria, **Dr. Henry A. Kissinger** fled Nazi Germany with his parents at fifteen and settled in New York City. A political scientist who advised presidents Eisenhower, Kennedy, and Johnson, he became a Harvard professor of government before directing foreign policy for the Nixon and Ford administrations. In addition to his diplomatic achievements with China, the Soviet Union, and the Middle East, Kissinger led negotiations that brought about a cease-fire agreement to the Vietnam War. He shared the Nobel Peace Prize in 1973 with North Vietnamese negotiator Le Duc Tho. Kissinger now runs an international consultancy.

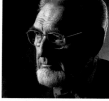

page 81

Born in Brooklyn in 1916, **Dr. C. Everett Koop** enjoyed a long career as a leading pediatric surgeon at Children's Hospital in Philadelphia and as a professor of medicine at the University of Pennsylvania from 1948 to 1981. In 1981, Koop was appointed surgeon general of the United States, a position in which he became a strong, independent voice on the AIDS crisis and the perils of smoking. He is now Elizabeth DeCamp McInerny Professor at Dartmouth College. The recipient of thirty-five honorary doctorates, Koop provides health care information to the public through his popular web site, drkoop.com.

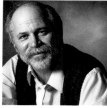

page 154

Ron Kovic recounts the story of his journey from disillusioned Vietnam veteran to leading antiwar activist in his best-selling autobiography, *Born on the Fourth of July,* which was made into an Academy Award–winning film by Oliver Stone. Kovic grew up in Massapequa, New York, and enlisted in the marines after graduating from high school in 1964. After accidentally killing a fellow serviceman in battle and later being seriously wounded by enemy fire, he returned home a paraplegic. He eventually overcame his experiences in battle and recovery to become a leading veterans' rights activist who addressed the 1976 Democratic National Convention.

page 46

Phil Lane Jr., a member of the Yankton Sioux and Chickasaw tribes, has worked for the past twenty-eight years with indigenous people in North and South America, Micronesia, Thailand, Hawaii, and Africa. Founder of the Four Worlds Development Project at the University of Lethbridge in Alberta, Canada, where he worked for fifteen years, Lane is now president of the independent Four Worlds International Institute, which promotes sustainable, spiritually based economic and community development. He received the 1992 Windstar Award for his work, as well as the 2000 Foundation for Freedom and Human Rights Award in Berne, Switzerland. | Four Worlds International Institute, home.uleth.ca/~4worlds, (403) 320-7144

page 132

The son of famed anthropologists Louis and Mary Leakey, **Richard Leakey** began his own career as a paleoanthropologist after discovering a fossilized australopithecine jaw near Lake Natron in Tanzania. He went on to make several important hominid fossil discoveries that placed human ancestors in Africa as early as 3.5 million years ago. In 1989, he became director of the Kenya Wildlife Service, where he halted the country's rampant elephant poaching and helped pass a worldwide ban on the ivory trade. In 1995, after leaving the government, he formed Safina—Swahili for "Noah's Ark"—a new Kenyan reformist political party.

page 20

At twenty-one, while a graduate student at the Yale School of Architecture, **Maya Lin** won a competition to design the Vietnam Veterans Memorial in Washington, D.C. Her design, which incorporates the names of more than fifty-eight thousand American soldiers who died or went missing during the war, initially met with controversy but has since become one of the most admired and visited monuments in the world. Her other designs, many of which incorporate natural forms, include her memorial to the Civil Rights movement that was dedicated in 1990 in Montgomery, Alabama, and the Women's Table, a monument commemorating Yale University women. | Natural Resources Defense Council, www.nrdc.org, (212) 727-2700

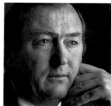

page 118

On August 10, 1976, a car chase between IRA and British troops through Belfast, Northern Ireland, led to an accident in which two of **Mairead Corrigan Maguire**'s nephews and one of her nieces were killed. Her sister, distraught over the death of her children, took her own life several years later. The incident led Maguire, a Catholic, and Betty Williams, a Protestant, along with newspaper reporter Ciaran McKeown, to found Peace People, a pioneering organization in the movement to end sectarian violence in Northern Ireland. They shared the 1976 Nobel Peace Prize for their work. Maguire continues to work for global nonviolence as honorary life president of Peace People. | Peace People, www.peacepeople.com

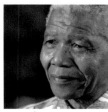

page 16

The foster child of a tribal chief, **Nelson Mandela** began his opposition to South Africa's government while attending college. He went on to become a lawyer and joined the African National Congress (ANC) in 1944. For two decades he led the fight against apartheid's racist policies, until he was sentenced to life in prison for sabotage in 1964. The long campaign for his release succeeded in 1990 and the newly legalized ANC elected him their president the next year. His negotiations with President F. W. de Klerk, which won them the 1993 Nobel Peace Prize, led to South Africa's first multiracial presidential elections in 1994, which Mandela won. He retired in 1999. | Nelson Mandela Children's Foundation, www.mandela-children.org

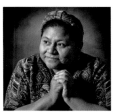

page 100

After losing her mother and brother to Guatemalan death squads in the late 1970s and her father to a fire, **Rigoberta Menchú Tum,** a Quichè Mayan Indian, followed in her father's footsteps in protesting human rights abuses against Guatemala's indigenous peasants by the country's repressive military government. In 1981, Menchú fled to Mexico and joined the international fight to stop the brutal repression of Guatemalan Indian peasants. A leading proponent of indigenous people's rights everywhere, Menchú Tum is the author of *I Rigoberta Menchú* and the recipient of the 1992 Nobel Peace Prize for her work toward reconciliation. | Rigoberta Menchú Tum Foundation, www.indians.org/welker/menchu.htm

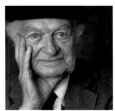

page 42

Thich Nhat Hanh, a Buddhist monk, poet, peace activist, and author, was born in 1926 in Vietnam. He entered the monkhood at sixteen and has since become one of the West's most recognized and beloved Buddhist teachers. A pioneer in the concept of engaged Buddhism, he was chair of the Vietnamese Buddhist Peace Delegation during the Vietnam War and was nominated for a Nobel Peace Prize by Martin Luther King Jr. The author of more than twenty-five books, he has lived in exile since 1966 in Plum Village, France, a small monastic community where he writes, gardens, teaches, and helps refugees. | The Community for Mindful Living, www.parallax.org, (510) 525-0101

page 86

Chemist **Linus Pauling**'s discovery of sickle-cell anemia's genetic cause and his application of quantum mechanics to molecules won him the Nobel Prize for Chemistry in 1954. Nine years later, he won the Nobel Peace Prize for his antinuclear activism, which included presenting a petition signed by eleven thousand scientists warning the public about the biological danger of radioactive fallout from nuclear weapons testing. Known as a champion of Vitamin C's curative powers, Pauling researched the genetic mechanisms of disease at many universities and at the Linus Pauling Institute of Science and Medicine. He died in 1994 at age ninety-three. | The Linus Pauling Institute, www.orst.edu/dept/lpi, (541) 737-5075

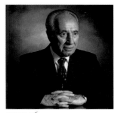

page 56

Born in Wolozyn, Poland, in 1923, **Shimon Peres** immigrated with his family to Palestine in 1934. He became an activist while living on a kibbutz as a youth. His long career in public service began at age twenty-four, when Israel's first prime minister, David Ben-Gurion, appointed him head of the new state's navy. Peres went on to serve as a member of the Knesset, minister of defense, finance minister, and prime minister. As Israel's foreign minister, Peres shared the 1994 Nobel Peace Prize with Prime Minister Yitzhak Rabin and Palestinian Liberation Organization Chairman Yasir Arafat for their negotiations toward a peace accord.

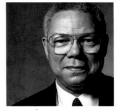

page 98

General Colin Powell served as the highest-ranking African-American officer in U.S. history. Born in Harlem to Jamaican immigrant parents, Powell joined the Army ROTC in college. In two tours of Vietnam, he was awarded two Purple Hearts, a Bronze Star, a Soldier's Medal, and the Legion of Merit. Powell's parallel careers in the military and politics brought him to high-level positions in the Carter, Reagan, and Bush administrations, including national security advisor and chairman of the Joint Chiefs of Staff. Powell retired from the army in 1993. He now promotes volunteerism as chairman of America's Promise—The Alliance for Youth. | America's Promise—The Alliance for Youth, www.americaspromise.org, (888) 55-YOUTH

page 142

Helen Prejean, C.S.J., was born and raised in Baton Rouge and has lived in Louisiana all her life. A member of the Sisters of St. Joseph of Medaille, she has long been involved in community work among the poor. Her contact with a man on death row in Louisiana's Angola State Prison led her to become both an outspoken activist against capital punishment and an advocate for murder victims' families. Prejean is the author of *Dead Man Walking,* which was made into a motion picture by Tim Robbins, and in which she was portrayed by actress Susan Sarandon. Moratorium 2000, www.moratorium2000.org, (202) 588-5489

page 120

Leah Rabin is the widow of assassinated Israeli Prime Minister Yitzhak Rabin. She served with her husband in the Palmach, the secret commando unit of the pre-state underground Jewish army, where he became a war hero. She accompanied him as he rose in the Labor Party to become the first native-born Israeli prime minister in 1974 and 1992, and was with him when he was assassinated in late 1995 by law student Yigal Amiras as the couple was leaving a peace rally in Tel Aviv. Since the assassination, Leah Rabin has been an outspoken critic of impediments to the peace process. | The Yitzhak Rabin Center for Israel Studies, www.rabincenter.org.il

page 36

José Ramos-Horta was born in Dili, East Timor, in 1949. Of his eleven brothers and sisters, four were killed by the Indonesian military, which invaded East Timor in 1975, resulting in the death of more than two hundred thousand people. Ramos-Horta worked as a journalist from 1969 to 1974, during which his prominent role in the political resistance forced him into exile in Mozambique for two years. He again left East Timor in 1975 to spend the next twenty-four years fighting for human rights and Timorese independence from abroad. Ramos-Horta shared the 1996 Nobel Peace Prize with Bishop Carlos Filipe Ximenes Belo. Timor Aid, www.timoraid.org

page 172

One of Hollywood's most revered actors, producers, and directors, **Robert Redford** is also known as a prominent environmentalist and champion of independent filmmaking. In 1981, Redford founded the nonprofit Sundance Institute, which encourages independent filmmaking, theater, and musical composition. The institute's projects now include the cable TV Sundance Channel, the influential Sundance Filmmakers/Screenwriters Lab, and the Sundance Film Festival, which since its inception in 1984 has revolutionized independent film's prominence. Redford also is known for his Native American advocacy and founded the environmental group Institute for Resource Management. The Sundance Institute, www.sundance.org, (801) 328-3456

page 53

Born in Upper Egypt in 1934, at age sixteen **Jehan Sadat** married Anwar Sadat, who later became president of Egypt. During the course of their thirty-two-year marriage, she earned a bachelor's degree in Arabic language as well as master's and Ph.D. degrees in literature from Cairo University. Dedicated to improving the status of women in Egypt, she established the Talla Society, which trains women in various handicrafts and pays the tuition of nearly one thousand secondary school and university students. The recipient of many public service awards, she has been a professor of international studies at the University of Maryland since 1993.

page 136

Carlos Santana is a pioneer in synthesizing musical styles from different cultures. Born in the village of Autlan, Mexico, Santana was introduced at age five to traditional Mexican music by his father, an experienced mariachi violinist. After his family moved to Tijuana and later settled in San Francisco, the Santana Blues Band burst onto the West Coast music scene in the late 1960s. Thirty years later—with more than fifty million records sold, and a record-tying nine Grammy awards in 1999—Santana continues to blend Afro-Cuban rhythms, twelve-bar American blues, and his singular guitar style to capture a diverse international audience. | The Milagro Foundation, www.santana.com/milagro

page 60

Responsible for ushering in the modern blockbuster era, **Steven Spielberg** is the largest grossing movie director in history. In 1993, he directed the Oscar-winning *Schindler's List,* based on Thomas Keneally's Booker Prize–winning Holocaust novel. Spielberg has since devoted all his earnings from the film to the Survivors of the Shoah Visual History Foundation, which has documented more than 100,000 hours of Holocaust survivors' testimonies, and the Righteous Persons Foundation, which grants money to various projects affecting modern Jewish life. Spielberg's award-winning 1998 film *Saving Private Ryan* broke ground in its harrowing portrayal of World War II combat. | Survivors of the Shoah Visual History Foundation, www.vhf.org, (818) 777-4673

page 30

Mother Teresa became known to the world for her selfless work with the "poorest of the poor" in Calcutta, India. She was born Agnes Bojaxhiu in Skopje, now the capital of Macedonia, in 1910, and began her novitiate in India in 1928. Since its inception in 1950, her order, the Missionaries of Charity, has opened more than five hundred centers around the world to help the dying and destitute. Mother Teresa is the recipient of the Nobel Peace Prize. She died in 1997. The Catholic Church is currently reviewing her cause for sainthood. | Missionaries of Charity, 54A, Acharya Jagadish Chandra Bose Road, Calcutta 700 016

page 150

Baroness Margaret Thatcher was Europe's first woman prime minister and the first British prime minister of the twentieth century to serve three consecutive terms. A leading conservative since she became the first woman president of the Oxford University Conservative Association, she worked as a research chemist and tax attorney before first standing for Parliament in 1959. As prime minister from 1979 to 1990, she supported privatizing state-run programs and reducing government's role in citizens' lives. She recaptured the Falkland Islands after a ten-week Argentine occupation and supported the position that a strong British and NATO military provided the best deterrent to war.

page 134

Starting with one bankrupt UHF television station in Atlanta, **Robert Edward (Ted) Turner** built a media empire that included TNT, TBS—the first new television network since PBS—and the revolutionary twenty-four-hour Cable News Network (CNN). As the largest private land owner in the United States, Turner works to restore overgrazed ranchland and to reintroduce native plants and bison. The owner of the Atlanta Braves and winner of sailing's America's Cup, he established the Goodwill Games in 1986 to improve relations with the then Soviet Union. His family's Turner Foundation donates $25 million to environmental groups annually, and in 1997 he donated $1 billion to the United Nations. | The Turner Foundation, www.turnerfoundation.org

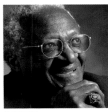

page 114

Archbishop Desmond Mpilo Tutu was born in 1931 in Klerksdorp, South Africa. Following his father's example, Tutu became a schoolteacher in 1954 but left his post in 1957 and was ordained an Anglican parish priest in 1961. Among his many pioneering church positions, he became the first black archbishop to lead South Africa's 1.6 million Anglicans. A leading opponent of apartheid who vehemently opposes violence, Tutu supported peaceful negotiation and international sanctions against the South African government. Tutu won the 1984 Nobel Peace Prize, and was appointed chair of South Africa's Truth and Reconciliation Commission in 1995. | Church of the Province of Southern Africa, www.cpsa.org.za

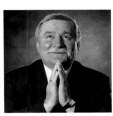

page 130

One of the main figures responsible for the fall of European communism, **Lech Walesa** began work as an electrician at the Lenin Shipyard in Gdańsk, Poland, in 1967. After losing his job in 1976 for organizing against Poland's Communist government, he climbed over the shipyard wall to join striking workers, who elected him to lead negotiations. Walesa eventually won the legalization of the ten-million-member national union Solidarity, which he led. After a landslide victory, Walesa served for five years as Poland's first noncommunist prime minister in more than forty years. He received the Nobel Peace Prize in 1983. | Lech Walesa Institute, (48-22) 622 22 20, 622 56 33

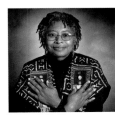

page 50

Alice Walker was born the youngest of eight children into a sharecropper and dairy farming family in Eatonton, Georgia. In the years after graduating from Sarah Lawrence College in 1965, she taught in Mississippi, worked for the Civil Rights movement, and began her writing career. Walker's written work includes several collections of poetry and essays, and five novels. Her novel *The Color Purple* won the Pulitzer Prize and was made into a film by Steven Spielberg. Infused with political activism, Walker's writing often focuses on the plight of black women. In recent years she has worked to increase awareness about female genital mutilation.

page 102

Born in 1957 into the Menominee Nation in Wisconsin, **Ingrid Washinawatok el-Issa, O'Peqtaw-Metamoh (Flying Eagle Woman),** worked with many organizations to promote indigenous people's cultures and rights. As executive director of the Fund for Four Directions in New York City, she worked in particular to revitalize indigenous languages. Washinawatok was one of three Americans kidnapped and executed in the remote highlands of Colombia by Revolutionary Armed Forces of Colombia (FARC) rebels, while on a mission to help the U'wa tribe set up a school system in February 1999. She is survived by her husband, Ali el-Issa, and her son, Maeh-kiw-kasic. | Flying Eagle Woman Fund, (212) 768-1430

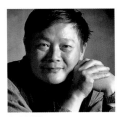

page 112

China's most prominent dissident, **Wei Jingsheng,** has spent most of his adult life in prison. He was first sentenced to fifteen years imprisonment in 1979 for arguing in protests and in his essay "The Fifth Modernization: Democracy" that, in addition to Deng Xiaoping's heralded reforms, China needed democracy. Enduring solitary confinement and unspeakable conditions, Wei was released in 1993 during China's bid to host the 2000 Olympic Games. Within eighteen months, after returning immediately to vocal protest, he was sentenced to another fourteen years. He was released three years later on medical parole. He now lives in the United States, hoping one day to return to China.

page 110

Presbyterian minister **Reverend Benjamin Weir** was kidnapped in Beirut, Lebanon, on May 8, 1984, while out walking with his wife, Carol. Members of Islamic Jihad, a terrorist group in Lebanon—held Weir for sixteen months—twelve of them in solitary confinement—along with six other Americans who were released later, including journalist Terry Anderson. Before the kidnapping, Weir had spent nearly three decades in Lebanon as a missionary and a teacher at the Near East School of Theology. In his various positions in the Presbyterian church since his release, Weir has been a voice of reconciliation and tolerance.

page 58

When **Elie Wiesel** was sixteen his entire family was taken from their home in Sighet, Romania, to the Nazi concentration camps of Auschwitz and Buchenwald. Wiesel and his two older sisters were the family's only survivors. Having devoted his life to teaching about the Holocaust, Wiesel has written for newspapers in France, Israel, and the United States. He is Andrew W. Mellon Professor of Humanities at Boston University and the author of more than forty books. He has received the Presidential Medal of Freedom, the United States Congressional Gold Medal, the French Legion of Honor, and the 1986 Nobel Peace Prize. | Elie Wiesel Foundation for Humanity, www.eliewieselfoundation.org, (212) 490-7777

page 158

As its coordinator, **Jody Williams** brought the International Campaign to Ban Landmines (ICBL) from a coalition of two nongovernmental organizations at its founding in 1992 to include more than one thousand groups from more than sixty countries. After receiving her master's in international studies from Johns Hopkins University, Williams worked on American foreign policy in Central America as coordinator of the Nicaragua-Honduras Education Project and as associate director of Medical Aid to El Salvador. Williams and the ICBL won the 1997 Nobel Peace Prize for its work to ban and remove land mines, which claim roughly twenty-six thousand victims every year, most of them civilians. | International Campaign to Ban Landmines, www.icbl.org, (202) 547-2667

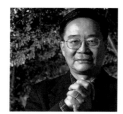

page 144

Harry Wu spent nineteen years in Chinese prison camps during the 1960s and 1970s. He was arrested and detained again for sixty-six days in 1995 at the Chinese border while on a fact-finding mission. He is executive director of the Laogai Research Foundation in Milpitas, California, and has held research positions at the University of California at Berkeley and Stanford University. He has built a database of information on more than eleven hundred prisons and concentration camps of the Chinese gulag system, or "Laogai," which literally means "reform through labor." He is the author of two autobiographical books. Laogai Research Foundation, www.laogai.org, (202) 508-8215

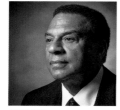

page 140

Ambassador Andrew Young began work in the Civil Rights movement when, as a Protestant minister, he joined the Southern Christian Leadership Conference in 1960. Instrumental in the fight for desegregation, he became one of Martin Luther King Jr.'s closest associates and served as executive director of the conference from 1964 to 1970. In 1972, Young was elected the first African-American congressman from Georgia since 1871. He served two terms in the House before joining the Carter Administration as ambassador to the United Nations in 1977. Young served as mayor of Atlanta from 1981 to 1989.

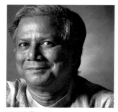

page 74

Muhammad Yunus was born in Bangladesh and earned his Ph.D. in economics at Vanderbilt University. After returning to Bangladesh to teach, he was inspired by the country's crushing famine of 1974 to leave academia to help the poor. His revolutionary microcredit concept began by giving out loans totaling twenty-seven dollars to forty-two villagers with no collateral. Microcredit has now spread to more than fifty countries worldwide. With a repayment rate of 98 percent and two million borrowers, Yunus's $2.5 billion Grameen Bank has expanded into dozens of other projects for empowering the poor, including telecommunications and venture capital. | Grameen Foundation USA, www.grameenfoundation.org, (888) 764-3872

THIS BOOK OWES ITS EXISTENCE TO THE SEVENTY-FIVE AMAZING individuals who opened their lives to include me and this project, always seeing its potential to educate. This book is their creation. My hope is that *Architects of Peace* will allow its readers to see and feel the incredible spirit contained in these individuals and to be informed and inspired by them as I have.

I would like to offer my deepest appreciation to my editor, Jason Gardner, whose integrity, diligence, and sensitivity created this work's scope and clarity. Thank you also to Michi Toki of Toki Design, who, along with her colleague, Jenny Herrick, poured her unique imagination into the design and execution of this book. I especially appreciated their flexibility and good humor under unreasonable deadlines. I owe a huge debt to Bruce Vogel for his invaluable assistance in gaining access to many key individuals. My gratitude also goes to Michael Jensen, an early and enthusiastic advisor who was a vital catalyst in creating the theme of this work.

I would like to thank the remarkable artist and technician Leslie Kossoff for printing all of the images. Ilford Imaging, through Wendy Friant, generously donated the Ilford Multigrade Warmtone Fibre Based paper for printing. Thanks to Mark Robyn of Robyn Color in San Francisco for his help with the high-resolution scanning. My gratitude to Cecilia Lee for her friendship and generous support.

Thanks to everyone at New World Library for their commitment to this project, especially to Becky Benenate for her vision in signing the book and Katharine Farnam Conolly for her positive attitude and hard work. Thanks also to Mary Ann Casler, Tona Pearce Myers, Marc Allen, Georgia Hughes, Munro Magruder, Victoria Williams-Clarke, Ryan Madden, Marjorie Conte, Cathy Bodenman, Dean Campbell, and Katie Karavolos.

Jim Garrison and the State of the World Forum were an integral component and catalyst for this project. I remain extremely grateful to Marian Wright Edelman for the light of her example.

To my family, Almis, Sean, and Paul, who continue to inspire and encourage me, I love you. I am grateful to my parents, George and Dorothy Collopy, for everything they have given me.

I am also indebted to many people for their help and support. These people, across a broad spectrum, made this book possible: Jim and Claire Garrison, Kath Delaney, Shuly Galili, John Balbach, Diane Mailey, Dr. Richard and Paulette Henning, Mike Duffy, Tommy Vano, Susan Simmons, the Harry Walker Agency, Wendy Miller, Villa Montalvo, Pavel Palazchenko, Judi Hinkle, Dr. Margaret Huber, Dr. JoAnne Boyle, Linda Mitchell, Seton Hill College, Jocelyn Sherman, Marc Grossman, Joan Daschbach, Defoy Glenn, Julie Fiore, Janet Moran, the American Program Bureau, Sherrie Granger, Mick Jones, Keira Cahill, Rebecca Nelson, Mary Lewis, Terry Aquino, Sima Wolf, Larry Guyer, Father Paul Obrimsky, the Missionaries of Charity, Hi Fi Lab, David Bernstein, Harry Rhoads, the Washington Speakers Bureau, Lee Poston, Debora Cartwright, Caroleen Toyama, Hank Armstrong, the Monterey Bay Aquarium, Dawa Tsering, David Krieger, the Nuclear Age Peace Foundation, Gayle Lederman, Mikhail Davis, Roger Graham, Digital Pond, Kitsaun King, Johanna Ransmeier, Theresa Simino, Sister Margaret Maggio, Siobhan Collopy, Jan Petrie, Marie Constantin, Bradley James, Mike Rinaldi, Fr. Steve Meyer, Sandy McMurtrie, Matt De Rhodes, Mark Gettys, Fr. Matt Elshoff, LeAnne Hitchcock, Kevin Wolfe, Kelly Vogel, John Zavalney, the Foshay Learning Center, Sarah Wayland-Smith, Robert Vickers, Steve Kline, Lyn Cothren, Maureen Donaghy, Carrie Harmon, Melinda Williams, Richard Dunn, Barbara LaPiana, Marlene Adler, Julie Sukman, Mary Beth Postman, Jackie Cole, Jean Bair, Kris Kelley, Susan Ray, Kristin Stark, Mary Ellen Zemeckis, Jesse Devore, Barbara Proctor, Lucille Martin, Inez Dones, Charlotte Pace, Wendy Kalkan, Roger Nyhus, Rebeca de Cardinas, Phil Borges, Hal Gordon, Kim DePaul, Natacha Meden, Phillip Evans, Khadija Haq, Nasreen Mahmood, Barbara Selfridge, Ann Roberts, Nadine Shubailat, and Gadheer Taher. Thank you all.

We gratefully acknowledge the many participants who generously provided original statements for *Architects of Peace:* Hafsat Abiola, Mahnaz Afkhami, Joan Baez, Benazir Bhutto, James and Sarah Brady, David Brower, Jimmy Carter, César Chavez, Theo Colburn, Jean-Michel Cousteau, Walter Cronkite, Dith Pran, Marian Wright Edelman, Arun Gandhi, Chief Leonard George, Dr. Lorraine Hale, Nadja Halilbegovich, Dr. Mahbub ul-Haq, Paul Hawken, Dr. David Ho, Queen Noor al-Hussein, Reverend Jesse Jackson, Bianca Jagger, Robert F. Kennedy Jr., Craig Kielburger, Coretta Scott King, Dr. Henry A. Kissinger, Phil Lane Jr., Maya Lin, Mairead Corrigan Maguire, Rigoberta Menchú Tum (translated by Richard Castillo), Colin Powell, Robert Redford, Jehan Sadat, Carlos Santana, Steven Spielberg, Mother Teresa, Ted Turner, Ingrid Washinawatok el-Issa, and Wei Jingsheng.

We gratefully acknowledge the following publishers and copyright holders for their permission to reprint the following statements:

Bella Abzug: Excerpt from *Gender Gap: Bella Abzug's Guide to Political Power for American Women* by Bella Abzug and Mim Kelber. Copyright © 1984 by Bella S. Abzug and Mim Kelber. Reprinted by permission of Houghton Mifflin Co. All rights reserved.

Maya Angelou: Excerpt from "An American Odyssey: From Martin Luther King to Rodney King" by Maya Angelou, Ryszard Kapuscinksi, and Ali Mazrui. Copyright © 1991 by Maya Angelou. Reprinted by permission of *New Perspectives Quarterly.*

Oscar Arias Sanchez: Excerpt from a speech given to the InterAction Council, "Some Contributions to a Universal Declaration of Human Obligations." Copyright © 1997 by Oscar Arias Sanchez. Reprinted by permission of the author and the InterAction Council, www.asiawide.or.jp/iac/speeches/ariasudho.htm.

Harry Belafonte: Excerpt from "Is America a Burning House?: We Need a Voice of Moral Courage to Offer a Vision for the Twenty-First Century" by Harry Belafonte. Copyright © 1996 by Harry Belafonte. Reprinted by permission of *Essence.*

General George Lee Butler: Excerpt from "The Responsibility to End the Nuclear Madness" by General George Lee Butler. Copyright © 1999 by General George Lee Butler. Reprinted by permission of *Waging Peace Worldwide: A Journal of the Nuclear Age Peace Foundation* and the author.

Dr. Helen Caldicott: Excerpt from *If You Love This Planet: A Plan to Heal the Earth* by Helen Caldicott. Copyright © 1992 by Helen Caldicott. Reprinted by permission of W. W. Norton & Company, Inc.

Geoffrey Canada: Excerpt from *Fist Stick Knife Gun: A Personal History of Violence in America* by Geoffrey Canada. Copyright © 1995 by Geoffrey Canada. Reprinted by permission of Beacon Press, Boston.

His Holiness the Dalai Lama: Excerpt from a speech given at the "Forum 2000" Conference, Prague, Czech Republic, 3–7 September 1997. Copyright © 1997 by His Holiness the Dalai Lama.

Yaël Dayan: Excerpt from a speech given at the State of the World Forum. Copyright © 1996 by Yaël Dayan.

F. W. de Klerk: Excerpt from *The Last Trek—A New Beginning: The Autobiography* by F. W. de Klerk. Copyright © 1998 by F. W. de Klerk. Reprinted by permission of St. Martin's Press, LLC.

Jane Goodall: Excerpt from "Four Rays of Hope" by Jane Goodall. Copyright © 1999 by Jane Goodall. This article originally appeared in the Winter 1999 issue of *Orion*, 195 Main Street, Great Barrington, MA 01230. Reprinted by permission of *Orion.*

Mikhail Gorbachev: Excerpt from *The Search for a New Beginning: Developing a New Civilization.* Copyright © 1995 by Mikhail Gorbachev. Reprinted by permission of HarperCollins Publishers, Inc.

Reverend Billy Graham: Excerpt from *Day by Day with Billy Graham* by Joan Winmill Brown. Copyright © 1976 by the Billy Graham Evangelistic Association. Reprinted by permission of World Wide Publications and the Billy Graham Evangelistic Association. All rights reserved.

Ida Jackson: Excerpt from "Ida Jackson: Oakland's First Black Teacher Reflects on Her Career" by Charles Aikens. Copyright © 1989 by Charles Aikens. Reprinted by permission of *California Voice.*

His Holiness Pope John Paul II: Excerpt from "Peace on Earth to Those Whom God Loves!" Speech for the Celebration of the World Day of Peace. The Vatican, 8 December 1999. Copyright © 1999 by Libreria Editrice Vaticana, 00120 Città del Vaticano. Reprinted by permission of Libreria Editrice Vaticana.

C. Everett Koop: Excerpt from "Essays on Science and Society: Protecting Medicine in the Twenty-first Century" by C. Everett Koop. Copyright © 1998 by C. Everett Koop. Reprinted by permission of *Science.*

Ron Kovic: Excerpt from "When a System Goes Astray, Go to the Streets: Today's Leaders Look to Tomorrow" by Ron Kovic. Copyright © 1990 by Ron Kovic and Time Inc. Reprinted by permission of *Fortune.*

Richard Leakey: Excerpt from *The Sixth Extinction: Patterns of Life and the Future of Humankind* by Richard Leakey and Roger Lewin. Copyright © 1995 by Sherma B.V. Reprinted by permission of Doubleday, a division of Random House, Inc.

Nelson Mandela: Excerpt from *Long Walk to Freedom* by Nelson Mandela. Copyright © 1994 by Nelson Rolihlahla Mandela. Reprinted by permission of Little, Brown and Company, Inc.

Thich Nhat Hanh: Excerpt from *Fragrant Palm Leaves: Journals 1962–1966* (1998) by Thich Nhat Hanh. Copyright © 1966 by Thich Nhat Hanh. Translation copyright © 1998 by Mobi Warren. Reprinted by permission of Parallax Press, Berkeley, California.

Linus Pauling: Excerpt from *No More War!* by Linus Pauling. Copyright © 1958 by Linus Pauling. Reprinted courtesy of the Ava Helen and Linus Pauling Papers, Oregon State University.

Shimon Peres: Excerpt from *Battling for Peace: A Memoir by Shimon Peres* edited by David Landau. Copyright © 1995 by Shimon Peres. Reprinted by permission of Random House, Inc.

Sister Helen Prejean: Excerpt from *How Can I Find God?* by Jim Martin. Copyright © 1997 by Jim Martin. Reprinted by permission of Liguori Publications, Liguori, MO 63057, www.liguori.org, 1-800-325-9521.

Leah Rabin: Excerpt from a speech given to the John F. Kennedy School of Government, March 7, 1996. Copyright © 1996 by Leah Rabin.

José Ramos-Horta: Excerpt from "End Poverty, Secure Peace," by José Ramos-Horta. Reprinted by permission of *Waging Peace Worldwide: The Journal of the Nuclear Age Peace Foundation.*

Margaret Thatcher: Excerpt from "Moral Foundations of Society: A Contrast between West and East" in *U.S.A. Today Magazine.* Copyright © 1996 by Margaret Thatcher and the Society for the Advancement of Education. Reprinted by permission of *USA Today Magazine.*

Archbishop Desmond Tutu: Excerpt from *No Future Without Forgiveness* by Desmond Mpilo Tutu. Copyright © 1999 by Desmond Mpilo Tutu. Reprinted by permission of Doubleday, a division of Random House, Inc.

Lech Walesa: Excerpt from *A Way of Hope* by Lech Walesa. Copyright © 1987 by Henry Holt and Company, Inc., and Librairie Arthème Fayard. Translation copyright © 1987 by Henry Holt and Company, Inc., and Collins Harvill. Reprinted by permission of Henry Holt and Company, Inc.

Alice Walker: Excerpt from *Anything We Love Can Be Saved* by Alice Walker. Copyright © 1999 by Alice Walker. Reprinted by permission of Random House, Inc.

Reverend Ben Weir: Excerpt from *Hostage Bound Hostage Free* by Ben and Carol Weir. Copyright © 1987 by Ben and Carol Weir. Reprinted by permission of the author.

Elie Wiesel: Excerpt from *And the Sea Is Never Full: Memoirs, 1969–* by Elie Wiesel. Copyright © 1987 by Alfred A. Knopf, Inc. Reprinted by permission of Alfred A. Knopf, a division of Random House, Inc.

Jody Williams: Excerpt from "The International Campaign to Ban Landmines: A Model for Disarmament Initiatives" by Jody Williams. Copyright © 1997 by Jody Williams. Reprinted by permission of the Nobel Foundation and Jody Williams.

Harry Wu: Excerpt from "The Other Gulag: China's Forgotten Prison Empire" by Harry Wu. Copyright © 1999 by National Review, Inc., 215 Lexington Avenue, New York, NY 10016, www.nationalreview.com. Reprinted by permission of National Review, Inc., and the author.

Andrew Young: Excerpt from *An Easy Burden: The Civil Rights Movement and the Transformation of America* by Andrew Young. Copyright © 1996 by Andrew Young. Reprinted by permission of HarperCollins Publishers, Inc.

Muhammad Yunus: Excerpt from "Empowerment of the Poor" by Muhammad Yunus. Copyright © 1997 by Muhammad Yunus.

Every effort has been made to contact all rights holders of reprinted material in *Architects of Peace.* The editors promise to correct any omissions or mistakes in acknowledgments in future editions.

*True happiness comes not from a limited concern for
one's own well-being, or that of those one feels close to,
but from developing love and compassion for all sentient
beings. Here, love means wishing that all sentient beings
should find happiness and compassion means wishing
that they should all be free of suffering. The development
of this attitude gives rise to a sense of openness and trust
that provides the basis for peace.*

—His Holiness the Dalai Lama